LIFE BEYOND MEASURE

SIDNEY POITIER

LIFE BEYOND MEASURE

Letters to My Great-Granddaughter

An Imprint of HarperCollinsPublishers

LIFE BEYOND MEASURE: *Letters to My Great-Granddaughter.* Copyright © 2008 by Sidney Poitier. All rights reserved. Printed in the United States of America. No part of this book may be used or reproduced in any manner whatsoever without written permission except in the case of brief quotations embodied in critical articles and reviews. For information address HarperCollins Publishers, 10 East 53rd Street, New York, NY 10022.

HarperCollins books may be purchased for educational, business, or sales promotional use. For information please write: Special Markets Department, HarperCollins Publishers, 10 East 53rd Street, New York, NY 10022.

FIRST HARPERLUXE EDITION

HarperLuxe™ is a trademark of HarperCollins Publishers

Illustration on page viii by Lydia Hess.

Library of Congress Cataloging-in-Publication Data is available upon request.

ISBN: 978–0–06–156279–2

08 09 10 11 12 ID/RRD 10 9 8 7 6 5 4 3 2 1

For my family,
and my family of friends

Somewhere, something incredible is waiting to be known.

—CARL SAGAN, 1934–1996

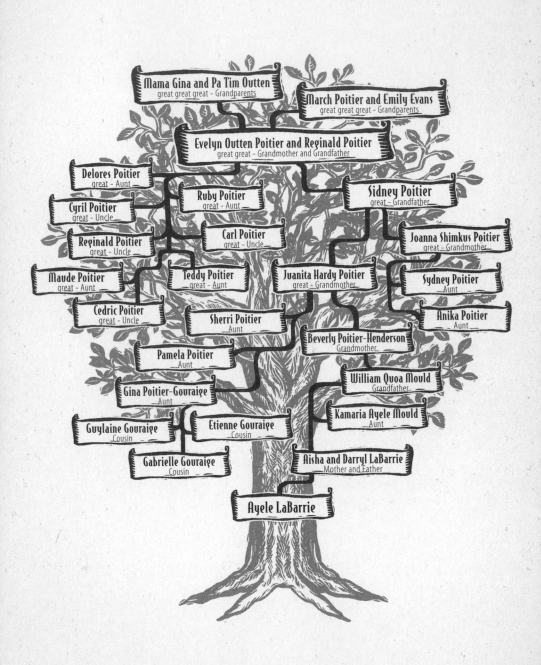

CONTENTS

Meeting Ayele

DECEMBER 23, 2005. ATLANTA, GEORGIA.

A rude blast of cold greeted me the moment I stepped outside of the baggage-claim area of the Delta Airlines terminal at Atlanta's notoriously labyrinthine airport. It was two days before Christmas, and I'd just flown from a sunny, mild Los Angeles morning into the darkening Georgia afternoon—where the plane landed, and where overcast skies further contributed to the somber mood that winter invariably conjures in me. While I was en route to the hospital in the old city of Atlanta to meet my great-granddaughter—just two days old—the weather outdoors struck me as woefully uncooperative in matching my inner feelings of joyful expectation.

At almost the age of seventy-nine, a year and a few months away from reaching the milestone of eighty years old, I had already welcomed two generations of offspring into the world—my daughters Beverly, Pamela, Sherri, and Gina (the four born to me and my ex-wife, Juanita) and my daughters Anika and Sydney (the two born to me and my wife, Joanna), followed then by Beverly's two, my late granddaughter Kamaria and then Aisha, and by Gina's three children, my granddaughter Guylaine, my grandson Etienne, and my granddaughter Gabrielle.

Now, incredibly, the first of the next generation had made her debut on December 22, 2005. Born to Aisha and her husband, Darryl, Ayele had shown the good sense to arrive close to her due date—demonstrating upon her entrance into life a grace and charm in keeping with the season of celebration.

Not for anything under the sun would I have missed the opportunity to be on hand in person at her life's commencement, to introduce myself—her great-grandfather on her maternal side.

That being said, I wasn't prepared for the impact of the sight that awaited me when I finally stood in the middle of the hospital room, surrounded by relatives, representing multiple generations, who had gathered to welcome Ayele into both the family and the world. As her doting father, Darryl, hovered nearby, there she

was, center stage, cradled in her mother's arms, snoozing contentedly with a look of such peace and wisdom, I was convinced she knew that time was absolutely working in her favor. With her mother, Aisha, holding her close and beaming down at her, just above the two of them, bathed in the same maternal glow, were the radiant faces of Ayele's grandmother Beverly and great-grandmother Juanita. Together the four generations presented a living portrait that was instantly arresting.

Vestiges of Native American ancestry could be seen not only in my ex-wife's features—the defined cheekbones, straight hair, reddish skin tone—but also in the younger three, though to lesser degrees. Some of the physical traits from my side of the DNA branch were evident as well, ironically not pronounced as much in my daughter and granddaughter as they were in the newborn—who appeared with her open yet serious countenance, even in sleep, to be as close to a female version of myself at her age as there has ever been. Or so I imagined the case to be, given that I have never been privy to what I looked like as an infant or as a young child; in fact, I was sixteen years old when the first photograph was ever taken of me. Nonetheless, judging by the chorus of declarations in the room, I wasn't alone in believing there to be a strong likeness between the two of us.

Of course, aside from discernible inherited traits, each of the four women shone with her own remarkable essence: Juanita with her quiet determination; my daughter Beverly, family-oriented, vibrant and alive, an embracer of life and others; my granddaughter Aisha, knowing and certain, a modern young woman; and even Ayele, already a trailblazer, already making her mark in our lives.

It was then, in that unforgettable moment, while looking on fondly at the four generations of women arrayed in front of me, that the idea for this book as a series of letters to Ayele first flitted into my thoughts.

As has happened a time or two in my wanderings, the idea that came to me unbidden in this fashion was about to require a shifting of gears. Over the past couple of years, I had been seriously at work on a book of essays that were to go under the collective heading "Unanswered Questions, Unfinished Lives." The scope of those questions encompassed everything from the most universally pondered issues of existence to the personal mysteries of my own travels—starting with the puzzles of life that I'd been attempting to unravel since early childhood.

In every stage of my growth—over the first ten and a half years, when I lived on tiny Cat Island in the Bahamas, separate and apart from the rest of the world,

through my youth in Nassau and then Miami, all along the road to adulthood that began when I arrived in Harlem at the age of sixteen, and over the next several decades, in which both opportunities and obstacles endowed me with a sense of the true measure of life—profound and nagging questions have continued to arise in me.

The notion that my time here is not unlimited—a reality that age and an earlier health scare helped to underscore—had certainly added urgency to the realization that I had many more unfinished, unanswered questions to address and much to do before resting. The other side of the philosophical coin had come from my observation that those who stop their questioning—at seventy-five, sixty, even at thirty—cut short their explorations and end up with permanently unfinished lives. To lose interest in life—to retreat from being totally alive and totally engaged in the worlds within and outside of ourselves—is a tragic plight in my eyes, yet one easily remedied whenever we muster the willingness to bear up to our thorniest questions.

Such had been the focus of my writing in the period leading up to Ayele's arrival. Now, suddenly, as I stood in the middle of the hospital room, positioned at the far end of my history in this lifetime, gazing adoringly

at my great-granddaughter at the beginning of hers, a new focus emerged.

It began with an awareness that I was more cognizant than anyone else of the four generations of women present there that day, which allowed me, as I stood looking at Ayele in her mama's arms, to focus even more closely on the child—on the stark differences between us and on our unique kinship. She and I were connected by virtue of the contrast, in that I was not far from eighty and she was two days old. Beyond the realization that she had just arrived and that I was moving toward the end of a journey, my thoughts unfolded next to consider all of the history that had transpired between my own arrival and hers.

In the weeks that followed my first meeting Ayele, the more I reflected on the intersection of our paths, the more I thought that it would be fitting for me to adapt the focus of the writing that I had been doing. After all, if she were to begin her search for roots later on, at age sixteen, twenty-two, thirty, or thirty-five, she would have not much more than a sketch of me from which to draw. Even if she read the previous books that I've written, hers would be only a partial view. And it occurred to me that I needed to go beyond the sketch to tell her more about the questions, answers, and mysteries that have concerned me at var-

ious important junctures; the partial view would not do for usage in her significant passages of life.

The partial view is the same sketch that I have of my grandparents. On my mother's side, I was able to catch a glimpse, while my father's mother and father were gone by the time that I—the youngest child of nine kids raised by my parents, Evelyn and Reggie—was old enough to form memories. The little bit that I was able to glean about those elders has only made me realize how limited the sketch of them has been.

And I wanted more for Ayele. I wanted her to know me in my own words, from stories not passed down but told from my lips, stories from my mind and imagination, from my philosophies and experiences—my life, as told to her, intended expressly for her and those of her generation wanting to bridge similar gaps of time and contrasting connections in their lineages. I wanted her to be able to lean on certain aspects of history that buoyed me, and that came before me, even before my elders—going back before the time of Jesus and Moses, before the time of written history, back tens of thousands of years to our earliest roots as *Homo sapien sapiens*, as our subspecies of our human origins is known scientifically.

Why should she not have that? If our human family, which began nearly one hundred thousand years ago,

is who we are today—with the same brain size and the same capacities to ask the fundamental questions that also define our species—why should Ayele not be introduced to our ancient roots early on? As she grows, there will also be more history, refined by science, that she will come upon, and I wanted to be able to expand her understanding by passing on what the knowledge was in my time.

All of that thinking provided the backdrop to the writing of the letters contained in this book, as did the decision to share the contents with those of you who are searchers like me—regardless of the generation into which you have been born.

The process of writing these letters to Ayele has been both sobering and enlightening. It has allowed me to revisit some old haunts and observe at a safe distance how perilously close to the flames I have danced. It has served as a reminder that even if I live to be a hundred, the time left to be shared between Ayele and me will be short at best. Nonetheless, I am encouraged that on these pages, between the covers of this book, she will be able to visit with me, learn who I really was, who I really am, and what life on this earth has been from my vantage point.

If perhaps you have read or heard some of the stories that I've told elsewhere yet repeat in new render-

ings ahead, I hope you'll indulge me in my choice to tell a handful of them again. The beauty of memory is how it allows us to look back at the events of our lives through the lens of different contexts and to see meanings overlooked before—revealing even more riches than we first suspected.

My intention has not been to send a message or to instruct my great-granddaughter, but rather to let her draw her own conclusions by seeing me at important, vulnerable turning points—in moments of fear, doubt, uncertainty, desperation, and loss of confidence, at times when the odds against survival rose higher and higher, nudging me dangerously close to the edge in more instances that I care to count. It has been with pleasure that I have shared with her my moments of victory and have described the kind of joy I feel when I look at myself through the eyes of my mother and see Ayele reflected there. It has been humbling and energizing to recount life lessons that had to be relearned more than a few times, to share intimate secrets, to shoot the breeze, to consider the juxtaposition of our respective "outdoorings" and expeditions, and to lend support to her search for answers that will undoubtedly lead to her own self-realizations.

One final thought has infused this undertaking as it pertains to the heightened challenges facing our

civilization in the times in which we're living. My sense is genuinely a hopeful one that solutions will be drawn by those of Ayele's generation, by those who rush forward and greet the discoveries of science while never forgetting the lessons of our primordial past, back when human creatures were called something else—those predecessors from whom we evolved. So many amazing earlier life-forms and creatures came to flourish here, and then fell into extinction, unable to make the cut. They are early cousins, untold numbers of prehistoric creatures who existed once, not in a span of so many years, tens or hundreds—but over millions of years. These living things took shape and inhabited the same fragile earth that we do now, and they had their time, but somehow they couldn't effectuate their survival in perpetuity.

Against that backdrop, we are all the more miraculous for being alive as human beings today and for continuing to ask the big questions—who, what, and where we are, why we're here, how we got here, and how our search goes on. Though my answers are not complete, what I have observed through my untrained but questioning sensibilities is included ahead. These observations are presented with infinite love to my great-granddaughter Ayele, and to you.

Part I

FIRST OUTDOORINGS

You and Me

Though these letters are addressed to you, my dearest Ayele, they are also written for me, so that I can rest assured in knowing that you will have me as a steadfast presence in your life—even after I'm gone and you are older. Much as I would have it otherwise, chances are that I will not be around long enough for you to know me well. Even so, on these pages you will find me waiting whenever you choose to visit.

But until such a time as I am not physically here anymore, it will be a top priority for us to spend as much time together as possible, you and me, hand in hand, eye to eye—in spite of the two thousand miles between your house and mine that do require logistical

adjustments. After all, we've got a lot of catching up to do, don't you think?

I am fully aware that the history between us is more than your seventeen months and my eighty years. Our history encompasses all that came before us. And all that came before us is the stage on which we were destined to appear.

As to exactly what role we are meant to play on that stage—that's one of those questions I'll examine at further length in upcoming letters. For now, I can start by relating a conversation that took place many years ago, when I was just about thirteen years old.

After spending the first decade of my life in the village of Arthur's Town on semiprimitive Cat Island in the Bahamas, where my family lived and worked as subsistence farmers, without electricity or running water or even cars, a change in trade policies caused my parents to move us to Nassau—which had all those things and more. It may have been rustic in those days to some, but at that point in my worldview, Nassau was the height of civilization. Though I was a fantastic, formidable daydreamer, the possibility that I could envisage one day traveling far from there was severely limited by a lack of exposure to other places. So when, quite out of the blue one afternoon, my older sister Teddy posed a question to me about my future, I was

forced to push past those limits of imagination in order to give her a solid answer.

Out of my eight siblings, Teddy was the one to whom I was closest. No longer alive today, I regret to tell you, Teddy was an original—so full of life, bright and open, bursting with laughter and affection. Though it was not her habit to ask me serious questions, she did so that day when, without an explanation as to why she wanted to know the answer, she asked suddenly, "Sidney, what do you want to do when you grow up?"

In a flash, it became clear to me. Confidently, I said, "I'm going to go to Hollywood."

"Oh," said Teddy. "Well, why Hollywood?"

"Because," I explained to her, "I want to work with cows."

Loving sister that she was, Teddy refrained from laughing. Then she patiently went on to describe Hollywood as a place where they made movies. Teddy figured that since it was in the movies that I had seen cows, I must have assumed that in order to be one of the heroic cowboys from the movies, I had to go to Hollywood.

Disappointed by this revelation, I concluded that my future apparently was to lie elsewhere. Ironically, however, as you probably know, I eventually did go to Hollywood—where I made two Westerns! And, as you

can imagine, when that time came, among our family members my sister Teddy would have been the least surprised of all.

That story is a reminder that, just as it was in my youth, questions regarding the future can be the most difficult to answer. It is my hope that insights revealed in such anecdotes and memories from my life will find a place of meaning in yours.

You will have questions after I'm gone. Such answers as I might embrace in the course of this book may or may not apply when you stroll across these pages. But never mind. What I can promise is to give you my best judgment on what I've seen in my time, and my understanding of what unfolded even earlier and in the millennia before we came along.

What I can also promise, here at the outset of our correspondence, is that as you meet up with some of the questions that have nurtured my curiosity starting at a very early age, you'll discover that none of them are new. Nor are the answers. They are all variations of other questions, other answers, passing quietly from culture to culture over thousands of years, proclaiming that for salvation and redemption one must frame one's own questions, seek one's own answers, in the boundary of one's own time. Each generation must be responsible for itself, and there's no escaping that.

Even so, dearest Ayele, it can be helpful at crucial moments to listen to the murmurings of ancestors in whose footsteps we follow. And sometimes, if we're fortunate, they catch us off guard and make themselves known to us as well. I hear them even today, out of a distant time, through fading recollections of my father and our village elders gathered in conversation, wrestling with the fundamental questions of life, survival, and death. All ordinary working men: fishermen, farmers, men who built houses out of palm leaves and tree trunks, men who exchanged fish for land crabs, others who worked the sea in respectful ways, others who worked the land with reverence. A few were teachers, and others worked for the colonial government. A few owned petty shops stocked with items shipped in from the capital island, Nassau. Mostly flour, sugar, rice, lard, pork, and the like. Some dry goods, tobacco, fishhooks; some lobster pots.

None, to my knowledge, were philosophers by trade. Certainly my father, your great-great-grandfather Reggie Poitier, who had no formal education and who made his living for most of his adult life as a tomato farmer, would not have deemed himself so. Nonetheless, I can see him in my mind's eye as a man of stature among his peers, respected and sought after for his sound judgment, as together he and his fellows dared to grapple

with the very questions that have come to occupy me and that will one day, soon enough, become important to you. My father and our village elders undertook the struggle to make sense of their surroundings and the world beyond, not by choice, but in response to life-and-death issues they were challenged by nature to address—both in their own interests, and in the interest of each member of our village community as well.

This is to say, little one, that though your great-great grandfather and the elders from my time are sadly not with us anymore, we keep them alive in part by honoring the questions they searched their whole lives to answer. From the bits we can know of them and the other individuals from our collective family tree, we can better understand where we come from and where we're headed.

On a recent return to the place where my life began, I was startled at first to find much of Cat Island as it was seventy-five years ago, when I was five years old. But that impression was fleeting. The reality, dear Ayele, is that nothing remains the same. The number of villagers has shrunk. The young are increasingly drawn to the world outside. No one that I could find was left with even hazy images or fading recollections of the stories passed on by my father's generation, history that is now on the verge of extinction. So it falls

to me to preserve what I can for you by returning to the fundamental questions and touching on answers in ways that my father and his peers of village elders would do today—assuming that they would be as conversant with the outside world in which I now live as I was with the village life they once lived.

Of course, my recent visit back to Cat Island flooded me with so many memories, and returned me to such a state of childhood, that I had to consciously remind myself that I, too, had changed. But I will admit to moments when I wanted nothing more than to prove to everyone that I could still race along the beach at top speed and scale the rocks as nimbly as ever.

There it is, my dear Ayele. I close my first letter to you by agreeing that, true to my nature, I've got much more to see and do before I will yield willingly to forces meant to tell me when to stop or to stand in my way. Still, from the perch where I sit now on occasion, it can be seen that I, your great-grandfather, my journey, my mission, my destiny, are all winding toward their final bend in the road.

You, my great-granddaughter, who have just begun to prance in the starter's gate of life: your journey, in effect, is now in motion, your mission assigned, your destiny already fixed in time. For each of us, our journey, our mission, our destiny, each knows exactly who

we are; how far we are from home; how close we are to our journey's end. And when we stumble along the way, as surely we will from time to time, as I can tell you from experience, or when we get lost, or, as in my case, when a touch of weariness slows us down, the light of wisdom from an unknown source draws near, lifts us gently to our feet, quenches our thirst, and points us forward toward wherever our destiny waits.

Getting to Know You

Dear Ayele,

So much has happened in the seventeen months since your birth that I have not been able to keep pace with the stream of electronically transmitted snapshots of your latest exploits. The most arresting of these are a dazzling series that show you bending over from the waist, your head only inches from the floor as you look back between your legs at the camera in your father's hands. The shots dance across my desktop in rapid flashes, capturing your upside-down face, already brightened with infectious delight clearly triggered by the raucous encouragement of adoring grown-ups, all members of your loving family.

Word has it from reliable sources that you are being spoiled rotten by all of them—your great-grandmother Juanita in particular. I've asked your mother and your grandmother Beverly to please keep an eye out on that woman. She's a baby spoiler for sure. But we may be out of luck. Those two, just like your great-aunts, have long ago fallen on her sword.

Fortunately, during your first year and a half of life these doting women have been cooperative in allowing you and me to share some quality time in four memorable visits together—starting with the moment I first met you in the hospital in Atlanta, one day after your birth.

Our next encounter took place when you were a little more than three months of age, on March 25, 2006. That was the day of your christening—which we referred to as "The Morning of Ayele's Outdooring," according to the tradition of the ritual that has been steeped in the religious practices of Ghana, in West Africa.

Held in the Atlanta home of your grandmother Beverly and attended by family and friends numbering in excess of seventy-five people, it was a ceremony the likes of which I had never seen, and certainly one I will never forget. As the principal player, you once again demonstrated a natural grace in enjoying your

role as the center of attention. When I learned that I was to have a supporting role in your rite of passage, I was all the more pleased to do my part in welcoming you out into the world officially.

We were honored to have a gentleman named Tralance Addy lead the proceedings—an accomplished native son of Ghana's cultural establishment who is an important figure on behalf of the political, spiritual, and social leadership of Ghana's indigenous people, among whom was your mother's father, your maternal grandfather, William Mould. Though fluent in English, Mr. Addy chose to conduct the ceremony in the Ga language of his tribe, with an English translator at his side.

In a voice that was steady, a tone both melodic and conversational, Mr. Addy began by asking the assembled crowd to gather in a semicircle on the back porch of the house, overlooking the garden—where he and his translator took their places, ready to proceed. The crowd, their anticipation at a high level, settled themselves in short order.

Mr. Addy then called for the eldest of the family's patriarchs to join him in the garden. That being my cue, I entered the garden and stood facing him. So silent and still were those present on the back porch that I was able to revel in the familiar sounds of the outdoors—the chirping of the lonely winter birds, the

whirring of a light breeze, the buzzing of insects com-
plaining about the chill in the air. After a beat or so,
Mr. Addy called for mother and child.

From the house, where you and your mother, Aisha,
had been waiting to be summoned, the two of you
emerged. With you in her arms, your mother stepped
out onto the porch and moved gracefully down into
the garden, where she, too, stood face-to-face with
Mr. Addy, who then called on your father, Darryl, to
step forward and, "Speak the name that has been cho-
sen for this child."

"Sydney Ayele LaBarrie," Darryl said with great
poise and pride, emphasizing as he did the music of
the pronunciation of *Ah-yayl-ee*, a name that means
"first daughter born," as you are to your parents and
the lineage that follows you.

Mr. Addy instructed your mother to pass you to
your father—who held you briefly before he was asked
by Mr. Addy to pass you to me. Once you were in my
arms, Mr. Addy asked me to raise you high above my
head and show you to the heavens. In doing so, I paused
for a second to look up at the endless expanse of sky
smiling on your upturned face, and then was guided to
slowly lower you down toward the earth, until the bot-
tom of your feet rested on the tops of my shoes. This
perfect moment, shared by everyone in attendance, was

understood to symbolize the coming of the day when you will walk in the footsteps of your ancestors.

Again, Mr. Addy asked me to repeat the offer of you to the heavens, and to lower you once more to the tops of my shoes. From there, I was asked to lower you further, until both of your feet touched the face of the earth.

Throughout the profoundly moving ceremony, Ayele, you seemed to be aware of the momentousness of the occasion, as though you could understand on some deep, ancient level what Mr. Addy was saying. Or at least that was how I felt listening to him speak, following his pace, which had the soft, unhurried ring of simple truths, almost as if history, tradition, faith, and destiny were speaking for themselves, allowing Mr. Addy's voice to be their instrument.

Now that you had taken your first symbolic step along the path into life, led by older generations, at the culmination of the proceedings all those gathered were solemnly tasked with the responsibility of serving as elders, looking out for you and protecting you in your journey to come. The ceremony thus transformed you and named you as one of us while elevating us to the status of ancestors—relevant in your life for as long as we would live, and even longer. Truly, it was one of the most joyful, reverent rituals I'd ever experienced.

Eight months later came our third meeting, not long before your first birthday in early winter 2006. It was not nearly as auspicious as the "Morning of Ayele's Outdooring," although it served to solidify my belief that you are as wise beyond your years as you have appeared to be already. This visit was made possible when I returned to Atlanta at the invitation of Morehouse College to receive their Candle in the Dark Award. Your maternal grandmother—who is also my first-born daughter, Beverly—invited family members living in the Atlanta area to dinner at her home, in celebration of my having been chosen by Morehouse to be honored that weekend.

You were beginning to walk, though your stride was not yet steady. You did a lot of hanging on to the hems of skirts and pulling yourself upright along the legs of chairs and tables.

As you were scooting between the legs of your grand-aunts, I noticed that when moving faster served your purpose, you switched abruptly to scurrying about on all fours, with no regard for speed limits. No matter where I turned, there you would be. How was it possible, I wondered, that you could cover so much ground in so little time? Then it dawned on me! Your great-grandmother Juanita was chasing you down, scooping you up, and transporting you to wherever I

was, even depositing you into my lap, from which you would wiggle your way back to the floor and scoot off along the same route she had taken on her exit.

I glanced around the living room until I spotted your great-grandmother, and I kept her under surveillance. In a couple of minutes you appeared and started tugging on the hem of her skirt. *Aha!* That's when I got it: the whole thing was a conspiracy. With my own eyes I watched as she "apprehended" you and headed back to where she had last seen me. You both found, to your great surprise, that I had relocated to some other part of the house, from where I watched the two of you search frantically for me, the object of your little game. Then, after a while—would you believe it?—I found myself missing the part you had secretly given me to play in your game. Finally I thought to myself, What could have been more fun than discovering the wool had been pulled over my eyes? Probably, I decided, it would have been learning that the pullers of the wool were none other than my great-granddaughter and her great-grandmother—whom I am sworn to keep an eye on.

But that was not the last episode in which you helped with some wool pulling. As it so happened, our fourth meeting—which took place a few months later—involved a conspiracy in which you participated

with others, including my beloved wife, who is by marriage your great-grandmother Joanna.

Around this same time—coincidentally, not long after I returned to Los Angeles after receiving the award from Morehouse College—I found myself being subjected to some rather pointed put-down comments about my taste in clothing. They came from the two youngest of my six daughters, your great-aunts Anika and Sydney, whose disdain for the way I dressed was no secret in the family.

Under almost any other circumstances, I am putty in the hands of all my daughters. With their beauty, charm, brilliance, and outspoken independence, Anika and Sydney know that on countless subjects I am more than interested in whatever they have to say. That is, except when it comes to my apparel. Knowing that, the two began a not-so-subtle campaign to convince me of what was wrong with my clothes.

"Too old-fashioned," they insisted. My suits looked "like thirty-, forty-year-old hand-me-downs," they charged.

"To the contrary: neither are my suits that old, nor are they hand-me-downs," I invariably responded—with hurt feelings. But they wouldn't let up; on and on they would go, pounding and pounding, trying to crash through my defenses.

Staying strong—very strong, I might add, for a man who was about to celebrate turning eighty—I refused to budge from the ground upon which I stood until one February morning over breakfast, when Anika and Sydney took a different tack.

"OK, Dad," Anika began. "Look, we want to take you out shopping for your birthday."

Sydney jumped in: "And we will pay for everything, on one condition: we will pick out what we think will look best on you."

Aha. I knew instantly how I would turn their proposal into a lose-lose situation for *them* in the end, and one that would teach *them* a lesson.

With my best poker face, one even your great-grandmother Joanna couldn't read, or so I gathered from her lack of reaction, I agreed to the plan.

By the time I get through turning the tables on the two of them, I said to myself, *they will hoist the white flag, and my wardrobe will once again be my business. And mine alone.*

Still, over the next few days, just knowing how smart those two are began to give me pause. I set to wonder if their proposal sounded too good to be that good. As I chewed on that thought, the scent of a rat flew up my nose. It was simply a reminder that my kids had outsmarted me too many times before.

My wife—who is also a mind reader, and almost always seems to be within earshot of all such conversations between me and our daughters—somehow figured out yet again what I was thinking. How did she do that? It was as if she had been sitting inside my head when I began to second-guess my daughters' motivations for our upcoming shopping expedition.

"As always," said Joanna, who actually had been listening after all, and not sitting in my head, as it seemed, "it's in the interest of your well-being."

And, she had a point. So I caved. I sealed the deal with my daughters and promised I would wait patiently until this makeover process completed itself, then check out the reinvented, cool, hip, laid-back, fun person who was expected to replace the old me.

When the appointed day arrived and the two took me out shopping, true to form they escorted me precisely to the places I knew they had in mind. They took me to Old Navy and the Gap. They took me to places where you find exotic T-shirts, places where I tried on T-shirts that had no sleeves. They tried cargo pants on me. They took me to places where I had to try hard to keep a straight face because I had to at least appear cooperative.

At each stop, one or the other, or both in unison, would say, "How do you like that, Dad?"

And no matter what I had tried on, each time I replied, "That's OK, that looks sort of nice."

Everything looked terrible! I looked like an old fool dressed up in that kind of stuff.

We visited seven or eight places, and we wound up—because they wanted to play their game properly—at Neiman Marcus, Saks Fifth Avenue, and a couple of French places, but that was just to keep me off my guard. The stuff they picked there was no different than the stuff they picked up at the other places.

We shopped until the sun started to go down, at which point we had about twenty-five outfits for me— none of which I intended ever to wear.

But finally, sticking to my own plan, I said, "OK, guys, I'm impressed. Let's go home."

"Wait," said Sydney, "we have one more stop."

Before I could argue, Anika announced, "Sneakers, Dad. We've got to get you some hip sneakers."

Now, I don't know what hip sneakers are, but I can tell you that when we made our last stop and I tried them on, I knew that these were not they.

Nothing appealed to me in the least. There were sneakers you'd find on any basketball court, and there were walking shoes and just casual stuff. None of it was stuff I would ever wear. One of my daughters pointed

out, "But remember your new pants and the jacket and the T-shirt. You can only wear hip sneakers with that outfit."

My other daughter nodded in agreement, adding that if I put on the new clothes and the sneakers, "When we get home and walk in the door, Mom is going to look and think you are so cool and see you the way we see you, the way the world should see you."

I thought—*Oh, my God! My children are so out of touch.*

But I went along, put on one of the outfits, and tried on a couple more pairs of sneakers to complete the foolishness. And my daughters were victorious in asserting that the sneakers looked very much as the two of them wanted them to look.

Meanwhile, I'm saying to myself—*No way am I going to wear this stuff!*

So they paid for the last of the purchases and we returned to the car, at which point I said, "Are we headed home?"

"Well, all right," they shrugged. "Did you have a good time?"

"Oh yes, I had a good time. Being with you guys, I really, really had a good time." And that was genuine. But again, just to myself, I added—*But after today I ain't gonna be wearing none of that stuff.*

When we pull into the driveway at home and exit the car, before we can go inside and show me off to their mother, they say they have to check me out.

"Oh yeah, that's cool," says one. "You're looking pretty good," says the other. "Let me fix your collar there." "Here, you should unbutton your jacket." And the two are fussing over me, admiring their handiwork and clothes selection, agreeing, "Oh yes, that's so classy."

So finally we go to the front door and I throw it open, ready to be done with this charade. And do you know what I see? At that very moment, I am greeted by the most amazing sight I have ever seen in my life— my entire family, which my wife had collected from around the world! There you were, Ayele, with your mother, Aisha (my granddaughter), your grandmother Beverly and three aunts Pamela, Sherri, and Gina (my other four daughters), your great-grandmother Juanita (my ex-wife), Mama Jean (a beloved member of our extended family), and my other grandchildren (Guylaine, Etienne, and Gabrielle), along with a couple of other people Joanna had invited. To keep me totally in the dark, she had arranged to put all of you out-of-towners up in a nearby hotel until her co-conspirators had gotten me out of the house to take me shopping. You played your part, too!

From surprising start to very late-night finish, the entire celebration was just an amazing experience.

This I can say even though all the grown-ups there must have looked at me and thought—*My God, what a ridiculous outfit he is standing there in!*

And that was how I began my eighty-first year in life, which was fabulous. So I now had to cancel my plans for turning the tables on my two youngest daughters, who helped to make possible the best eightieth birthday a guy could have.

What makes this milestone even more appreciated is that when I think back to the circumstances of my birth eighty years ago, the chances of my making it to this extraordinary day—and as a great-grandfather, no less—were just about slim to none.

My next letter to you will help explain how various forces allowed me to beat those unfavorable odds.

Where We Come From

Come with me, Ayele, as I tell you a story that occurred on February 20, 1927, in Miami, Florida, but that has its actual roots in one of those important, ancient questions of existence—who we are and how we arrived in our world.

By this I mean that we can begin to answer those questions by acknowledging that we are all members of the human family. We are the children of Africa, the fathers of America, and mothers of Europe. We are the sons of China, daughters of India, nephews of Central and South America, the nieces of Spain, cousins of Japan, Canada, and New Zealand, the uncles of

Southeast Asia, and the aunts of Russia. We are the in-laws of Australia, wives of Alaska, husbands of the Caribbean.

We are all that and more. But if we narrow our search as to where we come from, you and I can trace a vital branch directly to two individuals I call my parents—your great-great-grandparents Reggie and Evelyn Poitier. Had it not been for a choice made by my mother during a trip to Miami that she and my father took by boat to sell the tomatoes they grew on Cat Island, we would never have been able to answer the question in the same way.

After negotiating with the owner of a local sailboat to transport them and their crates of tomatoes picked early in order to ripen to perfection after their arrival in Miami, the two of them set sail that February day without apprehension. At the time, with a household on its way to totaling nine kids, my mother was six and a half months pregnant with me. She and my father had lived through previous miscarriages and a child who had arrived stillborn, although, as far as I've been told, her latest pregnancy was progressing well. So there was no reason for her to miss the trip to Miami that figured so vitally in the family's welfare.

Once Evelyn and Reggie arrived in Florida without incident, quickly delivering the tomatoes to regu-

lar buyers, they busied themselves with purchases that would allow them to return home and prepare the field for its next crop. Everything appeared to be going as smoothly as possible. But on their last night, February 20, before sailing back to Cat Island the following day, my mother's water broke.

Getting her to a hospital was not an option. For one thing, in those years racism remained a pernicious institution in the form of Jim Crow laws—which meant that most hospitals refused to admit black patients. Second, as I understand it, there wasn't time. Not only that, but my mother had, in fact, never been to a hospital. Instead, my father managed to locate a registered midwife, who delivered me that evening, more than two months premature. The prospects of my survival at all of three pounds, without an incubator or any medical technology to help me along, were hardly encouraging.

As a realist, by morning Reggie had accepted the likelihood that I wasn't going to make it and left the house where he and my mother were staying to make arrangements with a local undertaker for a proper burial.

Upon his return, a shoebox in his hand, my mother looked up from her bed and, without asking anything, said, "No, no, no." She knew that he was only trying

to lessen her pain by being realistic, but my mother had to stand against the inevitability of loss. She did so by rising up and getting out of bed, leaving instructions for my care with my father, putting on her clothes, and going out in search of guidance for options that were then hidden.

Where Evelyn Outten Poitier went that day, I don't know. Later I heard parts of the story but was never told the details of how my mother looked at the remotest possibility of my survival as her call to go out and face the mysteries of the universe. I do know that she left early in the day and was gone until deep into the night, and only as a last resort, when she had nowhere else to turn for help, on her way home my mother visited a reader of palms, a diviner of tea leaves, the local soothsayer—such as could be found in the black community—whose methods of divining the future may have been brought from old African and Caribbean folk magic, mixed with spirituality.

My mother's faith in God, which she had in a total way—so intrinsic to who she was—would have been enough to sustain her belief that I was meant to survive. But the actuality of the circumstances of that day, twenty-four hours into my life, a life that was holding on by so tenuous a thread—for that she chose to ask for corroboration from the last and only person

she could turn to, this soothsayer. She chose to ask for a sign. "Tell me, tell me," my mother asked her.

What the soothsayer told my mother was what she came home and announced to my dad—after she told him first, "Remove the shoebox from the house." Then she went on to say that the soothsayer had assured her that there was no need to worry about their new son, Sidney; that "He will survive and he will not be a sickly child. He will grow up and travel to most of the corners of the earth. He will walk with kings. He will be rich and famous. Your name will be carried all over the world. You must not worry about that child."

The soothsayer gave my mother a list of things that would happen to me in my life, and every one of them came true, every one.

Not for a minute did my father question the earth-shaking power of my mother's acceptance that this was going to be so. Mama had her faith and she knew what was to be. Whether or not she and the soothsayer turned out to be right because they actually foresaw my destiny, or whether they turned out to be right because circumstances happened to unfold that way, we will never know for sure.

We do know for sure that within a reasonable amount of time I was able to make the return trip to

Cat Island, where my parents, siblings, and nature soon nurtured me into robust health. These influences were my primary teachers as I was growing up, save for a few years of school where I was taught not much more than how to sing "Rule, Britannia! Britannia, rule the waves!"—a catchy tune, I'll admit, yet words that had little relevance to my life.

In time I would understand more about the history of the place where I came from and the influences that had shaped Reggie and Evelyn Poitier. Of African descent not too many generations removed, my parents retained remnants of the ancient African culture from which they came.

We do not have definitive accounts to go by, but it can be safely assumed that both the Poitier and Outten forebears were introduced to the Caribbean and Bahamian areas as slaves, bought and owned in perpetuity by European plantation owners in Haiti and other parts of the Caribbean. I am of the opinion that their African culture was the one they lived by in slavery for the longest time, the one they brought with them.

But in time their culture was subdued, constrained, and starved until it finally withered into oblivion, precisely as slavery required it to do. They retained none of their original language and only bits from their unique culture. They were forcefully encouraged to

disinfect themselves of where they came from, and to struggle to assume their new condition of slavery and assimilate to the society of the slave owners to whom they belonged.

All of that is to tell you that your ancestors in the Bahamas were still close enough to their original culture, and miraculously defied their bondage by storing roots to fundamental aspects of it. For as long as they could, they held on to their religion. But over time, generation by generation, their language, their religion, and bit by bit their culture faded into oblivion, and they were encouraged to convert to Roman and Anglican Catholicism. Some of the more defiant among the African slaves, like those in Haiti and other places in the Caribbean, resorted to combining their authentic African religion with occult religious practices.

That mix was an underpinning of the faith that resided in my mother, without question, who was the rock at the center of our family. Not a woman of many words, she was by nature terribly shy and not always able to articulate her thoughts and feelings. But even if we didn't talk all that much, the love we had for one another was as evident as the vast ocean that was a constant of island life—its pulse and power just steps away from our house, as present as the air needed to breathe.

Because of that proximity, my parents saw to it that I learned to swim before I could walk. At around ten months old or even younger, I followed family tradition by being more or less tossed into the water as the two of them stood close by, forcing me to literally sink or swim—rescuing me, of course, each time I became fully submerged, picking me up, and tossing me back in again. After a few lessons, they could confidently allow me to toddle around on my own without fear that I might fall into the water and drown.

My mother and father were more than husband and wife. They were lovers, best friends, and dedicated parents. They were a team. Though he was twelve years older than she, they were ideally suited for one another. They were soul mates. With my dad, and in most cases when we were together as a family, my mother's shyness and inarticulateness seldom surfaced. In those settings, I was able to observe and get to know my parents and something of the inner lives that they kept protected most of the time.

Their take on mysteries was introduced to me in this way. Their inner lives were lampposts of sorts that helped light the path for questions that started in me as prematurely as my birth—mainly, at first, those questions having to do with how to understand "Up There." My father didn't have the same connec-

tions to that realm as my mother did. Not that this was a topic of family conversation, although every Sunday, the one day of the week we wore shoes and went to church, we heard sermons and sang songs and prayers about "Up There," as generally associated with a place called heaven.

But for me, even as a small boy sitting beside his mother every Sunday morning in church, there was another, less ominous "Up There." I thought of it as "the place above my head."

This is where all the questions really started in me, where hours spent sitting on the rocks looking out over the waves toward the horizon, where sky and ocean meet, caused me to puzzle incessantly about how down here could intersect with "Up There," and how far I would need to swim or sail to be at that point. And then after the sun went down, whenever I looked up on a clear, moonless night, there it was, bejeweled: the place above my head, reaching as far as one could see. Stars in every direction. Bright stars that twinkled. Faint stars in the far distance. Clusters of stars. Empty spaces where there were none. And nearby stars that appeared close enough to touch.

These not only were my studies in rudimentary astronomy but were also part of my quest to know more of my mother's connections to "Up There," and to the

guardian angels among the stars that she believed in with all her being. These many decades later, whenever I look at the horizon or up at the night sky, with all that I've learned from taking my questions to the next levels, I still don't completely discount the existence of guardian angels. Or, perhaps, I hedge my bets and figure that if they are real, and if one is watching over me as I sit here at this moment writing to you, Ayele, then hands-down it's my mother, Evelyn Outten Poitier.

Aside from that mystery, I do believe absolutely that the reality of my mother's life was that of a woman whose balance was always centered in faith. The reality of Reginald Poitier's life was what kind of man he made of himself—what values were left attached to his name that would define him exactly as he would define himself.

My father, your great-great-grandfather, was born in 1884, lived seventy-seven years, and died in 1961. During his lifetime, the colonial system that controlled huge portions of the world didn't teach him much. It was not in that institution's best interest to do so. After all, of what value would he have been to those controlling powers had he been taught to read and write beyond the all but meaningless levels imposed on former slaves and the sons of former slaves?

By the day he died, what he never had the opportunity to learn could have filled all the libraries of the world. He knew little about the continents, the oceans, the major civilizations that have sprung up and fallen over the course of written history, about the trade routes of the seas or the ruling nations where wealth has long been overwhelmingly concentrated. Nor could he pinpoint any of those nations on the maps, identify their systems of government, their natural resources, their industrial capacities, their varying form of legal systems—the laws of conduct designed to hold each citizen legally accountable for respectable adherence to all the laws that cover all the citizens of each such country.

The subtleties and nuances surrounding most of the above were beyond my father's experiences. First of all, he didn't have a country: someone else's country had him. A statement of fact, Ayele—as some readers, closer in age to my generation, have always known.

But the essence of the man belonged to himself; to his one and only wife, Evelyn Outten Poitier; to his children, to his friends, his neighbors, and to the village of Arthur's Town on Cat Island in the Bahamas— the place he called home, a village of roughly one hundred fifty, including children. He could read and write, but barely. Much of what he knew he learned

from nature, and he passed on to me much of what nature had taught him. She had given him to understand that his existence was different from that of the eagle, for example; that he couldn't fly away and leave his young in a matter of weeks; that unlike the eagle, his young must walk the earth and he must show them how; that they must be taught survival do's and don'ts; and that they grow slower than most creatures, and therefore each generation must be fully prepared to defend themselves and protect the generation coming after them until they in turn are able to protect themselves and the children coming after them.

That was my father. And those were the times in which he lived. His father and his father's father, as far as the oral history of our family can tell, were cut from the same cloth.

That cloth, woven together with the threads of both my parents, is where you and I, at different folds of the tapestry, also come from.

The Early Days

Ayele, my little one, in looking at the latest snapshots of you to arrive on my desktop, I am both happy and amazed to see how much you have grown.

Your sparkling, wise eyes, your innocent smile, have once again captured my full attention. And those funny faces you made for the camera had me laughing out loud. I am also delighted to learn that you have spoken your first words: *Dada* and *Mama*. You also made your grandmother Beverly feel very special when your third word was the name of her little dog, Jet.

Even now I'm imagining how conversations between us will grow richer and richer over time. And

I assure you, my dear, nothing could please me more than that. In fact, I believe that by age five you will have accumulated a treasure chest of words and the meaning behind each of them; and that by age ten you will have gathered many times more.

An added bonus in watching your childhood unfold is that I am given a chance to remember moments from my early days that I thought had fallen by the wayside. Unfortunately, because no cameras existed on Cat Island, there are no images or mementos other than those I carry in my memory. It may surprise you, Ayele, that never in this eighty-year span of life of mine have I seen a photograph of myself as a baby or as a child. As a matter of fact, it wasn't until I was sixteen years old and had left home to travel very far away that the first photo was ever taken of me.

By that point in time, however, I'd been away from Cat Island for almost six years, light-years away from our village—first in Nassau, then Miami, then the mountains of Georgia, and eventually New York City, in places where cameras were no big deal. Neither were electricity, running water, cars, trains, telephones, radios, skyscrapers, or movies. All were goods and services—no more, no less—and, like the camera, all manifestations of technology that had been destined

to materialize in the aftermath of the volatile beginning of the universe.

Later, the topic of how these tools of civilization developed, through trial and error, would become a source of infinite fascination to me, possibly because of how I was raised without them. There were many early versions of the camera, for example, but for a long time none turned out to be a slam dunk. Many tries, many failures.

That was until a Frenchman, Louis-Jacques-Mandé Daguerre, after many misses, successfully managed to capture light in a box. By 1839, after collaboration with others and further trial and error, he produced the first-ever working camera to surface in the commercial marketplace.

By the time that I was born, in the year 1927, my father was forty-three years old and my mother was thirty-one. In the eighty-eight years that the camera had been known to the outside world, not even the wisest of our village elders had reason to believe that photographic images were on their way to being capable of capturing and holding priceless moments of our earliest years. For all of us in Arthur's Town, it was as hard to conceive of printed images of childhood that would be readily available for recall, reflection,

and reminiscence as it was for people growing up in the early nineteenth century and earlier in other places of the world. The introduction into our lives of mysterious instruments like cameras was not to take place until many years after my childhood had long since passed.

Suffice it to say that, as to the details of my early years, I am the last witness. To add challenge to the absence of cameras, for those first ten and a half years on Cat Island there were no mirrors or glass panes in which I ever had the chance to see my own reflection. Not once was I able to see what my face looked like.

Of course, I could easily see what the faces of other children looked like. I also knew well what the faces of family members, village elders, and people from other settlements looked like, simply from having seen them in the routine of their daily lives. But I had no way of looking at my own.

This wasn't, by the way, an issue of great concern for me at first. Besides, I wasn't alone in this regard. And I could see that I had arms and legs like the other children. We weren't very different from one other, I figured. Some were taller, others shorter, while our skin color was roughly the same. Making do with logic, reason, and imagination, I fashioned for myself

a mental image of my face that was acceptable to the little boy that I was at the time.

Somewhere inside of me that little boy is still alive, and shows up unexpectedly with one or another irresistible memory from the past—such as the discovery I made one day while playing by myself at the edge of a quiet pond.

Since I had only one real friend, Fritz—who lived a mile away and whose family's work didn't always allow him to join me in my explorations—spending long hours alone wasn't out of the ordinary for me. What was unusual on this day was how the sunlight at my back had thrown a shadow on the surface of the water. Instantly that shadow took the shape of a boy who appeared to be my age, who began mirroring every move I made. Was the shadow boy mocking me? Very well. Assuming it was, I responded with a flurry of nonsensical gestures executed as swiftly as my hands could fly, gestures bearing no logical connection one to the other, gestures I fully expected to prove far too swift and much too complex for any shadow on any pond anywhere to imitate. I was wrong. With not even a fraction of time lapse between its motions and my own, the shadow again mirrored, synchronized, and, yes, one could also say imitated my every movement to the letter.

OK, if it wasn't making fun of me, then what? As if on cue, the sun slipped behind a cloud and the shadow on the water disappeared. While waiting for the cloud to pass, I found myself having second thoughts about the shadow and myself. Had I misread its intentions? Might it not have been expressing its own playful nature or an innocent desire to engage me at play? Might it have been trying, through playful, childlike imitations, to invite my attention to join with it as a companion?

Soon after the cloud dispersed, the sun returned, and I consciously made the decision to accept this new and unusual friendship. With that, the rest of that day was well spent by us—a little boy and his shadow companion—as were countless days that followed.

We often raced each other along lonely stretches of deserted beaches toward finish lines where the winner was, of course, determined by the position of the sun. Together we could stroll, jump, laugh, and play all the day, every day, as long as the sun was shining.

In recalling those distant times of boundless pleasures, I am also reminded of how much I resented cloudy days and how my mood grew darker as the threat of rain increased. Even now, I am of the opinion that my shadowy companion and I shared the same sentiment.

We were similar in temperament and personality, both shadows and both little boys who had not yet

learned how to successfully hide whatever little boys and their shadows might be feeling inside. But we were different, too. This was proven when we were out and about one day and I was startled to see that my shadow was longer than I was tall. Sure enough, it was stretched out in front of me, leading the way, with me following in its footprints.

We were both fond of dancing, and did so together many times, always without music. We were like a set of Siamese twins, each with two left feet and awful footwork. Of course, we were careful and tried dancing only when we were totally alone, since anyone watching, even from a distance, would think it strange: a young boy, all by himself, behaving in an erratic, wildly disjointed manner, as if possessed by demons of one kind or another. "Yes! There he was," they would say, "Reggie and Evelyn's little boy Sidney, without one whit of embarrassment, wiggling and squiggling and throwing himself this way and that. What could be going on with that poor child?"

But my shadow and I knew of places where villagers never went, places where we could have been seen only by birds flying overhead, and we always surveyed the landscape to make doubly sure we were alone and not being watched from a distance by anyone. Secure in our privacy, we could let go with abandon—even with

our somewhat pornographic choreography, based on conversations I'd overheard from older boys while they were boasting, or outright lying, about amorous encounters with this beauty or that one from our village.

There was an exciting danger in the possibility of being caught, along with the drama of having to take responsibility for instigating the dirty dancing. That was only right, of course, since it would be unfair to blame my shadow—who was, after all, only playing along.

Eventually, the novelty of our friendship did wear off to a certain extent, although we have remained close all my life. In the meantime, at around the age of eight and then nine, as my interest in the opposite sex heated up, I became more and more intent on having a sense of what my face really did look like.

My efforts were to no avail. Even in the absence of the slightest breeze, the shimmering outline of my reflection on pond water was never clear enough to decipher. No matter how much I squinted for sharper focus, how often I twisted my head from side to side in unsuccessful attempts to steady the quivering water, only the same hazy, undefined image would show up. Oh, occasionally I could catch a glimpse of a distorted reflection elsewhere, like in pieces of broken bottles or in the blades of timeworn machetes and other sur-

faces off which the unfocused image of an unknown little boy might have flashed. Lacking a mirror, which was certainly not among our family's possessions anywhere in our thatched-roof, sparsely furnished wooden home, I felt doomed never to be able to recognize my face even if I passed myself on the road.

To this day, I can't say what my smile was like in my boyhood days. Was it my father's open grin after a taste of rum among friends? Was it my mother's shy, modest smile as she saw her root remedies curing whatever ailed us? Might mine have been a smile that caused my eyes to sparkle or brought dimples to my cheeks? I'll never know, just as I had no idea until later that a space existed where my two front teeth had been before my second set of teeth came in. At the least I can imagine how my little-boy face could have registered feelings and thoughts I vividly recall—crinkled with laughter, stung by embarrassment, frozen in shyness, darkened by disappointment, anger, or fear, lit by wonder and innocence, or mesmerized by the spell of the daydreams to which I surrendered so often during those years.

Ten and a half years without the opportunity to see myself in a mirror came to an abrupt halt in the latter part of 1937 when the state of Florida unexpectedly placed an embargo on the importation of tomatoes

from the Bahamas—which caused the sudden collapse of our family's tomato-farming business and our livelihood. In the hopes of finding work in Nassau, my father decided to move us there. At the age of fifty-three, Reggie Poitier was to learn that the pursuit of a new profession was to be a job in itself. But he had no other choice than to do what had to be done to provide for us. Undertaking the many tasks connected to pulling up stakes, he decided to send my mother and me to Nassau first, as the family's advance team. Our job? To find a rental house at a reasonable price. With that accomplished, the rest of the family would follow, and Nassau would become our new home.

The day we left Cat Island, not for a second did I pause to consider all that we would be leaving behind or even the possibility that I would come to sorely miss the world that had raised me and all the inhabitants of it. Once we'd set sail and headed into open waters, I never even looked back.

None of the amazing accounts I'd heard from others or imagined in my most far-flung fantasies about where we were headed could have begun to measure up to what I witnessed the day we sailed into Nassau's huge harbor. As we approached land, I spotted something that was akin to a massive beetle, the size of a small house, as it crawled menacingly down the hillside.

I pointed at it in alarm, asking my mother, "What is that?"

"That," she said knowingly, "is a car."

I had heard about cars but was nonetheless stunned at seeing one for the first time. And there in the harbor were boats of every description, from dinghies to motorboats of every conceivable size and shape, as well as gigantic cruise ships that unloaded thousands of tourists per week at the massive dock, officially named Prince George's Wharf. It was located one block from Bay Street, along which was the main shopping district, the seat of the government, and the financial district—each of which was a driving force in the overall economy of the islands of the Bahamas.

Overflowing with excitement, I leaped from the native sailboat that had delivered us safely to Nassau onto one of the smaller docks, and then waited as my mother got her bearings and then directed us toward Bay Street. As I walked along, my brain hummed with anticipation and my eyes scanned the terrain of the new world. There was so much to see, so much to learn, so much to know.

Never before had I seen paved roads like those in Nassau, with no rocky bumps sticking up everywhere like giant pimples, no wild bushes growing along the sides of Bay Street like along the roads on Cat Island.

Here the main thoroughfares were smooth, I could see, so that wheels and feet could move faster along them. But who made the roads smooth? How was it done? More mysteries to investigate, more unprecedented discoveries to make.

The first significant discovery of the day was set in motion by my mother, who stopped at the window of a tiny shop and bought two orders of a food item I had never seen or heard of before, one of which she passed to me. I looked at it, not knowing what to do with it. As we resumed wending our way along Bay Street, toting such luggage as we had, she referred to her purchase by a foreign-sounding name, something about "ice cream cones." She started licking at hers with her tongue, and gestured for me to do the same. Having been given the green light, instead of licking it with my tongue as she had indicated, I took a big bite out of the ice cream still sitting on top of the cone in my hand.

The shock that the frozen treat sent through my nervous system can still be recalled these seventy years later. I panicked, big-time!

In my ten and a half years of life I had never experienced anything so cold. On Cat Island, nothing was cold. The island had no electricity; hence, no ice, no refrigerators, no ice cream, no cold drinks. Temperatures, winter and summer, ranged between seventy and ninety

degrees, with humidity levels often going through the roof.

My mother, who had first tasted ice cream on trips with my father to Miami, was preoccupied that morning with the fragile state of our finances, which threatened to thwart her efforts in arranging affordable housing for us, not to mention the multitude of other concerns that needed to be addressed for our family to make the challenging transition to the new, sophisticated environment ahead of us.

Meanwhile, my teeth had frozen, so had my tongue, and my lips were starting to go numb—sensations that provoked a guttural cry that I couldn't contain. It was as if there were fire in my mouth, burning up everything inside it. My verbal and physical reactions were enough to draw my mother's attention and, apparently, her realization that she had not properly introduced me to this totally foreign food. She then gently walked me through the paces of ice-cream eating. Lick by lick I got the hang of it. And for the next fifty years, I was an ice-cream devotee—until lactose intolerance came between us. But I'm OK with that; we had a good run. And, as you and I both know, Ayele, nothing lasts forever.

Well, let me tell you, ice cream was not the only astonishing discovery I made on that first day in Nassau. More was in store, just moments ahead, as we

maneuvered our way through the swirling traffic of local residents and tourists moving in both directions along the crowded sidewalk of Bay Street. My mother and I paused occasionally to peer through plate-glass windows at shops filled with things I had never seen nor could begin to identify—articles of clothing and shoes for children and adults, toys, furniture, strange containers of items for eating and household use, objects made of materials of unknown origin. Unbelievably, there were electric lights that lit up the interior of the stores, making the inside as bright as the sun was making the outside. No one had told me anything about that! Sure, I knew what petty shops on Cat Island were like, but I had never dreamed of anything like the stores on Bay Street.

All the while, behind and beside us, traffic spun in all directions: people in cars, in carriages, on bicycles, on horse-drawn drays laden with wholesale products destined for local retail merchants. There were barefoot men struggling with backbreaking loads on their shoulders, delivering something somewhere nearby to a seller or a buyer, or from one warehouse to another, or from the hold of a cargo ship to the government's customs shed, or to the nearby Straw Market—where vendors with colorful, indigenous hand-crafted items hanging from their arms raced alongside tourists, ag-

gressively trying to coax them into purchasing souvenirs that would guarantee memories of the pleasurable vacation cruise they once took.

As my mother and I moved along with the bustling sidewalk crowd, continuing to glance into display windows as we passed, stopping at times for a closer look when something captured our attention, I was aware of the discreet happiness on her face as she observed me in the throes of amazement—my eyes, no doubt, full of wonder and surprise as I gawked unabashedly at every item on display, every character in this unfolding new drama.

And though my mother had seen these sights before on selling trips with my father, even though she had much to accomplish in a limited amount of time, she chose not to rush us but to slow her pace and allow me the incredible gift of drinking in this wonderland experience. Everything was sumptuous, glorious, out of this world—no one aspect more important or compelling than the other. That is, until suddenly I came upon the treasure I'd been seeking for years! A major find! A stunning discovery!

Yes, maybe you've guessed already. It was a full-length mirror that hung just beyond where I could see, right inside a store we were passing! I knew that it had to be a mirror because I could see a lady standing

in front of it, preening herself, and as I peered closer into the store window, I could see her reflection in it. My heart raced! At once I knew that it would be in this complex, intimidating new place called Nassau that finally I would see my face in a mirror for the very first time.

My mother immediately sensed my fascination and intent. Pausing as though to consider stepping inside so that I could investigate further, she then took another look at the lady in the store meticulously checking out her image in the full-length mirror. If I knew anything about Evelyn Poitier, I understood that she would have given the world for me to have something that appeared to be of the utmost importance. But a dynamic of entitlement that I didn't yet understand stood in our way. Lessons would come later about rights and privileges of those who can buy and those who can't, and there were to be many more store windows that I'd need to press my nose against before I could enter freely. Instead of disrupting the lady customer's hold on that mirror, my mother chose to teach me that sometimes gratification has to be delayed. Gently placing an arm around my shoulders, she led me along to the next display window. We didn't exchange one word, but both of us recognized that I

would be back again at my earliest opportunity to put myself in front of a mirror that I now knew existed.

In the meantime, there were other distractions to behold as we made our way to the home of friends who had migrated from Cat Island to Nassau a few years earlier and with whom we had arranged to stay. Their house was as modest as the one they had built for themselves back home. Nevertheless, they received us with open hearts and provided space for us in their tidy, now-overcrowded dwelling. Before we went to sleep that night—no easy undertaking for me with all the excitement—my mother announced that she would be leaving early the next morning to comb through the lower-income sections of the island for affordable housing. My job, as she repeated to me the next day when she left me to wait for her at the house, came with a typical Cat Island warning: "Stay from underfoot and don't get into any trouble. You hear me?"

"Yes, ma'am, I hear you." Due to past experience, she may not have completely believed me.

When the parents of the house had left for work and their children had left for school and I was alone, I searched the premises for a mirror, but there weren't any that I could find. So I left the house for a walk through the unfamiliar neighborhood, and

found myself unable to resist the urge tugging me to have another look at Bay Street. Once there, I started entering stores, looking for mirrors. Within no time, I spotted one on a wall at the back of a shop. As I approached it, ready for ten and a half years of suspense to come to an end, it mattered not that it was smaller than full-length, only that there was no one in front of it. My time had come.

So, there I was at last, giddy with excitement, standing in front of a mirror, looking at my face in detail for the first time! I examined every inch of its contours and features: my nose, my eyes, my cheeks, my chin, my throat, my hair—all bearing resemblances to my mother and father. Wow!

Mesmerized by what I saw, I smiled at myself and couldn't help giggling, and I was particularly happy with my teeth. I moved my lips and batted my eyes. Turning this way and that, I checked out my profile and found it much to my liking. For a flash, I considered returning to the store that had the full-length mirror, but I knew that my mother would not have been pleased if she found out. Besides, I wanted to savor this moment for as long as I could.

Another six years passed before my eyes would come to rest on a photograph of myself for the very

first time. That happened after I made it to New York City, at age sixteen, and had worked enough hours as a dishwasher to afford to stop into an instant photo shop—where I finally had my picture taken. By then I had cultivated a look in keeping with the prevailing style that was all the rage in the Harlem of that era—a zoot suit and a broad-rimmed felt hat.

As I look back at that torn-edged photo, the fellow in it doesn't look much like the me I've come to know. Of course, that look was my way of trying to fit in, to be indistinguishable from the hip and the cool who were setting the style, defining the tastes, and reaping the accolades. Being the outsider that has long characterized me, I was young enough to suppose that by masquerading as one of the insiders, I would be able to siphon off a little of the popularity so generously lavished upon them.

But my zoot suit added nothing to my efforts to escape loneliness and be seen as a person who mattered— a person worthy of a "hello" and a smile and a look in the eye. At that point in my travels, as I will recount to you in subsequent letters, the experience of dismissal and constantly being overlooked was to become much too familiar. It takes a toll, leaving one with the feeling of being erased gradually, silently, bit by bit.

So, a long, long distance from Cat Island, I did finally have my first picture taken, but I had accomplished little else, and there is some irony in the fact that the camera, providing no improvement in my social status and no record of my early childhood, would one day make my face recognizable around the world.

Family Poitier

As I write to you, Ayele, of the adventures, challenges, and changes that arose in the course of my early lifetime, news has arrived that the men's basketball program at East Carolina University has added Darryl LaBarrie, your dad, to its coaching staff, and that you are moving with your parents to a new home in Greenville, North Carolina—where I look forward to visiting you at my earliest chance. You may have already discovered in my letters to you so far how much I value family and community. What's more, I'm certain that as you grow, you will continue to discover that there is no shortage of interesting and unusual people among our relatives—a wonderful group

of characters. On every branch you look at, it's easy to observe that our family tree has borne some fascinating fruit, you being the most promising of the bunch!

On your great-grandmother Juanita's side, though it has never been fully researched, I've always been of the opinion that the ancestors were from one of the American Indian tribes that were very much evident in earlier years in many of the Southern states—where her folks were from. Before we were married, I went to meet her parents to ask for her hand. And not only did I see them to be very good people, but I was also convinced of the strong Native American influence in their background. What I can also relate is that your great-great-grandmother was an excellent cook; your great-great-grandfather Edward Hardy was a bricklayer by trade; a quiet, reasonable person, a very likable man. Edward Hardy and his wife had four children, a son named Edward and three daughters—Joan and Eleanor (your great-aunts, both now deceased) and Juanita, your great-grandmother. Because our marriage ended before I learned much about her family's earlier history, I'll leave it to you to do some more investigating in due time.

Meanwhile, there is much more to tell you about several members of the family on my side who, each in his or her own way, are all part of who I am today and

who played memorable roles in what I have learned about life and human nature.

Family relationships, I have learned, are not always easy to understand and predict. This was definitely true of an event that took place on Cat Island a few years before we left for Nassau. Back around the time that I was just going on eight years old, in addition to helping my mother take our laundry into the woods to wash in ponds where clean, clear rainwater had collected, and sometimes even helping work in the tomato fields alongside my parents and siblings, I was frequently sent to pick up an item or two from my Uncle David's small grocery shop—a six- to eight-minute walk from our house.

David Poitier was my father's brother. He lived next to us with his wife and children, and his grocery supplied basic foodstuffs and other staples to many of the villagers in Arthur's Town. Since it was a regular chore that I enjoyed, when my mother sent me for a few items about midmorning one sunny day, I was glad to oblige.

From the moment I arrived at Uncle David's store and told him what it was that my mother had asked me to fetch, I could sense some note of antagonism in his voice. Uncle David, a man known to be given to moods, seemed to be slowly working his way into one. "Where's your father?" he asked me.

"Home," I answered.

"Tell him I want to see him," he growled back as he handed me the items for my mother.

I headed home with no further thoughts on Uncle David's mood, having long ago decided for myself that my dad's brother, for some inexplicable reason, always managed to draw a strange kind of pleasure from ruffling his own feathers. What followed, therefore, caught me by surprise.

No sooner had I started off than I looked up to see my father coming toward me on his way to his brother's store. Suddenly, from behind me came Uncle David's voice, barking threats and curse words at my dad.

As my father passed by me, his expression severe, he urged me to hurry on home. I didn't, but instead ducked behind a tree and watched as a bizarre encounter played itself out. It wasn't pretty! The next thing I knew, war was declared as my Uncle David started in by pelting my dad with a barrage of stones at close range. My dad darted about in erratic patterns, trying to avoid making himself an easy target for his brother. He wasn't completely successful, and he took many hits, a few very serious ones. Reggie Poitier, with a dignity that defined him, never picked up a stone to fire back.

Neighbors, hearing Uncle David's verbal tirade, came rushing out of their homes and intervened. They dragged Uncle David back to his shop and calmed him down, while other neighbors joined together to safely escort my dad and me back home.

My mother's response, at first, was to calmly and quickly set about to stop the bleeding and to dress my father's wounds. As soon as that was done, she took a deep breath, and then she exploded. I mean, nuclear! Never had I seen her like that before, or after! A grievous offense had been committed against her family, and the volcano could no longer be held in check. It was about to blow.

There, just watching, I held my breath as my mother walked out of the kitchen, where she had just attended to the last of her husband's wounds, and looked out across the four-hundred-yard salt pond that separated the homes of Reginald Poitier and his brother David. At that time, there was a two-foot-wide path running along the edge of the salt pond from one house to the other. My mother began by muttering to herself about the unwarranted attack on her husband, all the while casting her gaze toward the salt pond.

Three of my older brothers who were on hand were paying enough attention to anticipate that perhaps the

worst of the eruption wasn't over yet, and they appeared to casually stand together as a barrier between our mother and the pond, just in case she made a move. As the youngest and most recent of her offspring, I was better at reading her than my older brothers, and I knew that a major move was indeed imminent. One glance at her face, and I could have told them that she was picking her spot.

Soon she was no longer muttering. Her voice level started to escalate as she began moving around in circles, at the same moment that she began to moan and keen. Then suddenly she screamed out toward the house at the far end of the pond, calling on Uncle David's wife to come over and see what her husband had done to his brother. The louder she screamed, the closer she moved to her point of detonation.

Then, as if on cue, Uncle David's wife appeared at the far end of the pond. She didn't waste a second. She came loaded for bear. She started out screaming back at my mom, firing off unfounded accusations. My brothers circled closer around our mother. But not close enough. Before they could readjust, she broke through the line of defense my brothers represented and was off, headed for the narrow pathway that ran along the edge of the pond all the way to Uncle David's house.

My mother flew at meteoric speed, heading for a serious dustup with a woman she had tried very, very hard to like. My brothers, too, were flying. To avert disaster, they had to reach her before she made it around the pond. The swiftest of my brothers finally pulled her down a few yards short of her goal. But by then, Uncle David's wife had deserted her post, frantically realizing that the whirlwind on its way to do her in was likely to make it after all.

The violent squall that had arisen so suddenly, for reasons never to be further discussed or addressed, thus subsided. From then on, the two families coexisted with as little contact as possible. To my knowledge, the two brothers never spoke a word to each other after that morning when an unspeakable chasm, to remain forever unbreachable, had opened between them.

Some years later, after we'd moved to Nassau, I was wandering about on the waterfront one day when a sailor on a cargo ship that had just pulled in recognized me and called out my name. I walked over to him, and he said to me, "Tell your pa his brother David is dead."

Without hesitation, I ran to the place where my dad was employed in that era and told him the news.

My father didn't say anything except to nod in acknowledgment that he had heard me. But I could

see in his eyes that he was deeply saddened that his brother was gone—disappointed, too, that their rift, such as it was, could never be mended.

There were other surprising turns to follow in the lives of different family members, particularly as my four brothers and four sisters, one by one, left home to seek their fortunes and start families of their own. One of the most ambitious of the brood was my brother Cedric, the one I followed by birth.

A dreamer who desired most of all to go to America, where he felt his dreams would be fulfilled, Cedric never made it because, being a dreamer, he was a guy for whom dreams were the stuff of life, and in his outrageous capacity for dreaming, he dreamed himself right into jail. When I was twelve years old, doing my best to stay clear of trouble in Nassau, Cedric and a friend nicknamed Rooster, having seen too many American films about gangsters and such, wrote an extortion letter to a businessman, the owner of a chain of grocery stores in Nassau, demanding protection money in order to prevent the stores from being burned down. The businessman was no lightweight. He went straight to the police, who in turn set a trap; my bother and his compatriot were ensnared, and off they went to the hoosegow.

When Cedric was released, he wanted desperately to leave Nassau and stowed away on a boat heading for

America. Again he was caught, and went back to jail. That was the way his life went, and I regret to say that he died young, at the age of thirty-four.

What happened to Cedric and my other siblings, earlier and later, gave me a chance to observe how we all shape our lives and how situations that arise shape us. I don't know where I got it from, but along the way I discovered that I was able to look at family and close friends and sense when they were being confronted by circumstances for which they were not prepared.

This was true of Cedric and of my brother Carl, my brother in line before Cedric. A longshoreman who worked on the docks in Nassau, Carl was troubled in certain ways. Reclusive and disconnected from others, he was not a very socially adjusted person. On the other hand, he never got into any trouble, and he worked very hard, had children, and did the best he could for them. But he had not been ready for challenges, as I recall, like the day he was sitting on a church wall near our house, and a couple of guys, friends of his, decided to test his bravery. I was near enough to see in Carl's eyes that he received their remarks as a challenge, and the receipt of it was too much for him to handle. Though younger than he, I knew that he should have diffused the challenge by dismissing it. But he couldn't dismiss it, because all his

life he had been unable to look challenges in the face. Despite how mild it really was, Carl was rattled by it. I felt sorry, and was ashamed for him, for he knew that I had caught it, and that once again he hadn't stepped up to a challenge.

But that was Carl's nature, and I knew it. Just as I knew that it was in Cedric's nature that he and his friend Rooster would be sending extortion letters. Carl never rose above the tendency to be intimidated by what ordinarily would be characterized as inconsequential stuff. Ultimately, his was not a very eventful life. He remained a longshoreman until he died at the age of sixty-five.

While those two brothers fended off difficulties in their respective ways, my older brothers Reginald and Cyril found opportunities they pursued to better advantage.

Reggie, named after my father, was the brother who had preceded Carl. My father had pinned his hopes on Reggie, and when we moved to Nassau, having had no children attend college, my dad went to someone he had once known, the headmaster at an advanced academy, seeking to get Reggie enrolled. The headmaster, knowing my father's financial state of affairs, warned him that it would cost a considerable amount of money. But my father declared he would try to man-

age it, and the headmaster agreed to accept Reggie as a student.

About a year into Reggie's schooling, the headmaster came back to my father and told him it wasn't going to work out. Reggie, he asserted, was not student material. My father was disappointed, but he was a stand-up guy against difficulties, so he faced the truth as he realized it to be and took Reggie out of school.

My brother soon thereafter became a cab driver, and remained one all his life until he retired. And as I write this Reggie is still alive at the age of eighty-eight, with lots of children and grandchildren who are flourishing today. He has a daughter who holds an important position in the dialysis division of a local hospital. He also has a son who for many years worked for a casino company and now has a business of his own. He has another son who has taken up the taxicab business that his father ran, and Reggie has other sons who work for the government or have other rewarding jobs.

Like his namesake, Reg is a decent man through and through, and was devoted to his wife, who some years ago became gravely ill and slipped into a coma. When her condition came to the point where the pulling of the plug seemed an option, Reggie and his daughter—I suspect with the concurrence of the other children—elected not to. They knew what a difficult

task it would be to keep her because they all worked, except Reggie, but he and his daughter committed to taking care of her. Reggie kept her alive, sleeping in the same bed with her for five years. For all the strife, he and his daughter, who lived in the house but still had to be away at the hospital, maintained that it was a wife and mother that they were not going to let go until she went, those five years later.

The eldest of our brothers, Cyril, was both a dreamer and a hardworking pragmatist who lived to be eighty-one years old. Like Cedric, Cyril stowed away on a ship to America. But unlike Cedric, he was not caught. Once in Miami, as an illegal alien he worked with his hands, earned citizenship, and married an American girl named Bertha; she also worked with her hands. Together they raised ten children, and sent them all to college. You can imagine how proud that made your great-great grandparents Reggie and Evelyn Poitier—that so many of their grandchildren—your cousins—had made it to college.

As to my sisters, there were four—Ruby, Teddy, Delores, and Maude. Lor and Maudy, as we called them, were half-sisters born to my father from earlier relationships in his life. My sisters are all gone except Maude, who is well into her eighties, with a number of children and grandchildren. Still, she remains a

chipper, energetic, loving personality who brightens the space she occupies. Because my older sisters Ruby and Delores were not in the household for much of the time when I was growing up, few memories exist of them for me today. Not so when it comes to my sister Teddy, who doted on me from the time my parents brought me home to Cat Island as a tiny, premature infant once not expected to survive.

What it was about me that Teddy liked so much I never knew, but for some reason I made her laugh all the time. Sometimes she laughed at me, but in such a loving way that I would join her in laughing at myself. And together we would just laugh and laugh until our bellies started to hurt. She would end up hugging me and asking, "Everything all right with you?"

"Yes," I would assure her. Then she would hug me again and we would find some interesting games to play.

Ayele, there is one story in particular that may give you a sense of why I thought my sister Teddy was such a remarkable person. It occurred during the first year after we moved from Cat Island to Nassau, when I was closing in on twelve years old. In the neighborhood where we lived—near E Street and Ross Corner, one of the intersecting corners—I'd started making lots of friends, and we used to hang out there on a daily basis,

doing all of the things that twelve- and thirteen-year-old guys would do. We were not a gang by any contemporary stretch, but we did run in packs and looked to do mischievous things, and we did accomplish a goodly number of them.

One of the guys in our group was a bit older—fifteen or sixteen—and was looked upon as having leadership qualities, but with criminal intent. He was larger than the rest of us, and had a tendency to order us about. This guy was always treading close to danger—picking fights, coming on to women with double entendres that would be lost on their more genteel ears but would cause the males in the bunch to laugh uproariously.

Funny though he could be, he was mean-spirited, and it could never be predicted who he might turn on next. One day, for reasons unknown, he challenged me. Probably he decided to take me on because he knew there was no way for him to lose. Here he was, one of the big muckety-mucks in the group, and I had nobody who would dare come to my aid. So he picked me and provoked me. Holding my ground, or so I thought, I tried to provoke him back just to let it be that kind of thing. Those were the unwritten rules of the game. At the least, I had to speak back to this guy and not let him intimidate me. Well, he hauled off

and whacked me across my face—*Pow!*—and I hit the ground: out cold.

One of the guys, rightfully concerned because I was lying there unconscious, ran to the house—which was the second door off the corner. At home, Teddy heard the news that I was on the ground and raced to my side, where she was told what had happened and the fact that the perpetrator had gone over to a nearby shop.

Teddy picked me up and walked with me in her arms back to the house, where she was able to revive me. Then she went back out to the corner to let the other fellows know that I was no longer unconscious. As it was later told to me, just as she asked if anyone had seen the guy who knocked me out, the guy came out of the shop and started walking back to the group. Teddy met him halfway, walked right up and took a pop at him, and he squared off like he wanted to fight. And my sister whipped his butt to the ground.

Her last words to him as he hobbled away were: "The next time you mess with my brother, I'm going to come out and kill you."

Well, the guy didn't show up again for several days, but he had no place else to go, so he made whatever excuses he had to make and stayed in the pack. He never apologized to me, but he knew, and the guys would say, "Don't you mess with Sidney, boy, 'cause his sister will

whip your butt." Until we moved to another neighborhood in a lower-income area, I enjoyed the reputation of being a guy "you shouldn't mess with."

Teddy's fiercely protective side was surpassed only by an independent, adventurous streak that couldn't be stilled. After marrying very young and having two children, she and her husband broke up, and she moved in with my folks. Then, during the war, Florida began importing day laborers from the Bahamas—mostly men, but also a few women—so Teddy applied and went to work in the fields there. The work was backbreaking, with long hours and very little pay, but she did it and sent money back to Nassau for her kids.

Upon her return to the Bahamas, Teddy took up with a man, aptly nicknamed Blood, who worked in a slaughterhouse. Violent and controlling, he was a very bad person, but my sister found him exciting, I suppose. In time, their all-consuming, addictive relationship turned to dust. Along the way, he almost broke her spirit—something I hesitate to tell you about, Ayele, but I do so in the hope that when in doubt as you approach relationships in your adulthood, you will know that you can rely on the family members who love you and who ultimately want what is in your best interests.

So it was when Teddy left her abuser one last time and turned to our parents. My father, already bro-

kenhearted from the toll Blood had taken on her, laid down the law. Teddy was always welcome in his home with her kids—provided it was over between her and her slaughterhouse boyfriend and that she would never see him again. My sister swore that she was finished with Blood and returned to the home of Reggie and Evelyn Poitier.

All went smoothly for a time. But Teddy's demons were such that she couldn't break free of the hold this man had on her, and she took up with him again secretly. As long as I live, I will never forget the look of sadness on my father's face when he called Teddy into our yard and let her know, in no uncertain terms, that he had found out.

Pointing to a certain branch of a tamarind tree, our dad gave her instructions to climb up, break it off, and bring it down to him. After she did as he asked, he wrapped his left hand tightly around that branch. Then, using his right hand, he pulled the branch through his tight grip, shedding all the leaves from it—leaving a perfect weapon for administering a never-to-be-forgotten whipping to any one of his children who warranted it. Ayele, that day my sister Teddy, as much as I loved her, certainly warranted it, and she knew it. And although his tough form of discipline seems extreme by our modern standards, I can

attest to the fact that he loved his daughter unconditionally and simply couldn't bear the punishment she was giving herself and others.

This was proven sometime afterward, after Teddy had been living on her own for a time. At that juncture, Teddy took sick, and the doctors at the hospital in Nassau couldn't determine what was wrong with her. She was so ill, had lost so much weight and become so frail and feeble, that the doctors called my father to take her home, because they felt there was nothing they could do to save her.

My father not only brought her home at once but adamantly refused to accept that Teddy couldn't be saved. Like our mother, who put stock in some of the older occult and voodoo practices, our dad had his own connections to such healing arts. And when he got word that a medicine man was coming to Nassau from one of the other islands to treat someone, my father made arrangements to meet with him—whereupon the medicine man agreed to come see Teddy. After the examination, he told my parents little except that he would be back the next day. He returned with roots and leaves from the forest, and he had my father bake and crush them until they looked like tea leaves. Indeed, they were used to make tea, and my father and mother fed Teddy the tea three to four times a day.

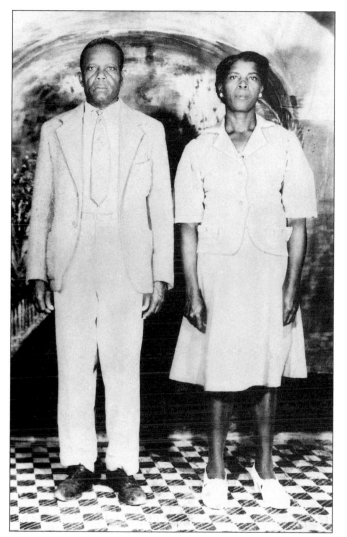

*My parents,
Reginald and
Evelyn Poitier*

*On a visit to
Cat Island*

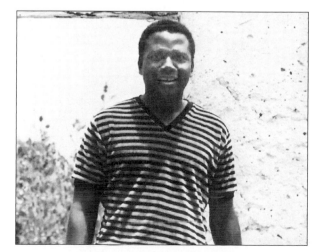

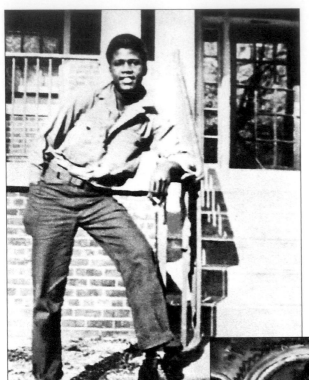

In the army, 1943

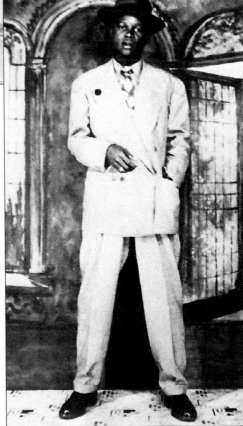

*In my zoot suit in
New York City*

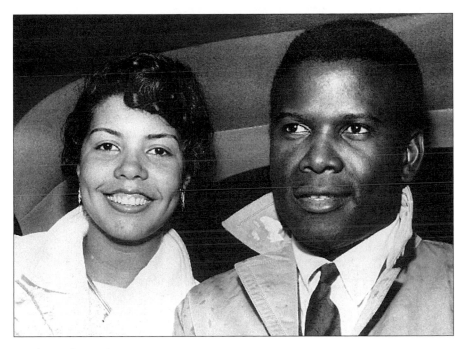

With my first wife, Juanita

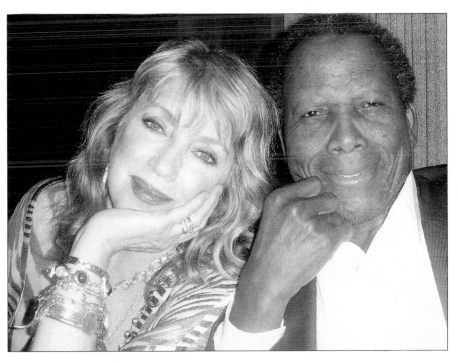

With my second wife, Joanna

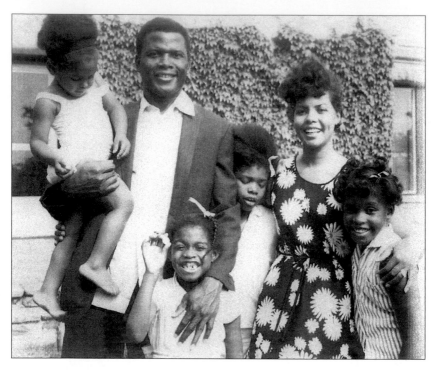

With Juanita and our four daughters: Gina, Pamela, Beverly, and Sherri

With Joanna and our two daughters: Sydney and Anika

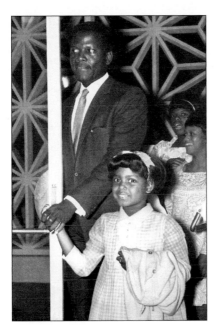

With my daughter Pamela

With my daughter Gina

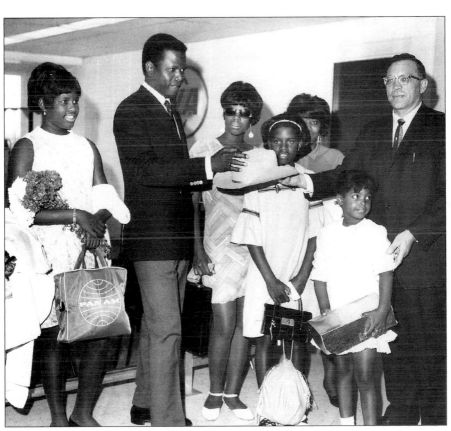

Traveling with my daughters in 1969: Pamela, Beverly, Sherri, and Gina

With my daughter Sydney on a fishing boat in the Caribbean

Clowning around with my daughter Anika

Four generations together: Juanita, Beverly, Aisha, and Ayele

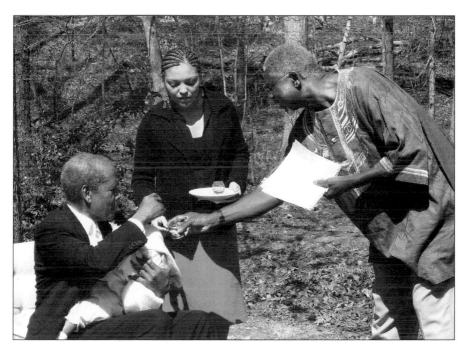

Tralance Addy from Ghana officiating with interpreter Adwoa Mould-Mograbi at Ayele's "Outdooring" ceremony

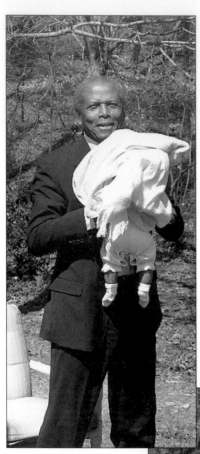

Raising Ayele up to the heavens at her "Outdooring" ceremony

Touching Ayele's feet to mine, symbolizing that she will walk in the footsteps of her ancestors

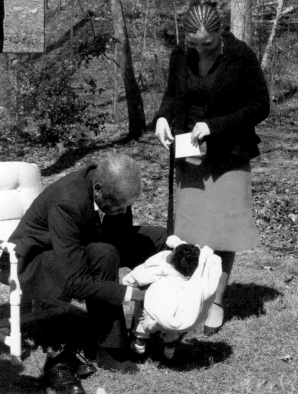

Slowly, she started improving, tended by love, faith, and nature's powers. In time she was back on her feet, and soon after that she found a job in a hotel and returned to work full-time. While there, some visiting tourists from Syracuse, New York, took such a liking to Teddy that she was told employment was waiting for her—if she ever came to Syracuse.

Here again, Teddy's adventurous spirit took hold and she subsequently went to Syracuse and worked there, proudly returning home on vacations to tell of her experiences in a world far away from where she had begun, laughing and musing about possibilities for her future.

Many years after I'd left home and was just beginning my career in movies in Hollywood, I received a call from someone in Syracuse telling me that my sister Teddy had fallen ill and was in the hospital. Within days, she died.

My sister Teddy was an adventurous soul, born in a time that didn't allow her room to rise. She was one of nature's children, kept alive in my memories by the echoes of her laughter and love.

As I search my recollections of all the members of the Family Poitier—those who are still here, and those long gone—I can't say that anyone in the family had a preoccupation anything like mine for delving into life's most

elusive mysteries. Was asking those questions the job that was assigned to me at birth? Was it a mantle that I accidentally came across and put on while roaming the island of my youth? More questions looking for answers!

Here are other variations: how did I end up in the family that I did? How do any of us get here?

Well, some say by design: faith and the will of God. Others say by random happenstance: trial and error. Modern science, on the other hand, speaking with its customary caution, points to the unfolding of evolutionary processes over billions of years—that when studied in depth will yield proven scenarios that soon will leave no doubt as to how we got here. Meanwhile—ifs, ands, and buts notwithstanding—how we got here remains an unanswered question.

For sure, some unanswered questions will meet up with answers that fit like a glove; some will not. Some will linger long, have no luck, and wither on the vine. Maybe, for some, there are no answers. Maybe some questions are eternal by nature, and we are never meant to find an answer. Or so it sometimes seems.

At odd times, it appears at first glance that unanswered questions and unfinished lives share—at the same time—a mutual attraction and an unbearable incompatibility. And yet the search goes on—with explanations as to how and why coming up later on.

The Loner

Ayele, I think by now you have a sense of who I am. And I hope that sense coincides with who I feel myself to be as I write this letter. But it is who I've been in the life I've lived up to this moment—5:17 a.m. on this seventh morning of November 2007—that should reveal more about the whys and hows of where my adventures took me.

Vivid in my mind is the memory of the day sixty-five years ago in Nassau when I was fifteen years old and came to a turn in the road when it was time to leave home for good. If that seems young to you, I would have to agree that I was ill prepared to face the challenges that awaited me in America—yet again an

environment radically different from the one to which I'd become accustomed in Nassau. One of my few advantages in weathering the storms ahead was that even by age fifteen I had a core of knowledge that was going to travel with me—a sense of who I was, regardless of what the world chose to say to me.

That sense of myself has been described by others as someone who is a loner, an outsider, a private person, and one driven to walk on the edges of life. Those descriptions are fairly apt. Whether I was pulled or pushed to those edges has varied, and depended at times on survival needs. Walking the edge doesn't mean that I've been reckless, at least for the most part. In fact, I have looked at options through reasonably cautious eyes. As a loner, I have needed to pay attention, to ask for explanations and read between the lines for hidden purpose, and, first and foremost, to rule out danger or assess the levels of such dangers that might be present. Misjudgments sometimes exact unpleasant penalties that will sit in memory as warning signals to protect against future misjudgments.

Caution has been well earned, especially because there was a time when I was a most impulsive risk taker—which I eventually outgrew, or have almost outgrown. But it is due to the nature of who I was long ago on Cat Island—even then a loner, an out-

sider, a private person—that I am still inclined to walk on the edge—of course, not nearly as much as I once did. Well, as you know, I'm eighty years old and have learned to adapt my risks appropriately. In those rare moments still when I flirt with the dangers of the abyss, it is the memory of my mother's whap-whap form of discipline, sternly administered in my earliest days when I was behaving foolishly, and the echo of her voice that intervene. "Sidney," she would say, "that thick skull of yours, what's up there? Not one thimbleful of common sense that I can see!" And then would come the two or three whap-whaps. That always pulled me back from the edge—and still does.

Being a loner can be lonely, my dearest Ayele, but there are rewards, too, to having a rich internal sense of self—a mechanism for making order out of life experiences and for owning the internal terrain, even when it is a terribly private place. For many years it was just me there inside it, alone; having feelings I couldn't put into words, and not having anyone with whom I might dare to share them even if I had the words—except for Teddy sometimes. In hindsight, I might have opened up more to my mother, which might have made the mother-child separation less painful when the time came.

Instead, I chose not to be alone as a loner by being at home in nature—in the daily outdoorings of my childhood and youth, where the world buzzed and sang with life that reverberated in my inner world. Walking on the beach or sitting on rocks, my eyes on the horizon, aroused curiosity, stirring joy, all the while allowing me to make connections to the externals: the sounds and sights of birds, some of them large ones flying from other islands over Cat Island; the lapping of the waves; the clouds coming over and obscuring the sun; lizards scrambling about; and the hum of crickets.

In my earliest days of childhood, I learned to converse with the environment that spoke to my own inner landscape, that tapped my curiosity and goaded my imagination into cooking up the most spectacular daydreams. The more accustomed I became to listening to what was being said, the more secure I became not only in the world outside of me but in my own self. There was much to hear: variations of sounds made by the changing winds; the booming battle of sturdy, raucous waves racing in to confront the rocky shoreline, which stands its ground and repulses one mighty charge after another until the rage of an angry ocean finally subsides, restoring calm to the waters of the Bahamas. Conversing with those sounds gave me an

anchor, a sense of place and location, made possible whenever I tried to figure out the direction each sound was coming from. Was it coming from the trees? From the bushes? From distant places?

In this process, I came to know and identify the various musicians creating the orchestration of sounds that were the vibrant voices of Cat Island. All those creatures and entities became my friends, my familiars: the birds and the land crabs, the crickets—all the forces of nature that had so much to say to me.

Sometimes I feel like I was born with the seed of a loner buried deep inside of me; and my external life was tailor-made, by nature, to nurture that seed in ways that were beyond my understanding. This schooling probably began even when I was a toddler and my mother, before setting off to work her long hours, dropped me off to stay with my grandfather and grandmother, Pa Tim and Mama Gina, her parents, your great-great-great-grandparents. She was able to leave me with my elders, who didn't say much to me and weren't able to scurry after me, because I was already being raised to be self-sufficient. Later, in the short period when I attended school, I would go home at the end of the school day directly to Pa Tim and Mama Gina, check in, have a bite to eat, and begin my wanderings.

Some days I headed into the swamps to look for berries, picking cocoa plums and outsmarting the wasps by shaking sapodilla trees and causing the ripest fruit to fall. As long as my eyes were sharp and I caught the fruit at the flood, I could feast on it as well. But I also learned that there are few tastes as terrible as biting into an unripe sapodilla.

These solo pursuits further tuned my logistic skills, especially when it came to the trial and error of getting past the wasps without being stung about the eyes, both painful and disabling. To that end, I had to study the growth patterns of the fruit trees, how cocoa plums grew wherever they could on branches in haphazard patterns and how the sapodillas congregated higher up, guarded by the wasps, yet hanging heavy enough on their branches that shaking the trees could cause them to fall without my having to climb up and get stung.

Thus it was that I became a logician in my own terms, developing instincts for survival needs and for responding to threats real and perceived—like those of the two main graveyards on Cat Island that I was forced to pass by on my way to wherever I wanted to go.

The passing of a graveyard alone was never, ever without impact, because, frankly, the imagination gets to running away with itself. You see the head-

stones—not modern, chiseled headstones, but rather a rock, with a little planted post at the head of the grave bearing the name of the person in the earth below. In one of the graveyards there were relatives from Poitier and Outten lines, while in the other lay the bones of strangers. Neither location seemed safer than the other. So the closer I drew to the graveyards, the more my internal self was awake and alert, tuned in to suspicious activity of any kind, particularly any motion that might reveal the presence of the bogeyman.

Now, I don't want to scare you, my dear, not the way that I was scared as a child when my older siblings and other children planted frightening images of the bogeyman in my consciousness. But that was a part of the culture, and so the bogeyman took root in my imagination very early on—a force that had an impact on me during the day as well as at night. Whatever the cause for fear, no matter where I was, I perceived the bogeyman to be involved somehow, and my imagination ran wild with all variety of images of his size, shape, and supernatural, terrifying powers.

But there was an upside to this kind of thinking, which was that I learned, in my solitary way, to be familiar with fear, to walk carefully past graveyards, and to investigate before kowtowing to alleged bogeymen.

And those lessons served me well in the long run, as an outsider and a loner.

So there I was, this private person living comfortably in the confines of his internal self and simultaneously maintaining a robust relationship with the external, real world, which was unfolding day by day. And then, suddenly, we moved to Nassau—where the environment, which had been my virtual schoolhouse, radically changed.

Now I had to adapt to a society of my peers, still as an outsider. That was when I discovered that a loner is most often referred to as a shy person. And for that matter, shyness makes up a large part of my personality, a trait that I inherited undoubtedly from the shyest person I knew: my mother.

This has all been to reveal to you, my dearest great-granddaughter, that in our travels to become who we are and who we were meant to be in the grand scheme of things—whether we see ourselves as outsiders or loners, or as shy or private, or as outgoing, gregarious extraverts—what really counts above all is that we do see ourselves. By seeing and knowing ourselves, we are given dominion over our lives—the capacity to steer our own ships, for better and for worse.

Though I was shy, an outsider, and a loner, I made friends easily in Nassau and was able to be at home

as well in my environment. The earlier music of Cat Island, played by nature and sung by parents, siblings, and neighbors to the homemade melodies and rhythms of hand clapping and foot tapping, had changed in Nassau to a livelier beat—the soundtrack of cars and trucks, the jokes and dares of kids hanging out on street corners, the banter of commerce, live music of rake and scrape mixing with radios in the stores and the movie theaters sounding the popular tunes of the late 1930s and early 1940s.

During the nearly five years when I came of age on Nassau, the adventure of that music called me. This was true when I attended my first school, Eastern Senior, which required me to walk as many as four miles each way—so far, in fact, that I later transferred to a second school, Western Senior. But before that transfer, while going to and from Eastern, I explored different shortcuts. On such an expedition, I met a boy by the name of Carl—who happened to be white—apparently out in front of where he lived in a neighborhood as poor as mine. We often spoke when I passed by, and we struck up a friendship of sorts. It didn't take me long to recognize that in spite of the fact that we were both from poor households, Carl exhibited a definite racist streak by claiming his superiority to me—because he was white and I was black. This was

another experience that reinforced my outsider status, such that at the time and from then on, whenever I smelled that in a person, I would address it and try to disarm it.

Later I better understood Carl in the context of the social hierarchy installed in the Bahamas by the colonial system, which was still intact to a large extent. He was looking for anything to lift him higher than the very low rung on which his circumstances of birth had placed him.

After I quit school at the age of twelve and a half in order to go to work to help support my family, I met a pretty girl named Dorothy—whose coloring was chocolate brown and who appeared to be of African descent—who turned out to be a half-sister of Carl's. This made me wonder about issues of class and race, but I kept those questions to myself.

In the meantime, other friendships weren't always conducive to my staying out of mischief and even some trouble, with enough close calls to cause my parents serious concerns.

I was never privy to any discussions they may have had, but I imagine they were able to look past some of the more typical teenage behavior that I was involved in—daredevil antics, street fights, and so on. That was, until my friend Yorrick Rolle was caught after

stealing a bicycle and then sentenced to a long stint in reform school. To this day, I don't remember how it was that I happened not to be along for that ride. But I do remember well another incident involving my regular group of guys when I was in tow.

It was on that particularly dark, moonless night that my friends and I planned and successfully pulled off a major raid of a sizable cornfield—just outside of town. So successful was the raid that we imagined ourselves to possess critical-thinking capacities well above the levels of the twelve- and thirteen-year-olds that we were. And, might I add, that collective assessment of ourselves remains solid proof that we were also the dumbest kids that anyone, anywhere, had *ever* heard of. And here's why: on that very same dark, moonless night, we took the bags of corn we had only just stolen and built a bonfire, over which we started roasting the corn—right there in that same cornfield!

We had barely begun to enjoy our feast when the farmer—who lived all of a quarter mile away—apparently glanced out of his window, spotted the huge glow rising out of the middle of his cornfields, and promptly called both the police and the fire brigade. We were all arrested. My co-conspirators each had parents who were able to manage the seven dollars of bail money. Mine couldn't. That meant I spent the night in jail.

The next morning, my dad arrived after borrowing the money for my bail and after paying an additional seven bucks to the farmer to keep me from more jail time. On the way home from the courthouse, my father and I walked along at a pace necessary to keep his rheumatoid arthritis in check. When he did speak, because I knew the measured person that he was, I wasn't at all surprised that his disappointment wasn't reflected in his remarks. But I could hear it in his voice. I had let him down.

Even so, his focus was on the future. "Sidney," he said finally, "you're my last born." He paused and then continued, "You're growing up. I can't run after you or look out for you, Son. Not like I used to. "

I said nothing, but nodded in recognition.

"You need a stronger hand," my father went on, and then took a different tack, reminding me, "You were born in America. The time has come for your mother and me to send you back."

Thus the wheels were set in motion for me to be sent to live with my brother Cyril in Miami, a departure that finally took place some time later. At that point I was fifteen years old and completely unsophisticated in the ways of the world, other than what I'd learned pretty much on the streets of Nassau. But in

his wisdom my father knew that my survival depended on getting me off that island.

Even though I wasn't happy at being sent away, in retrospect, my sense is that my dad also recognized that the environment I was living in had little to offer me, and he wanted more for me. Certainly, he must have been hoping that my hardworking brother and his family would be good influences on me. But I have to also believe that Reggie Poitier wanted me, his youngest child, to have a shot at going further than where he had landed after circumstances outside of his control had toppled the only business he knew. Maybe this was his way of tossing me into the ocean, hoping that I could teach myself to swim in a way that he didn't even know how to do. In any case, he made the call that it was time for me to leave home. It was one of the best decisions he ever made on my behalf.

Ahead of me were experiences and places that were, once again, so radically different from Cat Island or Nassau, but would only reinforce the outsider in me. There would be, in Florida, the searing shock of racism, segregation, and the mistreatment of people on the basis of color alone—unprecedented in my awareness. My time in Miami would last not much more than a few months before I would be forced to

get away, surrounded there as I would be by energies incompatible with my internal self. In my attempt to adapt to the atmosphere there, I was unable to hold to the beat, sped up and erratic as it was. By the time I wound up in New York City, beyond the mind-boggling millions of people and the mad pace of life in the midst of gargantuan buildings and the cacophony of sounds, there would be this blood-freezing, bone-numbing experience that I could never have anticipated: winter.

Ironically, my survival was to depend on my comfort in being a loner. How does a shy, private person who is suddenly plunged into that environment make it any other way? I would live internally, spending my time going to lots of movies, looking around and trying to figure out how things worked, paying attention to conversations as a listener, as I always had. Somehow, I eventually grasped a sense of the music of that city. I would go to bars and sit in a corner—I wasn't a drinking person at that point—and just watch people who came in, and listen to what they said to each other and hear their laughter. Too shy to even make any kind of eye contact, I was silently very connected to them by watching their gestures and sensing their moods. On street corners, waiting for the light to change, I'd pick up on a conversation next to me and

follow it, waiting to hear where it would go, how this story or that anecdote worked out, only to have to lose the ending when the individuals talking turned right and I turned left, leaving me to let my imagination fill in the blanks and, soon enough, join in on another conversation down the block.

Being as vulnerable as I was, unable to read very well, not really knowing the city, the weather, and having to work to pay my way—all of that brought me to the point where I was a bona fide adult person who would remain a legitimately shy person. I would ultimately make friends in New York, but I was fine on my own, knowing that even when I was being introduced to a new set of people, my shyness would be there still. Even in social settings where I knew people, I would do more listening, watching, and imagining than participating. But as others have observed, being a great listener often makes you an even better learner.

That didn't always lessen the burden of being a shy guy. As you'll hear later on, my shyness with girls was awful. My shyness in making new relationships with guys wasn't easy, either. My shyness was even intensified just from trying to communicate at first with a group of people whose speech pattern was different from mine. It wasn't simply that I had this singsong, Caribbean accent; I didn't speak well: my vocabulary

was sparse, and since I couldn't read sophisticated sentences, I had no written models to follow. Rather than embarrass myself, I followed my natural inclination to withdraw to maintain some space. And the maintenance of space included participating in conversations on a minimal level, making me that much more of an outsider. So, in New York, all of these crosscurrents combined with my loner quotient and the shy outsider nature in me, and the deal was done. It was finished. It was sealed. Who I was was who I was.

That was the case, really, from the moment I arrived, including when the option arose to go into the army to escape the brutal winter: my identity as Sidney Poitier, the private person, was set and nailed down. Throughout all the events that followed, no matter how much of a public life I went on to have, I never shed that first skin. I never became a social person in New York or in California. I was not a social person at all when I decided to become an actor. You'll hear more about that subject eventually, although I will say now what I've always said—that other than once having claimed the desire to work with cows in Hollywood, if anyone had ever asked me to think about being an actor, I would have said, "Get out of here. Are you crazy? Me? Nooooo!" But fortunately, on that score, fate was to intervene and push me in that direction.

So I sit comfortable after all these years, and I am very protective of my aloneness. I am very protective of my shyness; it never triggers any displeasure in me, any resentment of itself. It's a part of me.

That much I knew about myself at the age of fifteen when my dad walked with me down to the dock in Nassau to send me off into a completely undefined future. My mother stayed at home and chose not to accompany my father in seeing me off. Why exactly she didn't come I don't really know. At times I thought it was my fault, because I had told her once when I was upset that I was being made to leave that I wasn't going to America like everyone else from a poor Caribbean family just to work myself to the bone to send money back home. But over the years it has occurred to me that Evelyn Poitier knew her son better than that and she would have known that only to lessen the hurt of saying good-bye would I have said so foolish a thing. Of course, burning deep within was the desire to make something substantial of myself and to give my parents the comfortable life they had never known. That's who I really was.

I have also come to the conclusion that it would have been unbearable for her to watch me sail away, her last-born child, who, had it not been for her strong will and her indomitable faith, might not have lived.

Instead, my mother wished me a fond, shy farewell as she stood in the doorway—watching me go with a look of acceptance on her face, as if she had known and had been preparing for this moment to come.

After I could no longer crane my neck over my shoulder to look back and see her standing there, I imagined that she turned and went to sit on the bench in the living room, alone, where she allowed herself to shed private tears at my leaving.

As we walked along, me and my dad, we said little, but important understandings passed between us even so. I thought of the visit that I had paid to Yorrick at the reform school where he had been sent—a sobering experience, to say the least, that had helped make better sense of the decision to send me to America. And then we approached the home of another friend of mine, Harry Johnson. There he was, sitting on a wall, waiting for me to pass by, knowing that we might never see each other again. My father walked slowly past Harry as he sat on the wall, and left us the privacy to exchange good-byes.

At the dock before I boarded the passenger boat, my father reviewed the particulars of where I would be staying in Miami with my brother and his family. After a final, short lecture about remembering the values of respect and discipline that I'd been taught,

he patted me on the shoulder and pressed three dollar bills into my hand.

"Take care of yourself, Son," he said, leaving me with nothing to do but turn from him and board the boat.

He didn't need to give me any other parting advice, because all that he was—a person of decency, integrity, and substance—had already provided me with everything that I needed to know.

Certainly, my father may have said something about looking forward to hearing from me and to seeing me very soon. With that, I left behind the people that I loved most and the world that had raised me, and sailed off, alone. Due to the events that I'll describe to you over the next few letters, my dear Ayele, it would be eight long years before I was able to return or even to be heard from again.

Part II

EXPEDITIONS

Me and God

I will tell you, dearest Ayele, that I have lived to enjoy some of life's sweetest moments and most exalted experiences. One that I hold among the most precious was the first sighting of my parents, Evelyn Outten Poitier and Reginald Poitier, eight years after I left home.

At age twenty-three, I had begun the slow climb toward an acting career and had made my first movie, *No Way Out,* for which I'd earned $750 a week for four weeks. Knowing that I had booked a second movie, *Cry, the Beloved Country,* I had just enough of a break in my schedule and enough money to be able to go home for the first time in all those years.

I flew in to Nassau, took a cab to the house, and, though it was nighttime, found it very much the same as I had left it at age fifteen. The house was dark, except for a thin light in one room. Rather than knocking on the front door, I walked around to a window and peeped in. There on the bench was my mom—unchanged, it seemed, from when I had left her eight years earlier—talking to my father, who was seated next to her on a chair. The sight of my parents, engaged so intimately in conversation with each other, was how I had preserved them in my memory. I've never known any couple more compatible than my mother and dad; they loved being with each other.

For all those years that I was gone, my mother had kept a light on, so to speak, waiting for my return. Throughout the time that I was away, I had not forgotten for an instant the unwritten code of honor: that no self-respecting son or daughter would go away to America and not send a little something home in an envelope—for food, for basic needs. The amount didn't matter; what did was the symbolic nature of the gesture—not to mention the fact that the five dollars I paid for weekly rooming could have kept my family for a month.

That had been easier intended than done. From the moment that I arrived in the United States, I had fallen

into the worst of times in terms of making a living. But instead of sending a letter home to explain my circumstances, I kept telling myself that a better day would come and I would have the extra dollars to enclose for my loved ones. With every passing week and no such ability to do so, it became increasingly harder to write any letter whatsoever. When I entered the army to escape the cold, I arranged for a monthly allotment offered to parents or spouses to be mailed to Mr. and Mrs. Reginald Poitier. It had been a relief to be able to do that, although not enough to encourage me to write home as well to describe my various ordeals. What I didn't yet know was that for reasons never to be ascertained, those thirteen or so payments never arrived. Once I was out of the army, back into similarly tenuous financial straits, I still couldn't bring myself to write to my parents to tell them of my struggles. Ultimately, the shame of not having written earlier had snowballed to the point where it was too much to bear. The only way that I could bridge the chasm of the years of silence was to return home in person as I now was, bearing the long-postponed envelope, the contents of which represented the truth that I hadn't stopped thinking of my folks at any stage of my absence.

Nor had I stopped considering how my silence must have tested my mother. Even though I could have and

might have and almost did meet my demise in all that time, without a word or rumor as to my whereabouts and status, my mom unquestionably stood her ground and relied on her faith and prayers to protect me in my absence. That was who she was.

For a moment, before I announced myself that night, I considered how that had sustained her— thoughts that I'll share with you now. Your great-great-grandmother, as you have read previously, was a religious person. Her connection to the more ancient spirituality of the occult probably came from her mother, Mama Gina—your great-great-great-grandmother—who seemed to be conversant with the spirit world, as I recall. Though I have never had any interest in that world, it provides insights into the role that religion played in early mankind's monumental struggle against the forces of nature, on which the condition of our survival rested—with the outcome, so far, still in question.

Naturally, the struggle forged a yearning for salvation in our early human ancestors, a yearning for help of any kind, from any force mightier than themselves. A yearning that, over time, would evolve into a mighty unseen force, it was coupled with a belief in spirits, out of which has grown the ever-present need for a variety of gods.

Still, under the everyday conditions in which our early ancestors existed, survival came at a very high price. Getting food and water remained a risky business. Not by any stretch of the imagination would they have ever stood much of a chance once pitted against the dominant predators of the day: none among them was as swift as the lion; none among them had skin as tough as a tiger's, or that of the warthog or the hyena, or the many other creatures given to prowling the night in packs.

There were also times, of course, when our ancestors looked up and saw shooting stars, and, as always, were at once amazed and threatened by the spectacle of all that was the heavens. Lightning strikes! Thunder rolls! How might they possibly have described what they saw to others without the use of language? How could they have explained it to themselves?

I believe that from somewhere out of a given time came a moment of profound realization that nature has a voice within each of us that speaks a silent language. This language, which can be understood by our bodies, our minds, our consciousness, and our instincts, is universally recognized, constantly reminding us that survival is an eternal struggle for all the creatures of the earth. In this fashion, survival vulnerabilities gave rise to a spirit world that promised hope. Out of such

promises grew gods of the sea, gods of the sky, gods of the forests, gods of planting. There was a need for gods, gods, and more gods, because early humans found it difficult to accept the responsibility for their own survival when the odds seemed to be stacked so overwhelmingly against them. As they became more sophisticated, they found gods in all kinds of other things.

In my expeditions, survival has been achieved by applying logic and reason to most situations. But when it comes to faith from my mother's point of view, logic and reason had no influence with her in regard to what she felt. How did she come upon this feeling? She must have had a connectedness to things beyond my under-standing or perhaps her ability to articulate.

Surely, while I was away all that time, my mother returned time and again to the prophesy of the sooth-sayer who had told her not to worry about me. Still, eight years is a long time. And she could not picture the soothsayer's vision for me, because my mother had no idea what was meant when it was said: "He will travel to most of the corners of the earth." She had no idea what a corner of the earth looked like, nor did I. But I have since been there. The sooth-sayer said, "He will walk with kings," and, though my mom couldn't see it and I couldn't see it, I have

walked with kings. She said, "He will take your name all over the world." Our name is what I carry. I have been all over the world, and I have been recognized all over the world as Sidney Poitier. But who is Sidney Poitier? Sidney Poitier is the son of Evelyn Poitier and Reginald Poitier.

But I wasn't biding my time waiting for the prediction to come true in all those years. And as I picture my mother, what is it she's doing while waiting for the soothsayer's words to come true? She is connected to something in which she has placed her faith. She clearly expected something to materialize down the road in my life. What she said to me was enough for me to hear, but not clearly understand. My mother couldn't tell me that the world was round. She couldn't tell me that there were so many oceans, or so many continents. So she had to have a connectedness to something in which she had rested her faith.

What was that? Well, she was a churchgoer, an Anglican Catholic, that religion having been brought to the region by the British slaveholders in the early days of the same slave trade that made its first appearance in the American colonies in the early 1600s. In Haiti, an uprising against the French colonists led to the abolition of slavery in 1804, while it was not fully outlawed in the Bahamas until 1833. That was thirty-two

years before slavery was officially ended in the United States.

My mother didn't know this history or that the church in which she was raised had been imported to the islands of the area by the British. And though she was devout in her faith, she wasn't married to church doctrine, nor do I think that she actually recognized the fundamental differences between Anglican and Roman Catholic churches, and how the division came about. I don't think she was aware that the king of England wanted to marry Anne Boleyn, and the Roman Catholic Church would not give him permission to get rid of his wife to do that. So he set up his own Anglican Catholicism. I'm pretty sure she didn't know because my mother was not that versed a person. In fact, that was history I wouldn't know much about until many years later.

My mom had grown up in the Anglican Church and attended services every Sunday, where the priest talked about life through the vision of the church. But other influences informed my mother's spiritual vision. After all, she was descended from a different background than the Bahamas. Her forefathers, four or five generations previously, were slaves who were brought into that region, primarily to Haiti, which was a fairly large island. Her forefathers probably got

to the Bahamas as escapees, using handmade rafts. If that happened, there were no authorities in the Bahamas that would grab them and ship them back to Haiti. My mother's ancestors were able to retain a connection to those remnants of who they once were—in defiance of the institution of slavery, which set out to obliterate their original cultural and religious identity. And my mother inherited those older beliefs that were part of her faith as well. Now, we're talking about voodoo or some mysterious something. A power, an influence and energy source. So for her, there were two religions now: Catholicism and the world of faith that came from her heritage—the world of the spirits.

That was the mix in her that put words into her mouth when she told my father to get rid of the shoebox that he'd brought home to bury me in. That was the mix that had been sustaining her as I peeked in through the window at her and my dad, talking together on that night eight years after my departure.

Without saying anything to them, I went to the back door, which was open, and walked in. They looked at me, and then looked at each other. Then they looked back at me, and with her face scrutinizing mine, my mother spoke her first words. "Kermit?" she said. My brother in Miami had several children, the oldest of which was Kermit.

I didn't say anything, and they looked at each other again. Then it struck my mother, and she screamed like you can't imagine. She jumped up. I was almost six feet away from her, standing in this old kitchen. And she ran over and jumped up on me.

For my mother, this was fate. Since she believed in the soothsayer, this was fated to happen.

She had no idea what I had done. I tried to tell them what I was now doing, and it was like going in one ear and out the other. I tried to explain as best I could, but neither of them asked me much about it, because the ideas of acting and motion pictures were so foreign to them. I was back and I was their son, and my mother hung on to me like I was a little boy and wouldn't let me go. I had to sit down with her hanging on to me.

My father said, "Leave the boy alone. Why don't you go and make him some food."

My mother reluctantly let me go, but if she could have hung on to me over to the stove, that would have been fine with her.

I continued to tell them about my experiences, and finally my mother said, "I asked God to tell me if you were dead. I prayed to God every night for him to tell me." Although it must have appeared so, the idea that I had died was something she could not accept in her

own thinking. She never got an answer until I showed up, and that was her answer.

When she told me this, I knew what she had endured for eight years. She couldn't embrace the possibility of my not being alive, so she goes to her faith. And she appeals to God—whether it is a Catholic God or the spiritual God of her ancestors. She had to have it certified by God Himself and the faith that she held—and it was not. So when she saw me and leaped across the floor onto me like a football player coming at me, it was her saying, "I knew it!" She touched my head and my body all over, and she was having this experience of her faith being rewarded.

I see fate in that, because I see her in her faith. I don't think she ever said, "OK, it's been so long, and he's probably not alive." So she goes to God with her faith and her interconnectedness in whatever it is, and says, "You tell me."

That's who she was, and that is the faith that she had, the faith that the Book of Hebrews calls "the substance of things hoped for, and the evidence of things not seen."

My father was along for the ride. He wasn't coming from where my mom was coming from, but he was equally delighted with my being alive.

Am I the kid that my mother was told I would be? I've tried my best to be that kind of kid, even though I fought against it when I was a bad kid some of the time. But mostly I was a good kid. My mother saw a life for me that she put her faith in. She cracked rocks to feed me. She worked side by side with my dad in the worst kind of conditions in the tomato fields to feed me. They couldn't give me much of an education because they didn't have one themselves. But my mother did everything else for me, and she did it because she had placed her faith somewhere. I buy that, because I know it was really true for her.

For me, there is a difference between faith for her and faith for me. My faith is in other arenas—but my mother may have had the better of the deal. But the evolution of my faith didn't come from my mother's experiences; they were hers, not mine. I had just my understanding of her, the love of her, and the "motherness" of her nature. All of which made a connection between us that was substantive. Through that substance, I have had inklings about God.

For me, there was and still is more to know about God. There are millions upon millions of people— maybe billions of people—who believe God exists. There are other large numbers of people who are uncertain: agnostics. And there are those who have no

faith: atheists. So you have three kinds of responses: the atheists saying, "No, there is no God"; the believers declaring, "Yes, there is a God, definitely"; and the agnostics saying, "Well, I don't know; I just don't know."

As I write this letter in this winter of 2007, close to your second birthday, Ayele, hardly a day passes without something in the mainstream media catching our eye about the importance of faith. Or something that challenges faith by suggesting that there is no God. And right next door to that attitude are any number of people who have had an experience that says, definitely, there is a God.

Therefore, I have to trust myself to do the evaluation for myself. I didn't get much from the Catholic Church, Anglican or Roman. From the day I landed in Florida from Nassau, I didn't go to churches as a matter of faith. I did go to one to get married, a Catholic church, but I never went there as a parishioner.

I certainly had been in churches—for marriages, celebrations, theatrical functions, and off-Broadway activities that took place in rented church basements. But for spiritual communion, I have never needed an institutional setting to search for the connections that my mother had to her higher power.

So what is my faith? My faith is that of a person who questions. And my questions today, at eighty

years of age, haven't changed much in all those years. Among them is this one: am I to believe, am I to accept, am I to embrace the articulation of a faith from other human beings who have no more understanding of it than I have?

The question of God, the existence or nonexistence, is a perennial question, because we don't know. Is the universe the result of God, or was the universe always there? Was there originally an intelligence that has no beginning and no end, an intelligence that cannot be articulated in a fashion in which most of us perceive God?

A lot of people see Him as the image of a human being: white, on a cloud, with a beard, long hair, and a robe. I think it diminishes God for us to perceive Him in that way, because there is no way there could be a God on a cloud with long hair, a beard, and Caucasian. Could He not be a multicolored God? Could He not be an Asian or African or Hispanic God? Of course He could be.

I perceive God, in the event that He is there—and I have to constantly underscore the possibility that God does exist—as not in the form in which we have been encouraged to believe He exists. There are many people who are very satisfied with God on a cloud; they are satisfied with the imagery that Christianity, Buddhism, Hinduism, and Islam present. People by the billions are comfortable with those images. And they commit

themselves to that perception. They live their lives embracing it—in most cases, never doubting it.

I find it difficult to believe some of the images of God. The closest I can come is a belief that there is an intelligence that does not manifest itself in a solid material or in a presence; it is much bigger than the universe itself, because if God is as omniscient as He is supposed to be, the universe itself is one of His creations. And if the universe is one of His creations, we are entitled to ask the question, How many more universes are there, or is this the one and only universe? We should be able to ask God, as I perceive Him or Her to be, and get total intelligence of everything. And God would be able to say, "Yes, this is one of my creations, and I do indeed have them everywhere, and I'm glad you are interested in questioning about that."

So we come down to how I perceive this God, and my relationship to that perception. I think it is rather simple: I cannot have lived the life I have lived without reserving a limitless amount of respect for God. And my next point is that the images of God should also be limitless because my imagination tells me that God is bigger than one religion.

I don't see a God who is concerned with the daily operation of the universe. In fact, the universe may be no more than a grain of sand compared with all the

other universes. And if you put together the possibility of other universes, there could be as many as there are grains of sand in this universe.

Now, that may seem far-fetched, but it is not if you give God the due that He, I believe, would have, which is: there couldn't be a territory over which God does not have full sway. Then, if God does have full sway in everything that exists, that God is all encompassing. And that all-encompassing God is not just for some of us; that God is for all of us. It is not a God for one culture, or one religion, or one planet.

Granted, the most scholarly among us are likely to have a far deeper understanding of various religions, faiths, and how their churches came about. Both history and science have, indeed, unearthed extensive and compelling evidence surrounding the birth and subsequent development of many major religions. And, in the wake of untold passages of time, clues were left pointing toward questions not yet posed, waiting to be found and challenged by philosophers, sages, theologians, historians, and scientists in their endless search for ultimate wisdom. But, however far back one traces a faith, it is to that precise degree that one further distances oneself from the wisdom one seeks.

Skepticism is healthy, Ayele, I assure you. We're better off, I believe, by refusing to certify the legiti-

macy of everything we hear or read. For somewhere in the back of my mind is that old explanation that if you whisper a sentence in the ear of one person around a table of many—a short sentence such as "John slept close to a woman with whom he worked"—as those words go around the table, whispered to each person next to another, it might come out, less than a minute later, that John was a sleep-arounder, and he did it with every woman he knew; which meant he probably was gay, because he needed to give the impression of being a raging heterosexual.

Now, if that could happen in one minute, think of the long history of most faiths, which began before writing—in some cases, before language. We know from experience that some of what are spoken of as the specifics of how certain world religions came about couldn't possibly have happened in the literal manner in which they are described. Nothing recorded, nothing written down, no eye-witnesses—only the possibility that one day the combined vision of modern science, which by definition is a relatively recent phenomenon, might bring answers.

So it may very well be a good thing that we are left with the prerogative to say, "I don't have any proof," when in fact we don't have any proof yet.

I know that feelings are not proof. Nevertheless, I *have* a *feeling* that there was a specific reason why the universe came into being. Others have feelings that tell them there never was a time when the universe did not exist. "When?" "How?" "Why?" "If"—each has been explored ad infinitum, through scientific research, astronomy, and astrophysics, and by all those who study rocks, bones, buried temples, and other ancient artifacts. Still, we cannot come to the absolute answer that it was always here.

But on the other side of the coin, there are those of us who feel that it was created. Now, how was it created? Was it by some force that had intelligence and said, "OK, this is going to be created; this is what I'm going to do," and the force did it, and the universe began to grow from there?

Or, was it accidental? Well, if it was totally accidental, then let's go back to the universe that was always there. If it was always there, then you're talking about the universe as God and all that God was and is. In which case, the universe would be a part of God. Or, God created the universe. (Carl Sagan has said, "To make an apple pie from scratch, you must first invent the universe.")

As you go back, according to science, the creation of the universe happened at a point when nothing existed in terms of matter, other than something they

call a singularity, and it was of a size less than a grain of sand. The naked eye would have had to be ever so sharp to make it out. And it exploded (this is the theory of learned people, Ayele) into the universe. And it took a given amount of time, because the ball of fire in the explosion was so humongous that it is still widening, still expanding: that became the universe.

Now, was there a God who triggered it, who created it and made sure it was there and detonated it into an explosion? Yes, there could have been, and everyone has to presuppose that there could have been.

However, a counterargument is also held by many people. That argument is: no, there was nothing there except that less than a grain of sand, and it exploded. Why, then, did it explode? you have to ask. I really don't know, but I am not buying into anything until I can feel, in my own value system, how it was triggered.

As a result, I come down on the side of there being a power that existed, and probably always existed, before the universe was triggered, however it was triggered, and it was that power that activated it. Now, as for that power source, we have no idea as to its components. Was it ever material, or was it always intangible and there was no material matter anywhere in the universe with the exception of the "grain of sand," if indeed that is what it was?

Well, if that's the case, I edge a little closer to it as a possibility, because the universe is a quintessential example of that kind of intelligence, that kind of power—one so powerful that it cannot be described, that you cannot confine it to anything material. It has to be intangible, unembraceable—you can't get your arms around it, or your mind—and you have to take it on faith.

Millions finalize their understanding by taking it on faith. Thereafter, they cease their inquiry; they give up the search for an answer: that is the answer, that it's so big, so large, so all encompassing that it can be embraced only if you accept it on faith.

There are those, on the other end of the spectrum, whose faith has been lost or broken. They challenge the image of God as an all-knowing, ever-present watchful eye over the affairs of humans. They ask such questions as—where was God on the morning of September 11, 2001? They ask where was God during the two centuries that blacks were held as slaves in America, and during the holocaust in World War II? And where, they ask, was God when saint and sinner alike drowned in the New Orleans floodwaters of Hurricane Katrina?

So if, they say, you insist on giving God credit for the creation of the universe, then God should also be held accountable when horrors beset us.

Some go in another direction, expressing themselves as atheist, or "non-theist," declaring nature as separated entirely from the idea of God. And in looking at the beauty of the universe, they find it possible that nature alone is responsible for the creation of humans, with their capacity for love, compassion, logic and reason. And using that logic and reason, they also question the Christian accounts of both the birth and death of Jesus and the miracles implied within.

Well, that's okay with me. I defend the right of everybody to believe as they wish. I honor their reverence however they express it and I share a reverence of my own kind.

Dear Aycle, as you will learn in due time, there are many religions, many sects, many images of God. There are Christians, Jews, Buddhists, Muslims, Baha'is, Hinduists, Confucianists, you name it. Each culture has its images, while I have mine—which differs, in some measure, from images held by others. My image of God permits me to question it—and myself. Why else would we have been given a curiosity, an imagination, a network of instincts and perceptive capabilities? I believe these gifts were and are survival tools, without which we could not have survived as a species. Gifts given to us, I believe, by the image of the God that I embrace.

That brings me again to my own position, which is: I believe there is an intelligence and it is limitless. It is alive, it is conscious, and this is just a part of what it is. I don't think it's interested in partialities. I don't believe it is interested in one religion over another religion held by two different cultures.

But I feel this about my life: I feel that I am constantly in the presence of God. By that I mean, I am constantly going about my life conscious that the universe is aware of me, and I am aware of it. I go about my life feeling that the all-encompassing God has a personal relationship with me, and I with It. I have to then accept, or rather insist on embracing, the God that I think looks after me. I couldn't have survived as I have under my own direction, my determinations, or my own choices. I made all of my choices, and I stand by them all, even the ones that turned out, in one fashion or another, to have been incorrect, to have been unworthy of the me that I perceive myself to be. I don't lay it all to the fact that I believe myself to be imperfect and finite, which I am. And it is our mistakes or fears or prejudices—our imperfections—that damage some of the people we care about, that damage our environment.

So I come back to the belief that I am not here without Its concurrence. I may not want to believe that,

but I do not know which of Its designs require me to function in a certain way, not independently as an entity, as I may think, but as a part of other things, as part of another kind of objective. I am interrelated as a coming together of all kinds of energies. And these energies come together in order to produce a result that is necessary for the functioning of the universe.

There is more to say about the questions, answers, and mysteries related to God and the nature of the universe as I have contemplated them in my time. But before I arrive at those reflections, I want to return for a moment to the reunion with my mom and dad in Nassau, when that entity that delivered me safely back for a visit allowed me to put an envelope into my parents' hands that contained the fruit of my labors from the first movie that I ever made. That had been the one thing holding me back, as I mentioned earlier, and now I was finally able to uphold the tradition that, as sons of the Caribbean, we are raised to go off, do well, and not forget where we came from. Again, because of my struggles up to that era, this had been the first opportunity to do the right thing, other than trying to get my army allotment sent back to my parents.

Do you know, Ayele, I think that for your great-great-grandfather Reggie, his happiness was less about

the money in the envelope—which was substantial enough to start the building of the home that would one day be the culmination of a dream for me to give my parents a house with electricity, indoor plumbing, and an expansive porch upon which to rest in their later years—or whatever else I was able to provide for my family in years to come; rather, it was more about the unlimited prospects of the life on which I was embarking—a life beyond measure, without barriers to where I could go and who I could become. For him, my return marked the fulfillment of his dream to have one of his kids go to college, even if it was a different kind of college that I was entering.

There was nothing more that I could have asked that night than to see my mother's eyes shining with joy and the look of my dad's pride. And as we sat there late into the early hours of the morning, me trying to describe everything that I'd experienced, no one said it per se, but I know that deep down in the center of that joyous occasion we were all thinking the same thing: there *is* a God.

The Channel Between Want and Need

While I realize that what you can learn from me may not be easily applicable to your life when the time comes for you, Ayele, to navigate the challenges of your adolescence and make your way through the locks of the many decisions you face entering adulthood, I thought that I'd give you a bird's-eye view of some of the adventures and misadventures that befell me in those eight years I was first away from home.

Many of the toughest passages were those where I struggled in the channel between "want" and "need." My account may provide you with some understanding of the challenges of money, and the need for caution.

I didn't know what money was when I was a kid on Cat Island. In Nassau, want became much more acute as a sense of my family's poverty began to dawn on me. What I wanted most in those days was to go to the movies, which led to my first economic venture, one that I undertook with Yorrick Rolle—my friend who later had the misfortune of being sent to reform school. A tall kid for his age, with an easy smile and willing demeanor, Yorrick seldom had the sixpence—about a dime in American currency—that movie tickets cost. Nor did I. Together we devised a way to earn the money in an entrepreneurial fashion by buying raw peanuts, roasting them, and selling them outside the theater to get a penny here or a penny there. But often there weren't enough pennies.

This was the era when I had to stop school at age twelve and a half to go to work. It was a full day on a construction job. The few bucks I made went for the family to pay rent and buy food and stuff like that. You have to remember that my mother beat rocks into pebbles over months to earn what was the equivalent of two or three dollars for that much work.

The scramble had begun, and in the years since, at various stages of life, I've had similar and other problems with money.

When I got to Florida, I had to try to get a job as quickly as I could to help my brother, who was taking me in because my father wanted to save me from the dangerous life that could have been my fate in Nassau. But the reality that I learned was that since my brother already had seven or eight children of his own by then, it was a burden for him to have me under his roof. Yet he did it for our father. At fifteen, I understood that I needed to go to work to bring in some money to help my brother take care of me. Soon enough, I discovered that for all the perils that had threatened me back in Nassau, Miami had its own set of dangers for me, and before long I needed and wanted to leave—to get as far away from Florida as I could. With very little money in my pocket, I headed north, making it as far as the hills of Georgia, and from there, once I'd found work to put a few more dollars in my pocket for bus fare, not knowing even a single person among the 7 million people in New York City, I continued my trek, alone. At sixteen years of age.

I arrived in New York by bus in the early afternoon, totally on my own, with approximately fifteen dollars to my name. I came without much understanding of how the game of life was played, especially the economic part, on which so much of the rest of the

game is based. It would take me years to learn that the influence of economics was to be found lurking under, over, in, or around almost all the activities that make up the game, and would have a major bearing on how I fared. In my early days in America, I could have perished from that ignorance.

When I got off the bus in New York on that late summer day in 1943, I headed for Harlem. I needed to go to Harlem, because that's the place I had always heard about. But I couldn't afford a hotel in Harlem, so I came back to the bus station, put my little bag of clothing in one of the lockers, and then went exploring.

Not many blocks from the bus station, I spotted a sign in the window of a place at Forty-ninth Street and Broadway, a place called the Turf Club and Bar. The sign said Dishwasher Wanted. As I walked in, the guy behind the bar asked gruffly, "Can I help you?"

I say, "Yes, the sign says Dishwasher Wanted."

He says, "OK, come on in."

With that, I went behind the bar and he pulled up a trapdoor. I walked down some steps, and the kitchen was there. They hired me, and I spent that very evening washing dishes. And they kept me there on a day-to-day basis for many days, paying me four dollars and change a night. It seemed to me a very good sign that I'd found a job my first day in the big city!

But then came the first night in New York, when I sat in a pay toilet in the bus station at Fiftieth Street and Eighth Avenue and slept. To enter that tiny stall, I had to have a nickel, and at least I had that. Now I knew what it meant to be on my own in New York.

Unfortunately, I wasn't successful in maneuvering myself through the pending economic storm, and I wound up sleeping in more bus and railroad stations and other places like that. But I had to survive in New York. I was working, but how was I to manage the three, four, or occasionally five dollars I would get for a night's work? I didn't have a place to stay, and I couldn't manage those bucks across that divide.

So I started sleeping on the rooftop of one of the buildings in New York. Sleeping on the rooftop allowed me to accumulate a few bucks. Then I went to Harlem, and I prowled around looking for a place to stay. Eventually, I managed to get a room in someone's apartment. It was a tiny room with a bed and a little set of dresser drawers. That was it. And it was five dollars a week. Nevertheless, I was still in the treacherous economic waters into which I had unexpectedly fallen. I had tumbled head over heels into what seemed at the time to be a narrow channel whose depth I couldn't gauge. Nor was I able to estimate the swiftness of the current that was suddenly thrashing me

about. I knew for sure only that the channel, with its churning waters surging constantly onward like a river out of control, was not altogether a stranger to me.

There was always such a channel between "want" and "need." Even while I was working as a dishwasher and receiving a modest pay envelope every week, I was still unable to reconcile the uncontrollable passions of "want" and the unmovable insistence of "need" as they battled relentlessly over possession of my meager resources, with "want" winning out over "need" far more frequently than it should have. The "need" to set aside sufficient money to rent a proper room that I could call home would be overwhelmed by the ever increasing demands of "want." With hindsight, the results that followed would have been readily predictable.

Then winter came with a force that was devastating, and I was crippled: I'd never been in weather that cold. My feeble defense was to wear all my clothes at once—but they were the little fad styles of summer: shirts of summer, trousers of summer. I had a light jacket, but that was it—no topcoat—and I was freezing. As a matter of fact, the only warmth I ever experienced was when I was dishwashing in some kitchen, or in the little five-dollar room I was renting.

There was a self-defining moment that struck me in that period as I was standing on the platform of the

elevated train at 125th Street one day in extremely cold weather, waiting for a downtown train. Chilled to the bone, I said to myself, *Lord, one of these days—one of these days—I'm going to be able to stay in bed as long as I want to. I'm not going to have to get out of bed. I don't care what I've got to do, I'm going to make out in this world.*

While waiting for that train, I stood on that platform dressed in my insufficient clothing, freezing my behind off, not to mention my toes, my ears, my lips, my nose, and my fingers. *Everything* was frozen. And by the time I got on that train and defrosted a little, it was time to get off and go out into the cold again.

That's when I decided, weeks before my seventeenth birthday, to hike my age up and join the army—because I knew that if they accepted me, I'd have a roof over my head and I would get three meals every day. I felt that would give me time enough to regroup and manage myself through New York's swirling money waters, and to be able to send assistance to my parents as well. I stayed in the army one year and eleven days, and then I was back in Harlem—where I fell into the same situation as before.

I would get a job, but only as a dishwasher, and it seemed impossible to climb out of the economic paucity bin. I lost many places where I was living because

I couldn't pay the rent. Again, I found myself sleeping in large public places like railroad stations, fending off discouragement and doubt, and admitting that life was difficult.

And then by accident, as I shall relate in more detail to you later on, I went to the American Negro Theatre, got thrown out, and decided to show them I could be what they just automatically thought I had no chance of being. I didn't know that I could; it was a decision on my part based on no facts. And there was no real economic consideration.

When my persistence to get a foothold at the American Negro Theatre landed me an understudy role, by a stroke of good luck I was able to go on during a run-through attended by a director who, even luckier for me, was instrumental in my being cast in a production of *Lysistrata*, a Greek drama, on Broadway. As exciting as this was, money was still an in-and-out situation. On my opening night, I made the mistake of peeking out at the audience from the wings and was overcome by such paralytic stage fright that I completely botched my lines—causing the other actors to scramble for other lines. Delighted by our unintentional antics, the audience settled in for a night of high comedy. The production closed soon after that, with generally disastrous reviews, but the write-ups for me were generous—some

calling me a comedic talent to watch! Better still, on one of the last nights of the show, a Broadway producer named John Wildberg came backstage afterward and asked me to come in for a meeting—which resulted in my being cast in a production of *Anna Lucasta* that he was sending on the road.

Off I went, understudying two parts in the play, at a salary of seventy-five dollars a week. I could have died and gone to heaven, thinking all the while—*Oh, man, my Lord have mercy, seventy-five dollars a week! Whoa!*

So I traveled to Chicago, Philadelphia, Baltimore, Connecticut, Chicago, St. Louis, and Wisconsin, and though it was a marvelous learning experience as an actor, I also learned that even seventy-five dollars went only so far. You saved what you could, which wasn't a lot, because you were paying your own keep while you were doing this stuff. They only gave you a ticket to get on the train to go to the next place.

At the end of it, and in later intervals, I typically had to go back to dishwashing or similar jobs just to make ends meet. So my struggle economically to stay within the bounds of my ability to take care of myself was very exacting. I would often fall into "the channel," where the movement of the tide was so swift I could never get my bearings. It was the fierce economic struggle to steady yourself between the forces

of want and need—you want, and you need. There is a place between the two where you have to act with all your might, struggling to maintain your footing at the very center of them. If you are off a bit, here or there, you're gone. You won't be able to pay your rent. You won't be able to buy food. You won't have subway fare to go looking for jobs.

I knew there was need, and I knew there was want, and I knew that my money couldn't stretch across that chasm. "Want" beat out "need" almost all the time, and I would find myself in trouble: I want to have a malted milk; I want to spend thirty-five to seventy-five cents to go to a movie. The verdict? I would spend that money to go to a movie, or I would buy something that I could have done without.

There I was, flailing in the channel, and before I knew it, I had lost my bearings. I had no place to stay, and I had a kind of on–and-off situation with dish-washing jobs in various parts of New York. Sometimes I got them, sometimes I didn't.

The treacherous economic waters between "want" and "need" would continue to beat up on me for years to come. Finally I came to know much more than I did, but not nearly as much as I ought to have known. Still, looking back, after all is said and done, I was lucky.

Even after I made my first movie and had gone home victoriously to see my parents, I had difficulties: back and forth, back and forth. Before I knew it, I was married and the kids started coming. It was then that I had to decide that under no circumstances would I be in that channel again where the waters were so fierce that I couldn't hold myself steady. Whatever forces there were, I would fight them with whatever economic resources I had, and I'd never, ever, again allow myself to be washed away by those forces.

In your day, Ayele, the temptations of "want" will likely be many. Television, newspapers, the Internet, and whatever miraculous new instruments of communication exist will inundate you with stimulating delights; and credit-card companies, if they do as today, will stand subserviently by, ready for your every wish to be their command.

So, if you allow, I would recommend you learn the rules and the economics by which the game is played and, thereby, enter with as strong a hand as you can manage. If luck is late in coming, a firm grip on the rules and a sharp eye on the economics will help you keep your balance while self-reliance holds you on course. The game is tough, and you can play it only once in a given lifetime. You are the captain; you must

be at the wheel. You will chart the course; you will make the choices.

Over much of your upcoming years, money will command your attention. Allow it a proper place in your life, but deny it a throne. Money means many things, but nothing so much as a yardstick by which your measure will be taken—unfairly or not. The need of it, the use of it, the power of it, the love of it will be used by others to define who you are and who you are not. Even you yourself may use it to determine how you should perceive yourself. Be careful: money is also known to be a relentless master.

If I have learned anything from this balancing act, it is the importance of defining your worth in your own terms. That will be a subject to discuss in my next letter.

Taking a Stand

Throughout the years of traveling into adulthood, as you may have seen already in my stories so far, I rarely took the path of least resistance. Most of the time, in fact, I walked a proverbial razor-sharp edge. Time and again, had I fallen to one side, it would have spelled my doom; time and again, I stepped back and landed on the side of fortune and opportunity. How? Why? That's the bigger question for all of us whose lives might have gone either way.

When I look at everything that happened after I left home at age fifteen as a kind of proving ground that opened the floodgates eventually to a life that only a

soothsayer and my mother could have believed in, a question that nags away is—why me?

Did I become the protagonist of an extraordinary lifetime by my own engineering? Or, as I've questioned before, was it predetermined by external, intangible, conscious forces that quietly pushed, guided, and delivered me onto a path of destiny's making?

Why me? Why did I become an actor—me, a kid who at the age of ten and a half didn't know that there were such things as actors. As to the thought of becoming one, nothing could have been further from my mind, even after becoming fascinated with movies as a teenager. For that matter, why did I become a producer, a director, or an author? Me, a kid who had practically no education; a kid whose vocabulary was exceedingly limited when he quit school at age twelve and a half; a kid who was well into his twenties before he even read a book; a kid who couldn't spell (and who is still not terrific at it) and had no concept of the rules of grammar or the demarcations so widely known as essential elements in speaking, reading, writing?

I am as unlikely a candidate as anyone for what became my multiple callings. The voyage that I took could have been taken, and it has been in many other cases, by any number of other people, born at another time, raised in another set of family circumstances, out of one

ethnicity or another, one race or another, one religion or another, one set of societal circumstances or another.

So, the question of "Why me?" remains a challenging one. But it's important for me to ask it and to answer honestly, so as not to mythologize my life or myself, but to stay grounded in the truth. In my way, I can best answer it by looking at many of those trial-and-error passages of young adulthood and by seeing the combination of forces at work: the component elements of this activity, this movement, this journey, this happening. If you do that, you have to begin to think: what are those forces?

There is God, possibly. There is happenstance, possibly. There is a sort of individual sense of self that might be a part of it, a small part, in my behalf.

There may be more than a small amount of good, sound choices that I have made, but they have to be put in the category of chance, because I didn't know that much about the world. My MO was to make immediate, small incremental choices that were going to get me, almost from moment to moment, almost from hour to hour, almost from day to day, the necessities of life. No grand design there, other than a reliance on instincts, and, from time to time, on decisions made to stand my ground—and to live out the consequences no matter what.

For example, when I arrived in America, I had to make my adjustment, first of all, to the kind of segregation that existed in Miami, the kind of life available to black people. What prepared someone for the dismissal of a black person because of the color of their skin, and the inbred attitudes of slavery that held sway throughout the United States at that time? Ill-equipped with education for trying to drive my way through all that, I had only the value system of my parents.

So I arrived in America with nowhere to turn except to those values that life had implanted in me. That was the only ground that I could stand on. Much of that terra firma had to do with who my mother was, and who my dad was. Because of those values, I was not long for the stay in Miami and left town at my earliest convenience to travel north, as I have described to you already, on my way to New York City.

What I'd like to add to that picture for you are more detailed accounts of two pivotal events that helped cause an early change in my fortunes.

The first, most significant turning point came one morning when I happened to stop at a newsstand at the intersection of 125th Street and Seventh Avenue, where I picked up a local newspaper, the *Amsterdam News*, and thumbed through it to the want-ad pages, looking for a job as a dishwasher. With my couple of years of

schooling, I couldn't read much in the paper other than the help-wanted listings. Not seeing anything of interest, I turned to toss the paper into the trash. But just as I was about to crumple it up and pitch it into the trash can, I looked again at the paper and my eyes caught something on the opposite page from the one with the dishwasher listings, which happened to be the theatrical listings. It was a headline streamer that said, in bold type: "Actors Wanted."

Knowing nothing about actors, I was still curious enough to look more closely at the article underneath the heading, which told me of a production being cast at a place called the American Negro Theatre in Harlem—not many blocks from where I was standing! The proximity was a major enticement.

After all, ordinarily when looking for work I would get on the subway early and go all the way downtown to stop in at the scores of employment agencies where I would invariably find a dishwashing job somewhere in the distant reaches of mid- to lower Manhattan. But this was a different kind of help-wanted ad, and the theater was close enough to home that I figured, *Why not? Why not go to this place, this address, and see what kind of a job it is and what I will have to do?*

With that one tiny flash of nothing more than curiosity, I unwittingly altered the direction of my life.

Right there on the sidewalk of Harlem, standing over a trash can, a newspaper page in hand, puzzling over two words: "Actors Wanted."

How exactly, you may wonder, did it go at the audition—a word that was then as foreign as the fascinating sights, smells, and flamboyant personalities of the people who inhabited this strange behind-the-scenes world of the theater? Ayele, let me tell you, it could not have been worse! The first clue that it wasn't going to be easy was when the director had me read for him from a book. Needless to say, reading silently to myself was still a struggle, but reading aloud was painful for both of us. Before I got very far at all, he said abruptly, "Thank you very much for coming by," and he snatched the book out of my hand.

An extremely large, truly massive fellow, he didn't stop there but actually spun me around, grabbed me by the seat of my pants, and marched me to the door, letting me have it every step of the way. "Go on, get out of here," he bellowed. "Get out of here and stop wasting people's time. Why don't you go out and get yourself a job as a dishwasher or something? You can't read, you can't talk, you're no actor!" And with that he opened the door, pushed me through it, and threw me out. He threw me out! Not quite finished, without skipping a beat, he slammed the door shut.

There was no mistaking the message he had meant to send me, to be sure. But as I was walking to Seventh Avenue from Lenox Avenue and 135th Street to get the bus to go downtown to hunt for a dishwasher job, I got to thinking, and it suddenly occurred to me—Why did he recommend my going out and getting a job as a dishwasher? Not once during the audition did I tell him that I was a dishwasher, so why did he say it? And what became clear to me was that dishwashing was his view of my value as a human being.

In that moment, I made the choice that I could not and would not allow that to stand. Now, what was I operating on? I was operating on what I learned from my mom, and what I learned from my dad—that I am somebody. I was always somebody. And here this guy who didn't know me from Adam had fashioned for me a life that I could not allow to happen if I had anything to do with it. I decided then and there, in that pivotal moment, to be an actor, if only to show this man *and* myself that I could.

As I've written before, up to that moment, I had no interest in being an actor. What did I know about acting? Get out of here. But I was determined to stand my ground and prove to him that his view of my worth was wrong.

A fateful event soon provided another pivotal moment. After completing another shift at yet another

dishwashing job, this one in Queens, I took a seat at a table near the kitchen to wait for a group of waiters to finish up their coffee so I could wash the last dishes before heading home. To pass the time, I started idly browsing through a newspaper that had been left lying there.

An older Jewish waiter, seated with his fellow waiters, noticed me, stood up, and came over. "What's new in the paper?" he asked.

"Oh," I said, somewhat awkwardly, and hesitated, not sure how to answer. "I wish that I could tell you," I offered, "but I don't know how to read very well."

"I see," said this gentleman. "Would you like me to read with you?" He was offering me a gift that would transform my life in ways that I couldn't imagine. And the gesture was one of basic kindness, made not so as to embarrass me or obligate me, but because that was who he was.

Of course, I answered yes, enthusiastically. And starting that night, and on many nights that followed, he sat with me after work for as long as we were able to remain, and he taught me to read—sounding out words, explaining syllables, pointing out the patterns of sentences and paragraphs, giving me pointers even on pronunciation.

Long before I could let him know in substantive ways how the power of literacy would change my life,

my friend and teacher procured a job waiting tables elsewhere, and we didn't keep in touch after he left. That remains a tragedy, as far as I'm concerned—one that has haunted me for years. My heartfelt regret is that I was never able to properly thank him and tell him the story of how, in part because of his help, I became an actor.

The willingness to receive help and appreciate its value when it arrives, sometimes unannounced, is a subject that returns us to the question of why and how our lives turn out as they do. Serendipity—like the newspaper's "Actors Wanted" listing and the question "What's new in the paper?" posed to me by a waiter at my place of work—is a vital accomplice to the other forces that shape us and our destiny. But the real answers to the why and how of journey's ends also come down to choices. I believe that I am sitting in this chair writing today in large part as a result of choices I have made—good ones, not-so-good ones, and bad or wrong ones.

Bad choices got me into a lot of trouble, sometimes got me hurt, sometimes got me rejected, sometimes destroyed opportunities that would come as the result of choices I made. But those are choices as well as the choices you make that you can later applaud yourself for having made.

All in all, I made a good number of sound choices before and during my acting career. It was my recognition of a need to read better and to speak better, driven by a rebuff for the lack of such skills, that put me on the road to becoming an actor. After that initial rejection by the director of a production at the American Negro Theatre, I returned and auditioned for acceptance into their training program—and was again rejected.

But being a kid who had grown up trying to figure out how to avoid being stung by wasps in order to reach fruit at the tops of the trees on Cat Island, I came up with a novel strategy that allowed me to override this second rejection. As it happened, I became aware that there was no janitor at the facility where classes were given, and I volunteered to take the job—in return for being allowed to study for a semester. To my delight, the arrangement was made, with the understanding that if I didn't show reasonable improvement by the end of the semester, the deal would be off and I wouldn't be invited to continue. But when the first semester ended and I missed the mark, I managed—with the help of some of my fellow students who lobbied on my behalf—to have the agreement amended so that I could continue on with my janitorial services in exchange for acting classes through a second semester. This time, when the semester drew

to a close and the teacher cast a student production without giving me even a walk-on part, my fellow students rallied on my behalf again. Together they went to the teacher and asked, on the basis of how hard I'd been working, if she couldn't see to it that I was given something to do in this play. When she granted their appeal by casting me as the understudy to the lead, she knew that the chances were one in a million that I would ever get to go on. And no one, least of all me, could have predicted how rapidly doors would begin to open after that—as I wrote to you previously.

Once they did, and later, after I achieved some success, I made the conscious choice to go beyond the basics and to reach deeper into the art of creating believable characters for an audience, and thereby maximize my talent and my opportunities.

On the flip side of the better choices that I've made, I will emphasize to you, dear Ayele, that I have made and continue to make choices that I regret. It is the nature of free will, with which each of us is endowed, that sometimes choices are very hard to make, and sometimes you are ashamed to make some that diminish you in your own eyes. But you cannot exorcise those choices out of the millions of choices you make in life. They are there, as if stamped into the passport of your existence. You can't escape it,

you don't like it, and you would like to change it, but it's there and it's OK.

And these observations and stories—such as they prove useful to others who ask "Why me?"—are as close as I can come, for now, to an answer.

Love Is a
Many-Splintered Thing

Love comes in many colors and stripes, and we encounter it throughout our lifetime, for good or ill. You, my darling Ayele, by the time you are sixteen, no doubt, will have discovered boys. You will have been aware of their existence much earlier, seeing them possibly as merely nuisances that girls have to put up with. But somewhere in your teens you will "discover" them as an intriguing (and perhaps infuriating) species. The question of love may even arise. The emotion will not be new to you, for you will have felt its outpouring from the members of your family, and you in turn will have experienced love for

them. But with boys, and later men, the aspect of love will be different.

As the father of six daughters and a veteran of many complicated relationships over the years, I come honestly to the following observations of love's many dimensions, and pass them now on to you, your peers, and those of other generations for whom the subject of love is never outdated or ahead of its time.

We all have a capacity for love, for kindness, for passion. We also have a capacity for the opposite, but love is infinitely more effective in the world than hate, although they exist as equal opposites. So I reject hate and choose to explore the nature of love, both emotionally and philosophically.

There is love of self, there is love of family, there is romantic love for another individual to whom we are not related, and there is love for a friend. Then there is love of things that are cultural in nature: music, art, and literature; love of animals; love of adventure.

The first and foremost of these is a mother's love for her child. It is all embracing, all forgiving—even though it may not seem so at those times when she is administering the discipline that is necessary for a child's growth and understanding. But it is a love of such fierce magnitude that any unwelcome intrusion is likely to meet with disaster. The powerful connect-

edness of mother and child is evident throughout the animal kingdom, where death is often the penalty for trespassing.

Although we talk of love as residing in the heart, it is actually a function of the brain. That fact, however, doesn't diminish what love is, and it doesn't change the fact that you feel it inside you. Emotionally, love is a conscious state driven from within.

If it is romantic love, it is no mere cliché to say that in its presence your heart seems to beat fast, and your whole body has a quivering over it. You see another human being—nowadays, we know that for some it's not necessarily of the opposite sex—and something about the visual impact of that individual triggers something inside us. And it might not necessarily be the triggering of love at first sight, but it is something in the configuration of the face, how the lips and the nose and the eyes form the forward aspects of the face. Then the smile complements all of that, and the sound of the voice contributes to the overall impact. And of course, the eyes, when they glitter and sparkle, sparkle like you would expect those eyes to sparkle. Bodily contours also often come into play.

All this, then, prompts in us an interest. Not necessarily love, although I'm sure falling in love at first sight is probably a valid description in some cases. But

when we see such a person, the longer we look at that face, the more we like it. We're not talking about love yet, but a kind of visual compatibility that affects you internally.

Given opportunity, you carry this to its logical conclusion. That is, you meet, have an intellectual exchange, and you find that the person is quite intelligent, has a nice sense of humor, and is very easy to engage. There is no sign of anything negative, and the conversation works out very nicely. So you have a date, if they're not married or attached to someone else, and if you can arrange one, because you're interested in knowing other things about them. And if, over lunch or dinner, or perhaps on an outing, the discovery lends itself to further exploring, you may permit yourself to be invited to the person's house. Afterward you go back home and say, "Wow, what a terrific person."

You get together with them a few more times, and before you know it, you are forced to say, "You know, I'm having a problem. I think I'm falling in love with you." And if the feeling is reciprocal, the other person says, "Oh my God, I thought I was the only one." And there you go.

That's one kind of love, where the emotional, physical, and psychological elements all come into play.

Then there is another kind of love—for human-kind or for concerns—that can be roused in a person enough to make a choice to leave home, father and mother, brothers and sisters, and go to work in Asia or Africa with agencies like Doctors Without Borders, as one example. This love is derived from the compassion that is in the person's being, either inherited from forefathers or seeming to have appeared on its own. Such people may join the Peace Corps and go into places like Darfur, often putting their lives on the line. During the civil rights movement, there were white kids who went down South and stayed for weeks and months, and some of them were killed because they believed in the brotherhood of mankind.

There is love of God and love for the values of one's faith, of course. In many people there is a strong love of country, and it motivates them even to go to war to defend their homeland. In many people there is similarly a love of and quest for peace that is motivated by a willingness to take a stand for its pursuit.

There are people who love children, who love family, and those who love other human beings, other living creatures, and nature itself. In my daily comings and goings, I hear of those in my community of Los Angeles who volunteer at animal shelters, who work

on violence prevention, who spend time downtown in some of the most marginalized neighborhoods helping fight homelessness—all with no reward for their actions other than self-satisfaction. There are many examples articulating that kind of love.

There are several philanthropists I know who not only have the ample means to give to important causes but genuinely love knowing that they can be instrumental in benefiting others. One of the women in our family's circle of friends who has made a history of being true to her charitable instincts is now focused on contributing funds to stem-cell research, which promises to produce findings that will help millions who are suffering around the world. Those motivations are likewise from love.

There are people who actually love the pop culture, and see themselves as part of it. They have idol representation: individuals in the pop culture, either in films or television or music, for whom they feel love. Then there is a love of self-improvement, which people indulge in to develop themselves to be better human beings. They simply love their efforts in that regard.

Oddly enough, there are also people who love turmoil. Their temperament is best articulated by chaos. In my years of forming a variety of personal and professional relationships, I encountered more than a few

of those, as you may well also in your explorations of the different facets of life.

The point here is that love is never elusive. In all its permutations, love surrounds us in the world, whether we are accepting of it or not. There are people who reject it; they become antisocial, reclusive. But I believe it is the nature of people to seek love—no matter what they later become—as babies right out of the womb. And it ultimately, to a great degree, shapes who we are in terms of how we develop as individuals and how our lives evolve. After all, it is by love that we are often joined to another individual. That joining, in a way, determines who we are as we develop.

Now comes the challenge. Since love is universally available, and also universally sought after, how do we—realizing that love is nevertheless still a minefield that we have to chart our way through—engage it successfully and safely, or if not successfully, at least with the least amount of damage?

It seems to me that we have to be accepting of the idea of love in order to find it and to have our lives shaped by it—even though we know the minefield is there. We have to be willing to take chances. We have to be willing to expose ourselves to some degree.

So far I've written to you of the dimensions of love in the abstract, hoping you'll be able to relate different

situations in your life to some of those points. Now I have some real-life stories to include in the discussion, as I was there once in learning that love, possibly the most glorious way that we can experience life, can be a many-splintered thing.

I was shy and couldn't get a date for the longest time. On Cat Island, my friend Fritz and I plotted daily about methods to attract attention from the opposite sex, even resorting to voodoo practices that involved catching frogs and burying them in boxes until the appropriate waxing of the moon, at which point their bones could be retrieved and combined with the hair of our love interest—with no luck whatsoever! There was one girl, lovely Lurlene, whose name and alluring face I could never forget, having once inspired a love letter from me, written in my boyish hand, and who I was certain would be susceptible to my charms and the voodoo magic that I'd practiced so diligently to attract her. But she turned out not to be interested. When I saw her years later as a grown woman and reminded her, she said, "Yeah, I remember that time." And she still didn't recall it all that fondly.

My progress with females wasn't much better after we moved to Nassau. There was one girl at school, when I was about eleven and a half, who was my dream girl. Her name was Vernice Cooper. Never

spoke to her. Just smiled a lot. Vernice would give me a little bit of a smile in return, or she would turn her head just before I caught her eye. But my handmade clothes, sewn by my mother from flour-sack cloth, were a signal that I was from the wrong side of the tracks, while Vernice was from a family that was substantial in every way: strong educational background, middle class. In fact, she wound up as an executive for a telephone company. And in our grown-up years, we wound up with a warm friendship that has flourished.

Then there was Emmy Gibbs, another girl at school, who was kind of rough-and-tumble and tomboyish, but very pretty. I liked her a lot as well, but that was the extent of it.

None of these fleeting attractions came close to the ardor inspired in me by the compelling and sweet Dorothy—with whom I could actually converse, albeit in my shy, unworldly way. Dorothy—who I was surprised to learn was the half-sister of my racist friend Carl, from the other side of the island—lived close to the ocean. Because I lived over the hill at quite a distance, in order to see her I either went the long walk on foot or rode on the front handlebars of my friend Harry's bike—whenever I could talk him into taking me. The effort notwithstanding, it was worth it just to see her and exchange even a few words.

But over the course of our shy courtship, I could never figure out how to move past friendship with Dorothy to a more serious romantic relationship. With so little experience and exposure to the opposite sex, how could I? Throughout these adolescent years, I never had any physical contact with any of these girls, or bought them so much as a piece of candy or a trinket; I didn't have any money to do that. Totally unaware of how lacking I was in sophistication and gracious behavior, not savvy at all in matters of the heart, I had never held the hand of or exchanged more than three or four words with any girl, except for Dorothy.

So by the time I left Nassau, it was with the intention of returning worthy of her affections and of marrying her one day. By the time I was in a position to do so, she had married someone else. And after he passed away and she was available, I had gone on to other relationships. Years later, I did stop in to say hello to her at the British Colonial Hotel in Nassau, where she was then working as a waitress. In a flash, I was fourteen years old again, amazed at how great she still looked, and at how easy it was to talk to her. But we both realized that the time had long ago come and gone for any possibility of getting together.

In the meantime, back when I first arrived in Florida, there were lots of pretty girls there. But my na-

tive shyness—as well as now having reached the age of fifteen without any dating experience—left me clueless. If there had been openings with any of the girls, I probably wouldn't have recognized them. Besides, I had no female friends, and hardly any male friends except my brother's children who were around my age. They were the ones who knew the girls, and I was just a young cousin who wasn't really up on anything in terms of how young people behaved and got along.

When I made it to New York, I was as virgin as they come, and by then I was sixteen years old. At long last, as I began to acclimate to city life, I ran into a couple of girls who took a bit of a notice. However, I didn't know how to follow through. Each of them invited me to meet their parents, and I did. The parents were fine with me because I seemed like a decent person. But nothing came of those two friendships.

It seemed almost as if I was waiting for lightning to hit me. One day, I felt as though it had when I spotted a particularly striking girl at the top of a set of steps, sitting beyond the balustrade of an apartment building on 116th Street between Seventh and Eighth avenues. She was dressed simply, with a simple manner, an open demeanor, dark brown complexion, bright eyes, and an aura of niceness. The impact was so powerful I can still remember at age eighty how it was as

I walked by and saw her sitting there and the somersaults I turned inside as she kind of smiled at me. Without hesitation, I kind of smiled right back. A few paces past her door, I mustered the courage to turn back and walk in her direction, while trying to drum up enough nerve to say, "Hi, how are you," but I actually walked right past her again! Finally, I turned back and shyly approached, seeing her shyly trying to say hello, too. Magic! As we talked, I couldn't help noticing that there was a movie theater across the street. It would have been so natural to invite her to the movies, but I didn't have any money to pay for tickets for the two of us. And soon enough the moment of opportunity passed me by and into the fog of memory.

Then, during a period when I went to work pushing and loading dress racks in the garment industry, I met Frances, a statuesque knockout with a spellbinding smile, skin color that matched my own, and an earthiness that made me comfortable. At last, I was able to make some headway and the two of us clicked, long enough for us to become a steady couple.

When she found out that I was trying to be an actor, Frances wasn't thrilled. "What a waste" was all she said, but the next time I went to call on her at her Harlem residence she seemed to have lost interest. In fact, as she opened the door and asked me to step into

the railroad apartment, instead of taking me into the kitchen near the front door where five or six people had congregated and were in a party mood, she led me down the hall all the way to the living room at the far end of the apartment.

"Make yourself comfortable," Frances said and then returned to her friends in the kitchen—leaving me by myself for the better part of an hour. Again, given my lack of experience, I didn't understand that instead of just breaking up with me, she was sending me the message indirectly. In any case, I eventually gathered the cool to walk down the hall and past the kitchen, where I excused myself and left. The bruise to my ego took me a week to shake off. But once I let it go, I was better prepared for the slings and arrows of love that followed.

Decades later I met someone who happened to be related to Frances, and I took Frances's phone number. When I called, we had a warm conversation, during which she touched me deeply by saying, those many years later, how much she regretted that last encounter. Even though it was unnecessary for her to say so, as it was very much water under the bridge, I so appreciated how it underscored that for most human beings, even when we briefly touch up against other lives, we leave our marks on each other.

So, after Frances, I kept working at being an actor and was starting to make some significant progress, and then I met Jackie, a beautiful girl, very smart, at a dance, and we saw each other a few times after that. Then she went to Long Island for a summer and I went to visit her there. When she came back, she invited me to meet her folks. After I learned they were West Indian, probably from Jamaica—and I knew that Jamaicans were a very fastidious people, hardworking and interested in education—I figured they wanted to look me over, so I accepted her invitation. Not only did they live in Striker's Row, an upscale Harlem neighborhood, but her father was a highly esteemed, prominent lawyer. Afterward, Jackie was as sweet as ever, but she implied that her family was old-fashioned in the West Indian way, and they were not particularly happy with anybody she met. Clearly, she was dropping me, though as nicely as she could.

For years after, I wondered what it was that got me so dismissed. Then I began to realize that besides the fact that I had no table manners whatsoever, I had tried to sell myself as something that I wasn't, pretending to be knowledgeable about topics of acceptable conversation when I didn't know beans about anything. Whenever they asked about my education, for example, I told the truth, but nevertheless tried to

infer that my education was more in-depth or significant than it really was. Eventually, I could almost hear what they were thinking—*Oh, this poor thing. He really doesn't know much, does he?*

Not long after that, just before I left to go to Africa to make my second picture, *Cry, the Beloved Country,* I fell madly in love with a woman in New York. We had decided that upon my return, once she spoke to her folks about it, we were going to get married. While I was away, we were talking twice a week by long-distance telephone calls, and about the fifth time I called, she dropped it on me: her folks were up in arms. They didn't want her to marry me, and they wanted her to finish school, where she was studying to be a psychiatric social worker.

"But what do you want?" I asked

"Well, my parents . . ." she began. And each time I asked what she felt, she picked up the same refrain: "My parents . . ."

And there I was in South Africa.

I came back and saw her, and realized there was no chance at reconciliation. After we parted ways, she followed the path that her parents had wanted for her. And they were right to feel that I didn't have the experience that qualified me to be the husband of a daughter they were sending to Barnard. They were

thinking of what was best for her. After we broke things off, they sent her to Jamaica with friends and relatives to look for a husband, and she soon found one. That marriage, however, lasted less than a year. Later, she married a friend of mine, with whom she had children, but the marriage was short-lived as well. And then she married a guy who was several years her senior. She is now eighty-one and in a convalescent home, where I went to visit her not so long ago—and found the same person, very bright and still very attractive for her age.

Though I wasn't always happy when girlfriends' parents disapproved of my background or my choice of career, I tried not to take it personally. Instead, I focused all the more on improving my standing with the work that I'd chosen. In much later years, from time to time I would run into an old flame or two, or their parents, like an ex-girlfriend's mom who regretted that her daughter hadn't married me. "Oh," she said, "if only I knew that you were going to turn out to be Sidney Poitier!"

Back during the ups and downs of becoming secure and successful in that pursuit, I received a memorable phone call from a friend, William Garfield Greaves, a gifted filmmaker of documentaries on African American culture. He said, "I have somebody I think you

ought to meet." He knew how many times I had been dumped, and he was a good friend looking out for me. He went on, "I've met this girl. Her name is Juanita Hardy. She's a model and a dancer, and an absolute show-stopper."

After he showed me photos, I was intrigued, and then I went to see her dance. He was right: she was quite attractive, and she was a show-stopper.

After such an inviting introduction, Juanita and I began dating. Given my lack of experience, I figured that I was ready for a serious relationship, and she seemed to be similarly disposed. After dating for quite a while, we began talking about marriage. Then came the daunting prospect of meeting her family—who turned out to be quite gracious. They asked me a few questions and came to the conclusion that I wasn't a bad guy.

We were married not too long after that, amid much celebration. Neither of us, however, was prepared for marriage, and neither of us had a way of knowing that. One may have seen successful marriages among family and friends, but there are so many independent energies intertwined in marital success that luck of the draw has to be a part of the whole equation. And we weren't lucky.

We were kids who didn't know what to look for in each other. We saw images that were more out of our

imagination. We superimposed over our togetherness a kind of potential that we didn't have, and we didn't have the wherewithal to analyze, pick apart, and see how much depth was really there. Once we had gained acceptance of each other, we got married. We had a strong imprint in our minds of what marriage ought to be, but we didn't know how to bring that about. And we were coming at each other from two different sets of circumstances.

I knew that my mother and father were as they were. I experienced their love for each other every day of my life with them. And Juanita had loving parents as well, as was demonstrated to me. But she was no more versed than I was as to the manner in which two people can begin to build something, realizing that each comes with what he or she is. You have to take those two forces, if there is a mutual compatibility, and make out of it whatever you can. You have to look dead center at what the possibilities are—not the daydreams, because that is all foreplay. You have to determine what the real possibilities are of understanding each other. You need to have exchanges through which you learn each other's positions on things—a relationship where the economics of it and the sense of responsibility for the nurturing of children can be determined.

Juanita and I came to marriage without having a sense of how the dynamics were made to work, even if they were operative in our individual families. We weren't ready—and few people are. Almost half the marriages in America end in divorce. Among those that do last, some do so unhappily, welded only by children or religion or economics. And where unions have lasted a lifetime, many couples look back with recognition of how little they knew in the beginning of those compatibilities that would later bond them so joyously and can only say, "How lucky we were."

There you have a candid understanding, as great-granddaughter to Juanita and to me, of the love and the challenges that were met in our marriage—which lasted eighteen years; and, to her joy and mine, resulted in four children, four beautiful, brilliant daughters, who were—and are—really terrific people.

There may be within you, Ayele, as there was once in me, the streak of the undying romantic who sees love only in its mythic perfection, and not for its thorny though still beautiful reality. Rather than protect you from the complexities, I would rather you know about them in advance, not for you to guard yourself from love when it comes, but perhaps to see its true intentions for you.

In any event, experiencing hurt, disappointment, and even a broken heart or two can still be worth the price of taking the chance to love.

Even if you are someone used to wearing armor, guarded and afraid, I think love is such a strong force it would find a way through your protective guard. It will get to your heart, and you can't put any fences around that. As much as you might try, you simply can't. You're going to have other forces that will be operative at the same time if it is right for you to fall in love with this activity or individual or cause or process.

There is no right or wrong in the general scheme of things when it comes to love, only what's right or wrong for you. Like all of life's great mysteries, we have to search for our own answers. What I now know, as a basic, is that love has many forms and shapes. It is an indispensable element in the bonding of all creatures. We fall in love because we have a capacity for it. This capacity may never find the object of it, the one who will make it whole. And the capacity within us can wither and die, depending upon external factors. Many times we sense a potential, or we engage in wishful thinking, assuming that it would be wonderful if one's capacity for love could be fulfilled by that which one believes to be in this or that personality, and something wonderful could come to fruition. And

that something wonderful happens every day. There are people who can just pick it up in another's eyes, or laughter, or the way the person walks or turns away when embarrassed. There are endless numbers of such moments that can spark an array of possibilities.

But though there is always a capacity, there is not always the destiny. Among other things, love might be damaging. Or maybe the hurt comes from the lack of love, or the absence of love, or your love being rejected—such that some people, greatly disappointed, turn bitter. Many have a great love for a very short time and never experience it again, and they live a full life in the number of years that they have left. They live with a wounded self, but they live. But the greater tragedy is that there are some who live full lives in terms of years and yet never experience the love of another human being.

You will probably discover for yourself, Ayele my darling, that love does not always last. There is a perishable quality to it, and if it is not nurtured and tended much like a garden, it may wither. But you will also discover, I pray, that though love is complicated, it nevertheless is an essential, endlessly abundant force in our lives.

What I can add to that, as well, is that sometimes, when you least expect it, when you're not even looking

to find the love of your life, every now and then love comes along and discovers you. In any case, about forty years ago, that's exactly what happened to me.

In those days of the late 1960s, I was riding a wave of a great deal of success as an actor. Earlier in the decade there had been such well-received films as *A Raisin in the Sun* and *A Patch of Blue,* along with *Lilies of the Field*—the movie for which I won an Academy Award. In 1967, I had the good fortune to become the year's top-grossing actor, thanks to three major hits, released that same year, that touched a deep nerve with the public: *In the Heat of the Night, To Sir with Love,* and *Guess Who's Coming to Dinner?*

Well, I mention some of those highlights to give you a sense of the atmosphere of those days, when my focus was very much on continuing to grow creatively and professionally, not on falling in love or starting a new relationship. So when I prepared to start shooting a picture called *The Lost Man,* nothing in my instincts led me to suspect that the love of my life was waiting in the wings. An extraordinarily beautiful Canadian model and actress then living in Paris, she had come to the director's attention after appearing on the cover of French *Vogue.* When she was first approached by Universal Pictures to do a screen test for the movie, her initial question was "Who else will be starring in

it?" And when she was told, "Sidney Poitier," her response was "Who's that?"

Yes, indeed, that was Joanna Shimkus, and though she had never heard of me, after some encouragement she did agree to do the screen test, and was cast in the role. It didn't take us long, once we started working on the movie together, to wonder if perhaps forces greater than ourselves had brought us together. By the end of production, we knew that we would indeed be together from then on.

And that was forty years ago.

This time, I was ready to live the love story that I had seen in my parents' marriage at the start of my life. Part of our compatibility is that we are so different. Where I'm a thinking guy, she has such a great heart; where I'm private, she has an outgoing nature that puts everyone around her at ease. With our differences, we have so much more to discuss—our kids, our interests, friends, family, life, new ideas; nothing is off-limits. A woman of boundless generosity and energy, remarkable creativity, and a dog lover, too, Joanna stopped her acting career to raise our children, and has also become extremely close to my four daughters from my first marriage.

Later, even though Joanna wasn't looking to embark on a new career, as the girls got into their teens,

my wife found that her natural gifts for interior design were responsible for opening up a new professional chapter for her. Before long, the ball began rolling so dramatically that today—you will be happy to hear, Ayele—your great-grandmother Jo has a partner, and the two are represented in several showrooms around the country.

So you see, the entrepreneurial spirit of the women in your family lends encouragement to the stance that there are no limits to how far you can go or to what you can do. As I think back on my mother and my sisters—of the women in the Caribbean and other cultures who don't have the freedom and the economic power, rights, and protections that we have in our time and our country—it makes me all the more happy and proud of the women in our family and their accomplishments as independent individuals, charting their own destinations in life.

Of course, Ayele, let me not forget to add that the formula for the kind of love story that I share with Joanna isn't something you can buy over the counter. Certainly, in our case we weren't looking to buy anything when the fates were so kind as to bring us together. But there is one key ingredient that my wife has helped me to recognize over the years, and that is the importance of articulating love for one another

*In 1963, receiving
the Academy Award
for Best Actor
for my role in*
Lilies of the Field

*With my family at the American Film Institute's "Salute to Sidney Poitier"
in 1992*

With my family and President and Mrs. Clinton at the White House for the Kennedy Center Honors in 1995

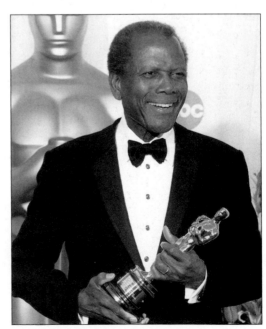

After being awarded an honorary Academy Award in 2002 for "extraordinary performances and unique presence on the screen, and for representing the motion picture industry with dignity, style, and intelligence throughout the world."

The loves of my life, Joanna and Juanita, together

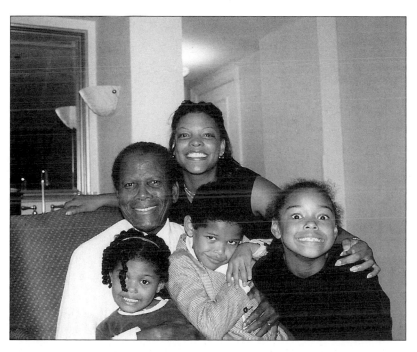

With grandson and granddaughters: Aisha above and Gabrielle, Etienne, and Guylaine below

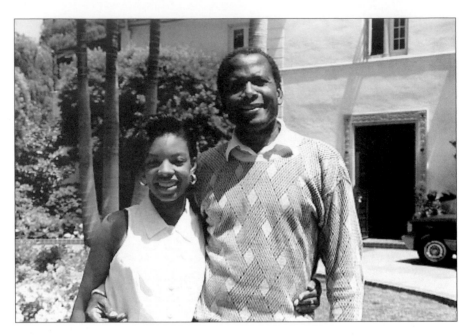

With my late granddaughter, Kamaria

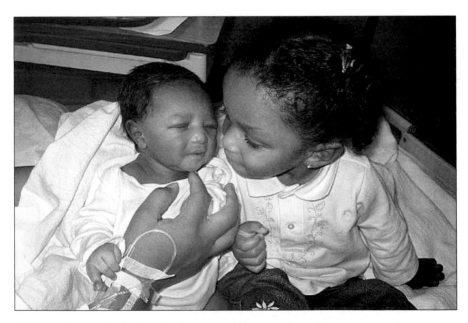

Ayele and our recently born Kai; my two great-granddaughters

Surprised at my eightieth birthday party

With Juanita, Beverly, Aisha, and Ayele at my eightieth birthday party

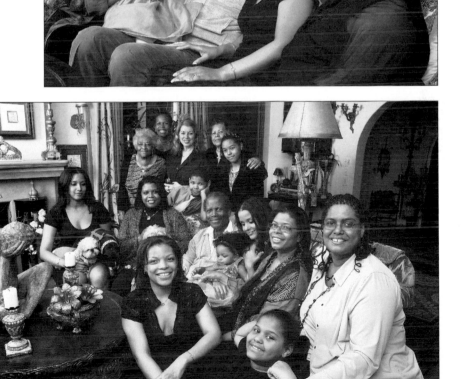

With the whole family at my eightieth birthday party

With James Baldwin at the 1963 March on Washington for Civil Rights

With Harry Belafonte at the Lincoln Memorial during the 1963 March on Washington for Civil Rights

With Thurgood Marshall, a man I greatly admired, whom I had the honor to portray in the 1991 movie Separate But Equal

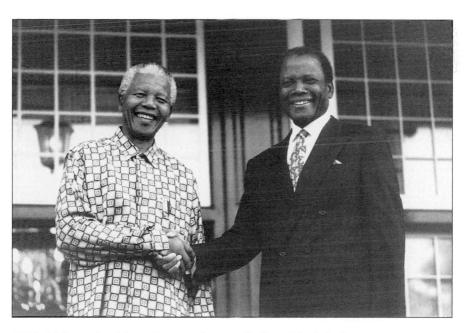

With Nelson Mandela, a "person of courage" whom I had the honor to portray in the 1997 movie Mandela and De Klerk

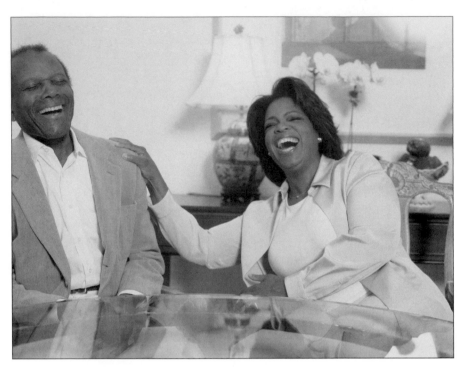

With my remarkable friend Oprah Winfrey

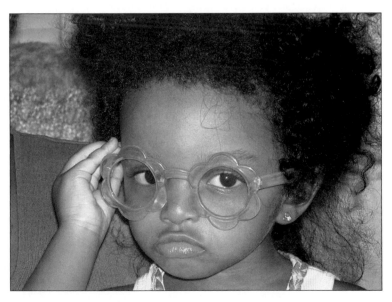

My great-granddaughter Ayele in her flower sunglasses

on a daily basis. The words *I love you*, spoken in acknowledgment in the morning upon rising and before going to bed, or when sitting down to dine, make the most beautiful music recognized by human ears. In every conversation with our daughters, never have I heard my wife not emphasize those three words or their message, no matter what the subject of the discussion is.

Simple though it may seem, when it comes to love, there isn't much more I can ask but that you are graced throughout your life to hear the music of it spoken aloud to you and given unconditionally, as you grow up in an environment that encourages learning, exploration, and the appreciation of opportunities to experience great love—in all its splintered magnificence.

Fear, Doubt, and Desperation

Ayele, one day in the years ahead, your eyes will come to rest on the contents of this page. It is my expectation that by then you will have discovered for yourself that fear is a visceral response to imminent jeopardy, real or perceived, threatening to come crashing down on you with devastating results.

Undoubtedly you, your parents, and your experiences will have prepared you for dealing with different aspects of fear and with challenge in general, to which I might add a handful of the understandings that I've collected over the years—starting with the basic notion that fear is a name given to a particular *feeling.* Now, by definition, feelings came

first, long before the arrival of language, thereby allowing the eventual placement of names on every feeling that human beings are known to have.

Let me briefly return to the example of the graveyards of my childhood on Cat Island. The feeling that reverberated through me while walking past a graveyard in broad daylight with not another person in sight was pure, unadulterated fear. I was always scared out of my wits! On a dark, moonless night, when I was walking past a graveyard, even with my parents holding my hand, I was apoplectic!

Maybe in hindsight, the cause of my fear wasn't as logical as, say, when I swam in waters where sharks and barracudas wandered about in search of food. That overabundance of caution, and a like amount of fear, were well founded. It was similarly logical for me to be guarded and afraid whenever I went scampering up fruit-bearing trees, careful to avoid drawing the attention or ire of the wasps who were on patrol, looking out for plunderers like me.

The irony, Ayele, is how so much of what we fear can shape who we become. In that connection, graveyards, sharks, fruit trees, and wasps owe their names to the survival needs of mankind, among which was the indispensable tool of language—a tool that took the human species hundreds of thousands of years to

hammer into its present form; a tool that allows us to understand our feelings and say of ourselves, *We are what we are, and half of what we are is what we are not.* That's why I was drawn to graveyards equally as much as I was petrified by them!

The other way that fear and its ancillaries must have also evolved was that at some point our ancestors realized that we were imperfect creatures, and didn't like it, not one bit; never got used to it, and in fact fought against it mightily. We nursed resentful feelings toward whatever it was that didn't provide us wings with which to fly, as birds were able to do so easily, or provide us with the size, strength, or swiftness of other creatures whose intimidating presence would signal, "Heads up, everybody! A threat is in the vicinity! Death is in the air!"

Without wings we couldn't scatter swiftly. Without size and strength, we were open to being lunch or dinner. If, with luck, we lived to see another day, we busied ourselves in search of ways to extend and secure our survival across as many days as luck would provide. Birds we were not, nor elephants, nor lions, nor saber-toothed tigers, nor alligators. We were at risk, night and day.

That's the truth of it, and has been the truth of it for millions of years—since *Homo erectus* followed

Homo habilis 0.4 to 2.0 million years ago, who followed *Australopithecus robustus* 1.6 to 2.2 million years ago, who in turn followed *Australopithecus africanus* 2 to 3 million years ago, who followed *Australopithecus afarensis* 2.7 to 4 million years ago.

So, it's as if we are tapping into our ancient origins when such feelings occur as part of some larger inborn response mechanisms, programmed to send out alert warnings whenever danger is believed to be lurking nearby. This range of feelings was a part of our beginnings, experienced by our ancestors long before the creation of language—which eventually clarified such differences as existed between our feelings, one to the other; identified their presence; and gave each of them a name appropriate to their function.

Though we developed a range of tools with which to defend ourselves from entities that stalked us then, we retain those feelings that continue to stalk us, often from within—the feeling we call *fear,* as well as the feeling known to us as *doubt* and, not far behind, the most damaging of them all, *desperation.*

Ayele, by age twenty, I am sure you will have at your disposal all the words necessary to chart your course through life, providing you always remember the following: behind each word is a meaning. Some words are friendly; some are not. Some will cause you

pain. Some will make you cry. Some will protect you. Some will deceive you. Still, words and their meaning can be indispensable in preparing you for the battles you must win in order to survive.

The fact is, my darling great-granddaughter, long before your young life will deliver you to this moment on this page, fear, doubt, and desperation will have made many appearances in your life. But it is my hope that by then you will be standing strong in the face of each one; that you will know them by their nature; that you will have come to understand each by its function: they can alert us, they can hurt us, they can strengthen us or weaken us. And, in time, you may even come to know why they visit some of us more frequently than others of us.

I have danced with them all. Never to the same tune; and never with the same results! Fear, doubt, and desperation: they are almost related. I've never been afraid when there wasn't doubt somewhere, and I wasn't doubtful when there wasn't some desperation near at hand.

Let me put these dramatic responses into the context of the period in early adulthood when, though I had begun to understand my path, I had no guarantees of future security. After making a few movies, contrary to the assumption that it was all going to be smooth sailing

from there on out—and contrary to what many assume once they've had a taste of initial success—I found myself in a gloomy passage. A young man with a family, I had, at that time, no acting or other job, no rumors or possibilities of acting employment.

Aware and willing to reroute and reconsider my options for finding work, I faced the same obstacles as before—no marketable professional skills and only a rudimentary literacy that I was still developing. Whatever I could have done, I would have. With a wife to support and a child, plus another on the way, to feed, clothe, and eventually send to school, it was a scary time for me—damaging to my generally healthy sense of self, provoking doubt as to my worth, making me fearful about providing primal survival needs for me and mine.

Unlike my boyhood response when food wasn't readily available, it wasn't as if I could head out to the ocean and put a baited hook in the water for fish, or gather sea grapes or pick cocoa plums in the forest. I was way out of my natural element in New York—an urban, industrialized setting not set up for fishing in Central Park or foraging for native fruits. When we came perilously close to having to worry about not having food for our children, fear, doubt, and desperation raised their heads simultaneously for sure. Before sliding down that

slope, however, I was able to find temporary work that required the harshest physical labor. Fear and desperation subsided, although the doubt lingered. The feeling that then stalked me was that of an unsavory "what if?" What if the life fashioned for me by the guy who threw me out and told me to stop wasting his time as an actor was coming true?

Now the resentment surfaced in response to old fears, the kind that accumulates in us from childhood—residuals from my life as an outsider, old false stories of being dismissed and told that I was valueless to society. I was not valueless to myself; I had a sense of myself. But society back then had judged me next to zero.

That was the gloomy low point to which I'd fallen, even after my exciting launch. The reality was that in the late 1940s and early 1950s, there were hardly any film roles for black actors and actresses, and of those that there were, many notoriously reinforced racial stereotypes that, even at my hungriest, I couldn't bring myself to take on. Ayele, this isn't said for me to claim any heroic choice to suffer rather than allow myself to be exploited. The truth is that I just couldn't bear to admit to being so fearful, doubtful, or desperate as to do something that demeaned a person of color, and myself in the process.

In this period, just as we awaited the arrival of our second-born daughter, Pamela, I went in to meet with producers and read for the film role of a father who witnesses a crime in the casino where he works—an acting job that initially seemed like an answered prayer. From the short scene that I read for them, the producers and the powers that be were interested in my doing the role and gave me the full script to read before a final decision was made. But as soon as I read it, I contacted the agent, Marty Baum, who had submitted me (though he didn't represent me at the time), to explain that I couldn't do the role.

Marty asked whether it was because the role was racially insensitive.

"No, not really."

"Is it insulting to you?"

Not wanting to elaborate at the time, I simply said, "I just can't play it."

Marty didn't understand my reasoning, but he must have sensed that there was something of import underneath my decision not to take work that he knew I desperately needed. Some time later I got around to telling him what it was about the story and the role that bothered me. In the script, the father who witnesses the crime is threatened by the bad guys, who kill his daughter and throw her body onto

his lawn—as a warning. But he does nothing in response. I couldn't play that role. I had a daughter, and another one was about to be born at Beth Israel Hospital in New York City. My first thought, in fact, when I read the script was that I didn't want my father to see me playing the part of someone who allows hurt to be done to his children without fighting back.

Marty Baum decided that I was crazy for turning down the role, so crazy that he wanted to be my agent—and has been ever since.

But having stood my ground and faced down my fear, I had to face another challenge—how to find the money to pay the $150 that the hospital delivery of my second child was to cost. The only option that I could see was to borrow the cash from Household Finance against my furniture. And that's what I did.

But my choices to turn down certain parts didn't make me heroic.

By this same token, when controversial roles were later offered to me, I didn't feel noble for taking them on. Rather, I felt fortunate to be given a shot to play parts in movies that challenged prejudices, took on oppressive regimes, or involved interracial relationships, for example, and whose story lines dared to show a black man as powerful, articulate, and important at a time when that wasn't acceptable to many. And I

should add that during the volatile years when some of the films that I did were banned in the South and when death threats were made against many of us involved, fear was no stranger, either.

As you know, my dear Ayele, in a short enough time that lean period ended, thankfully, and my fortunes soon began to change in hopeful ways. Without question, each time I came out of doing battle with fear for the survival of myself and my family, I came out stronger. The possibility continued to be there that another wave of fear could return at any time, given my circumstances. But it did make me strong enough to be as ready as I could for the next wave, and the wave after that.

And I suppose at the core of me was the lesson that we can all learn in order to safely navigate the shoals—which for me was that my salvation was in my own hands; my fears were to be worked through; my fears were to be overcome, subdued, wrestled with in the hope of taming them enough to get to the high ground—to never come out of the struggle weaker, because the strength you lose in an effort to come out of it is never recoverable. However, the strength is multiplied if you subdue the fear: you don't have to thrash it into extinction, but you have to overcome it. You have to put it behind you, and once it's behind you, there is a victory of sorts—a strengthening of your own view of yourself.

You may be wondering if we ever get to the point in our lives where our fear stops visiting us for good in our daily lives. My answer is no, although its intensity and influence often diminish and its form alters, depending on the constant flow of activities in your daily life. There are some days when you get up and most of it is terrific and maybe a small part of it may be problematic and can cause fear or stress. And you have a night where you go to sleep and rebound the next morning with pretty much the same difficulties facing you as you had the day before. You work your way through some of them, you duck some of them, you climb over some of them, and you turn your back on some of them.

Then there are those causes of fear you can't turn your back on, that you can't step away from, and that you have to surrender to or fight. If you surrender, that's it. If you don't wish to surrender, if you cannot surrender, you fight. You fight by standing in fear's face and saying, "You may have me, but you're going to have to take me. I am going to give you as much hell as I can give you, because I don't want to go with you, I don't want to be subjected to you, and I don't want you to be pulling my strings." Some of those fights, even, are won.

How have I been left as a result of my confrontations with fear, doubt, and desperation over the years?

I have been left wounded in some measure, in delicate ways. I've been made suspicious to some degree; I've been made reluctant to engage in some things, particularly in some areas where I have been the loser.

But those are experiences that we generally try to avoid, although we are not always successful. And there are other kinds of experiences that come toward us, and traveling in that force is a requisite amount of doubt, a requisite amount of fear, a requisite amount of desperation.

We are vulnerable. If you strike our skin hard enough, not only does it hurt, but it destroys a part of us. If you are thrashed about in your self-perception by forces that you are not able to defend against, they overwhelm you and leave you weakened in so many ways.

Doubt itself is one of the most difficult responses to fight. Doubt is inside you—and it isn't something that accidentally finds itself inside you. It is there because the component elements of it are there; and they congeal in a way, triggered by external forces, by social mores, by economic conditions, by family responsibilities, or by accidental occurrences. And once they congeal, you're looking at self-doubt. You don't have to look far to know that it's you that you're doubting: "Do I have what it takes? Why did I fail there? How come I haven't been able to get this job?"

Yes, fear, doubt, and desperation are very real forces. And there is nothing you can do about them except to stand up to them. And if they push you to your knees and you can't fight back enough to stand up, they've got you, at least for the moment. But you will mark that and learn from it. And when you escape, when you fight back, when you subdue or overwhelm them, that's a mark for you, and that mark strengthens.

Would I love to tell you that I have vanquished fear from life? Yes, as much as I would love to keep you far from it. Unfortunately, it's a battle, and mine has left me with checkered results. You see, Ayele, it is in facing the smallest fears, the fears that are somewhat short of self-destruction, that we make most of our compromises. Because if it is less important, we make a compromise rather than saying, "It's OK to resist. I shouldn't compromise on the basis of it not being that important. I should face it, because it is the correct thing to do."

Now, as to you, Ayele, and the reality of your life, which I pray will be long, productive, and useful, with an appreciable amount of joy and pleasure—I don't expect that you will escape battling fear, doubt, and desperation any more than I have. You will prevail, however, I am doubly certain, because you come from

a long line of individuals—like Reggie and Evelyn Poitier—who have stood against their fears in the worst of deluges and triumphed over them. You will be strong; that I predict.

Remember that the more times fear wins, the more vulnerable you will be. The big difference will be up to your judgment as to when and where, and on which issue, you choose to stand your ground against each fear.

Standing your ground will have to be done many times. Sometimes you will win, and sometimes you won't. The outcome all depends upon the nature of it—the fear—and the nature of you, the individual.

I'm closing for now. When I write again, I'll have more stories to relate about different responses to fear and other instigators of our closest calls—some that worked, and those that didn't.

Battling the Demons

In my early years, Ayele, I had no knowledge of the horrendous extremes that give the word *addiction* its terrifying meanings.

But I am writing to you now to recall the various ways I saw it in action before I knew its name. There it was, every day, repeating itself, deepening its ties with those already in its grasp; and seducing any and all observers who seemed most likely to believe that a smoker is simply a smoker, no more, no less; a gambler, a gambler; a drinker, a drinker. That each person, in his or her own way, is searching for pleasures of a harmless nature—pleasures that suit his or her particular needs.

In that era, long before words like *addiction* and *science* had reached my ear, addiction was under scientific scrutiny. Even to this very day, in late 2007, medical experts, through science, are looking inside the human brain to see how and why both chemical and nonchemical addiction alter the perceptions and behavior of human beings.

Confronted with similar problems long ago, I had to deal with them on my own. Mama Gina, my grandmother on my mother's side, smoked a white clay pipe. I had no reason to wonder why. My auntie 'Gusta, my mother's sister, smoked a pipe as well. Later, as a teenager I, incorrectly, assumed that such an activity was a habitual carryover from the African culture of their forefathers long before the slave traders arrived with their schemes of evil. Still, my mother never smoked. My father and our village elders had a taste for rum, but never in excess.

I smoked my first cigarette when I was seventeen and in the army, having hiked my age, as I have said, to get in. I saw my fellow soldiers smoking, all of them eighteen or older, and I thought it would be a cool way to give the impression that I was one of the guys. I didn't take to it well at first, but after a while smoking became such an addiction that I arrived at two packs a day, then tried to back off but couldn't kick it.

After I began smoking, I started drinking casually, socially—but drinking nevertheless. For a shy guy like me, that eased the tension in social gatherings whenever I would have otherwise been more comfortable in the corner, just observing. A drink in one hand, a cigarette in the other—well, it was part of the environment, the ambience of the clubs and parties of the Harlem social world that I was trying to fit into. Soon enough, drinking snuck up on me as well, and turned into a habit. And habits, as we all now know, can slip, unnoticed, into addictions.

Gambling was my last acquired addiction. Such an activity was unimaginable in my youth. First, I never had money with which to gamble. I had never heard of dice or cards or Las Vegas. As a kid, the only thing I saw relative to gambling was grown men playing dominoes and checkers. I had no interest in either one. But years later in New York City, I somehow developed an interest in cards, dice, and horse racing. Gradually, over time, while still a young man I became addicted.

It started with me playing pinochle with a few friends I had gotten to know. From pinochle, I gravitated to poker, and from poker to blackjack. And then I got started playing the numbers. Gambling, you see, was a huge activity in New York City.

I later added horse racing to my list of dangerous indulgences. By the time I started earning money as a young actor, I was already a veteran gambler.

Early on, I could have gotten into substantial trouble had it not been for a notable Harlem figure named Bumpy Johnson. He was very well known, and had considerable influence. He was a numbers guy and was perceived as an underworld character in Harlem, having recently returned from prison, where he had spent several years for challenging (it was rumored) the Mafia's dominance in the region's underworld activities.

When he came out of prison, Bumpy went into business, creating heavy detergents for cleaning and scrubbing and selling them to local business establishments. At the time, my acting career was starting to move and I was out of the leaner stretches, but work was still intermittent enough that to supplement my income, I had partnered with a friend, Johnny Newton, in a restaurant called Ribs in the Ruff. That was the context in which I got to know Bumpy—when we started buying products from him. He would pop by now and then, and was always kind, personable, and interested in the success of our place.

From time to time, we'd also run into Bumpy at the Theresa Hotel, where my partner Johnny was once

manager of the hotel's bar—which was then among Harlem's most popular watering holes. There was a familiar crowd there who knew me and knew that whenever I was flush from an acting job, I'd be looking to play some poker. I happened to be at the bar one afternoon, talking to Johnny, when I noticed that Bumpy was there as well, holding court with a group of his cronies. I'd planned on going over to say hello, but before I could, Bumpy rose from his chair and made his way toward the exit, nodding in my direction and explaining that he had to meet someone at Small's Paradise, another of Harlem's chic establishments, located about ten blocks away.

Fifteen minutes later, while I was still talking to Johnny, a phone call came in for me. When I picked up the receiver, I recognized the voice of Bumpy Johnson as he asked me to take a cab over to where he was, because, as he put it, "I want to talk to you."

He was sitting alone when I arrived at Small's Paradise. "Have a seat," he said in a friendly enough manner. He studied me carefully as I took a seat across from him. Then Bumpy began slowly, saying, "I hear you've been playing poker."

"Yes, I play some poker," I answered.

"I hear you've been losing pretty good."

"Yeah, I haven't been winning a lot."

Bumpy didn't smile at that. Instead, catching me by surprise, he gave me a serious look and said, "I want you to stop playing poker."

"Oh?"

"I know the people you've been playing with, and you can't win there."

I understood instantly what he meant. A silence fell between us. He stared at me to see if what he had just said had gotten through. Satisfied, he continued, "Listen, I like you. If you want to gamble, go to the Rhythm Club." He was referring to the most famous among Harlem's many gambling houses. He went on, "It's clean, aboveboard, and nobody's going to cheat you. If you're lucky, you'll win, and if you're unlucky, you'll lose. But I don't want you playing with the guys you've been playing with anymore, and don't mention this to anybody."

I agreed, and afterward whenever he saw me, he was very friendly, very gracious, and I guess he saw me as the kind of good kid he wanted me to be. He was much older than I, and he didn't want us to hang out together. He just wanted me to stay on the straight and narrow.

Looking back, I realize what a godsend Bumpy Johnson was in my life at that time. From then on, I was more careful as to who was running the game. Another sensible choice that I made in regard to gam-

bling was to set limits on how much money I was willing to lose. Whatever I was earning on a weekly basis, I couldn't gamble it away. First I had to cover rent, food, subway fare, business and career expenses, and so on. After those basic needs were met, I would put away a certain amount of money with which to gamble. Again, here was the balancing act between want and need.

As my responsibilities increased as a homeowner, in my marriage, and with kids continuing to come, I still gambled, but again with a sense of caution. I was not risking everything: a portion was put aside solely for gambling purposes.

In time, the more money I made, the higher the stakes I was willing to risk. If I made ten thousand dollars, I would put aside a thousand dollars for gambling purposes; if I made twenty-five thousand dollars, I would put aside twenty-five hundred.

When I first went to Las Vegas, I found it to be every bit the seducer it promised to its customers through its risqué advertisements. It sells itself with every means of seduction that it can and makes no bones about it. What one sees is what one gets. In due course, I went there several times, but always limiting my losses by a predetermined percentage.

I kept it that way for a long time, but in the aggregate I was losing enough money to have been able to

do something much more productive and useful than just gambling it away.

After I attained a goodly amount of success in my career, I was able to return periodically to Nassau. There on Paradise Island, I used to join in poker games in the offices of a guy named Jack, who managed a large hotel in that resort area. He was a nice man, quite pleasant, with a friendly personality, and he loved to gamble. Poker was his game.

Jack had put together a group of guys, lawyers and other professionals, whose income levels were well above average. We would meet in Jack's office, he would order food, and we would go until two or three o'clock in the morning.

One night, as I was crossing the bridge on my way home from one such poker game, there wasn't a soul anywhere you looked. No living creature north, east, west, or south. The moon was the biggest I had ever seen it, and it was way off over the other islands, sitting at that far elusive point where the sea and sky meet. With that white orb hanging there for me, my thoughts zeroed in on my addiction to gambling.

I turned around and looked in the opposite direction, which was in the general direction of where I grew up on Cat Island, and then over to the dock

where I had arrived when I first came to Nassau with my mother. Turning in a different direction, I cast my gaze deeper into the neighborhoods of Nassau, where some of my family was still living: brothers, cousins, and aunts. And among all the individuals in our family groupings, there were children.

Now, in the poker game that night I had lost ten thousand dollars. How many of those young people, I asked myself, could I have put through college? At that time, college in the West Indies would have been three thousand dollars for one person. Or, I could have sent a couple of kids to school in the United States or Canada.

I turned back to look at the moon, looked around myself once more, and I decided, on that bridge, never to gamble again, because it was a wanton waste of a resource that could be put to better use.

The test came shortly thereafter when I left Nassau and went to Las Vegas, where the comedian Alan King had invited me to participate in a fund-raising celebrity pro-am tennis tournament. Typically at such events, celebrity amateurs play the first day and then the rest of the time are encouraged to gamble or take in the shows and sights of Las Vegas. Now, I get there and remind myself that I am not a gambler anymore, but I have to prove it to myself.

Fine. My first day there I went to the casino cashier's window and asked for three thousand dollars against a line of credit I had. Yes! That's correct. Then I took the chips and put them in the handkerchief pocket of my suit jacket, and I walked in and out of that casino for eight days or more, and I didn't gamble once. I would intentionally stop at the craps table, the baccarat table, or the roulette table—just to test my will. At the end of my stay, I returned the chips to the cashier and left. I returned to Las Vegas several times subsequently, and never gambled.

But there were the other addictions yet to be dealt with: smoking and drinking.

As to smoking, having begun at the age of seventeen, I was now several years into it. Then on a hot, hot day in Nigeria, where I was making a picture, *The Mark of the Hawk*, with Eartha Kitt, my nose suddenly started to bleed. It was just flowing, and for the longest time I couldn't stop it. It scared the daylights out of me. I somehow made a connection between the nosebleed and smoking, for I had eventually gone from two packs a day to three. I decided then and there to stop.

We worked in Nigeria for a couple of weeks more, and then went to London to finish the movie. *There, I said to myself, I haven't touched a cigarette in three weeks: I am in the clear. To prove I am in the clear, I*

am going to smoke one cigarette, put it out, and not have another one, and then I will know I've got it licked.

I smoked that first cigarette, and before two days had passed, I was back on three packs a day.

This continued when I later made the picture *Porgy and Bess* with Dorothy Dandridge, Sammy Davis Jr., Diahann Carroll, and Brock Peters. When it was finished, I went home to Mt. Vernon, New York, where I was living with my first wife and kids; but by then there were stresses in my marriage, which only increased my smoking.

It was in Mt. Vernon that I was able to fully see the hold the demon had on me on one particular night when, to my horror, I couldn't find even a cigarette butt in the house. I went into the garage and, in near panic, emptied the trash can out onto the floor, looking. There were some butts there, but they were soggy from the garbage.

So I went back into the house, got out of my pajamas, put on my clothes—including snow boots and an overcoat—got my car keys, and drove from Mt. Vernon into the Bronx, looking for a store still open where I could buy a pack of cigarettes. This was how bad the addiction had become.

Having quit once and then fallen back, I felt I was never going to be able to stick to my determination

because I didn't have a reason strong enough. I thought about it then, and I created a reason. It was the kind of reason that represented everything and everyone that mattered to me, and I made a secret agreement with myself that I, absolutely, could not break; and I have not smoked a cigarette since. And the promise remains a secret.

There yet remained the drinking problem. Granted, I was not an alcoholic or even near being what some people would consider a heavy drinker. In the beginning, I would have, on a given day, one drink. Then it became two drinks. Sometimes I would have a can of beer or two; sometimes I would have one or more drinks of rum or scotch.

Not long after meeting Joanna Shimkus—who, as you have heard, eventually became my wife and is your great-grandmother by marriage—my drinking habits began to change. In those early days, we would often go to a favorite restaurant in New York and have a bottle of wine with dinner. We did that for about a month or so, and then one day I noticed that around four o'clock each afternoon, I began looking anxiously forward to the dinner hour. Not because of the dinner, but because of the wine. *Aha*, I realized, *this has the earmarks of an addiction.* Having learned from other

arenas, I decided that I was not going to be subject to it. And I stopped drinking cold turkey. That was some forty years ago.

Joanna, however, was still smoking at the time, and continued to do so until she became pregnant with our first child, Anika. I was on her to quit because of the pregnancy, and she promised she would. Not too long after making that vow, Joanna was having lunch with a good friend of ours named Caroline, when I happened to walk into the restaurant. There the two of them were, under a cloud of smoke, puffing away.

Caroline sees me, and panics, then quickly tries to cover for Joanna by taking the lit cigarette from Joanna's hand. And there sat Caroline, unaware that she had a cigarette in each hand, as she said, "Hi, Sidney."

It was a ridiculously funny sight. After that, Joanna never smoked another cigarette. And not long thereafter, Caroline also quit.

Ayele, my dear, we are all human, all subject to be drawn to pleasures and pursuits that give us a sense of excitement, well-being, even altered states. But if my experience provides insights, it feels incumbent upon me to emphasize how easily habits segue into addictions. Not always, but very often, a first try seals the

deal. One is trapped, no options available. The dye is cast. One step taken. One indulgence. One line crossed. Crossing back might require the struggle of a lifetime.

And remember always that one lifetime is all one has.

Bravery and Cowardice

Hello, Ayele, my dear. I hope that you'll continue with me as I recall scenes from my life that you have heard before, but that perhaps might shed light on subjects of our ongoing conversation about the ways we may live in this world bravely—in spite of our fears, in spite of our demons.

Let me say at the top that there were moments in my young life when cowardice called the shots more often than self-respect should have allowed. Apparently the forces of nature had deemed me too young to be trusted with knowledge they believed was far beyond my years. In their view, I had not yet learned all there was to know about a masterfully cunning, unseen culprit

we've been discussing, named fear, who quietly roams the landscape far and wide in search of the vulnerable to terrorize and plunder.

Bravery, meanwhile, repeatedly presented itself to me in the form of key survival responses: the endurance of courage under stress; one's capacity to mark one's territory, and then to hold one's ground as best one can—doing so whenever fear and its sidekicks come stampeding into one's life without permission. All of which eventually focused my thoughts and set me to wondering whether bravery, courage, and heroism would have meaning in the total absence of cowardice, timidity, fear, doubt, and desperation. How significant is the existence of one in the absence of the other? Might they not all be threads of differing energies, differing colors, intricately and, it seems, mysteriously woven into the fabric of life by nature herself? Threads whose collective presence is viewed as having provided immeasurable resilience and unfathomable complexities to the ongoing process of human existence. Threads on which, some believe, life, death, survival, and extinction hinge.

So potent is this push and pull in us that though younger brazen acts fade into memory, even in recent days I still find myself high up on a building rooftop, fraught with the fear of heights, stepping compulsively

toward the edge, where, for primal reasons, I dare myself to put my nose far out to where I can look down and see the street far below, all the while bending and holding my haunches counterbalanced at a safe distance from peril. Yes, even at eighty years old, I am compelled to that drama. It definitely gets the heart pumping!

Not understanding this drive in my younger life, I couldn't put my actions into the greater context of a survival struggle that is constantly under way. It's a search for balance between soaring high and falling low, between good and evil— hope and despair—a win and a loss. I hadn't yet learned that all the accompanying thrills—even vanity, ego, and self-aggrandizement— have a value, and are therefore entitled to reasonable space in which to express their right to exist. Who knows? Maybe a single thread will be all one needs to hold on to one's self-worth, one's knowledge of being purely and simply alive.

In specific terms, there were foolish things that I did as a kid that were later described as bravery but that, in fact, had all the earmarks of compulsions. Having risked my life many times and lived to relate the circumstances surrounding each action, I can now look back and clearly see that the driving forces behind each such action were compulsions of many stripes.

But the question for you and me is whether they were compulsions to *act* in a brave way. Were they compulsions that were driving me to live at the edge of destruction? Or were they compulsions that were born out of a need to exemplify bravery as a part of my own self-perception? Or to be perceived as brave in a given set of circumstances? If, in fact, one has such a need, then the truth would follow that ego was the operating force at work.

Ayele, my dear, I'm talking to you now of thoughts and actions I have long held closely guarded, and how I have come to view them now. They include the misdeeds of my youth, some of which have placed burdens upon me, some of which have lifted burdens from me.

I referred to some of these in an earlier letter to you about how I came to leave home as a teenager, but they merit a frank accounting in connection with the discussion at hand.

I'll start with the incident that took place when I was between twelve and thirteen years of age, living then in Nassau, on a day when I stole a pair of roller skates from a hardware store. Later, in searching for the real reason as to why I had designed and executed such an operation, I wondered how that act was different from the other thrill-seeking opportunities I pursued. In those

times I believed that I was acting out of an enormously dangerous feeling deep inside of me that I did not yet know by name. It was a powerful feeling that would lie dormant for long periods and then unexpectedly stir, raise its head, and I would be off again in search of all that was promised. Daunting challenges they were—ventures of the most hazardous sorts that invite only the courageous and beckon only the brave.

I was not able to put a name to most of those feelings, but eventually I began hearing them being referred to as compulsions and that they could manifest themselves in many ways.

I wasn't caught after stealing that item. Soon the compulsion went back into its neutral place and just cooled it. There were only four times in my whole life that I have stolen something. All were in my youthful years. The hardware store and the skates were the first. There were between five and seven employees present in the store that day. All of my maneuvers were premeditated; I had obviously scouted and planned it. I walked into the store and went upstairs— and picked up the box of skates and came breezing back down the stairs, where I would ordinarily go to someone and say, "I would like to have this," and they, in turn, would send me to the cashier. But the

people who worked there were just standing around and paying me no attention, and I walked right out the front door, scared to death that I was going to be apprehended and taken to the cops—who had a station house just around the corner!

I made it outside. Still, I knew I was not out of it. I was thinking, *They're letting me get clear of the building to make sure they catch me and make a clear-cut case for shoplifting.* So I walked to the nearest corner and made a right turn, walked about half a block and made a left turn into a very small street, and from there made it onto a thoroughfare and walked along until I felt it was safe to turn and head for the district in which I lived.

The long and short of it was that I was successful.

The second act of thievery involved stealing corn, as you know—an impulsive act that I was caught and jailed for. Again, that was the point at which my dad made the decision that it was time for me to leave Nassau and go to Miami to live with my brother. My dad probably knew me better than I knew myself and understood that though I was basically a good kid, I needed an environment that didn't encourage my compulsions.

But before my departure, I stole again. This incident arose from my fascination with comic books. Ironically,

as you know, I could read only barely. But because the words in the comic books were short ones, by and large I could read the stories they were telling in connection to the drawings and was dying to immerse myself in them, but as usual I had no money to allow me to buy them for myself. So one day I walked into a bookshop located just a few yards from the police station— around the corner from the hardware store where I did the roller-skate job—browsed for a minute, and when conditions were right, I stole several different issues of comic books. Again, I had predetermined how that theft would unfold. This time I wasn't caught, but after the heightened sensations of excitement, fear, and relief wore off, I took no victory in my spoils.

My final act of thievery occurred in New York City. What I took was something that I thought I *needed* and that justified the stealing of it. But I quickly realized that it was only something that I *wanted*. Compared with earlier acts, the risk level was no less electrifying—and by electrifying I don't mean exhilarating; I mean scary, really scary—and again I was successful. What it was that I took wasn't consequential, and that made me the most ashamed. And out of that shame, I decided never to steal again. I was sixteen years old by then, and that was the last time I stole anything.

Ayele, I'm telling you this not to make you and your fellow readers play a guessing game or tantalize you by not revealing more details. I'm telling you this so that if you ever are in the position of carrying a secret about something that you have done that makes you ashamed you will make the choice to confront yourself. It will take guts to admit that you have behaved in a way that prevents you from being your better self, and then choose to act differently.

It would be easy for me to say that the things I stole weren't such a big deal, but that wasn't who I was. As time went on, I tried to reconcile my former acts with the person I was trying to become and understand what had been behind those choices. With a look back it was possible to spot a behavioral difference between the theft in New York and the others in the Bahamas. The compulsion manifested itself most forcefully when I had changed societal environments.

On Cat Island, I was in a more unforgiving environment, one where the values by which I had lived, and those by which my parents and family had lived, offered no chance for seduction by the impact of materialism. For me, there was nothing to steal. I knew there were fruits on trees in the forests, and I could go and climb those trees. Fish I could go and catch at the waterfront. The level of materialism was simi-

lar for all the people. Though poor, they had a code of conduct for themselves and expected the same from their fellow citizens and their children. That's where I was when I was a kid, and I would never have stolen in that environment.

But in moving to Nassau, then Miami, and soon to New York, I was exposed to sudden impacts unlike anything I had ever experienced. In each new place there were levels of glitter, staggering ranges of materialism, lots of money, and lots of seemingly important things like cars, trucks, movies, radios, and stuff of that sort, with potent imagery that escalated exponentially at every leg of the journey.

I believe that the eventual turning of my back on that compulsion was an act of faithfulness. My mother was not a thief; neither was my father. And I knew that they would have been devastated, as my father was when he realized I had been arrested, along with my friends, for stealing from a farmer's cornfield. The influence of friends may have fed my compulsion, but, that aside, it was wholly unbecoming of me to have put my parents' decency at risk. It was all the more uncomfortable for them because my behavior rubbed against so many values. The degree of discomfort made it necessary for me to step away, and never go back to it: never. Well, yes, but never is a demon

seducer, too, and when I did steal again, once more, when I went to New York City, it was as though I'd been stricken with a case of amnesia.

As minor as some have suggested the thefts to have been, I live with a lingering sense that I was disrespectful to myself, and more than that, I was disrespectful to my parents. My mother would never have done that; my dad would never have done that. So standing like a bulwark against any compulsion to repeat those earlier misdeeds remained the memory of Evelyn and Reggie—your great-great-grandmother and great-great-grandfather, my mom and my dad.

As time went on, they were foremost in my thoughts in my efforts to put into proper perspective both compulsion and myself. At the heart of the issue was a matter of self-perception. What were my responsibilities to myself? To become the best me that I possibly could, temptations and compulsion to the contrary. I was not a thief, after all, although for sure I had been one in my earlier years. And, however strong compulsion glowed, I would never allow it to make of me a perpetual one.

My natural tendencies toward impulsive actions, however, didn't vanish during my late teens or early adulthood, as flirtations with other kinds of risks arose. Those forms of dancing close to the flames, as

I've referred to them, were part and parcel of the excitement that came from the day-to-day way of living in New York City. And all these many years later, yes, I do indeed still take risks: those that I feel are worth taking.

Nor is my life altogether devoid of compulsions. Here is a list of those that remain: a compulsion to read more, and better understand the world around me; to keep an eye on the dualities inside me and try to center myself at the point of balance between as many pairs of opposites as I might; to experience all that I can. And, most of all, to learn all that there is to learn that might make of me a better person—with better insights and a deeper understanding of myself and of my fellow human beings. Such has been a preoccupation of mine, a life goal, perhaps the principal one, as far back as I can remember.

What kind of compulsion, you might ask, draws me toward such internal wanderings—as to the nature of bravery versus cowardice, and as to the nature of human nature? Some of this drive comes to all of us when we reach the age when we become living time machines, seeing the lines of our lives stretching back and forward. Apparently, it can be a common affliction. Moreover, there are some instinctual qualities at work too numerous and certainly too difficult for

me to comprehend, though I suspect there might be the presence of intangible forces from the distant past lingering still in the primal memory passed on to us, through the bloodline, from ancestors long gone—telling us who they were and how they came to be. The one unerring compulsion that I never try to rein in is the one to learn, to understand, to decipher complicated things and circumstances.

Once again I return to the richness of mysteries everywhere, Ayele. There are probably more than we can imagine, safely hidden away in distant corners of our primal memories—like lost civilizations buried under the bottom of the seas, in other places we cannot imagine, where mysteries are awaiting the arrival of the curious travelers.

One of the greatest discoveries of my expeditions is that stronger than the compulsion to dance close to the flame has been the urge in me to be a person whose life differentiated itself from that of a thief—a person who wanted always to be a better person.

You may have questions here, Ayele. A better person than what? A better person who constantly is in search of enhancing that part of him that counts to him, not to any other authority. This was made certain as far back as when I arrived in Florida and the world there didn't see anything but another black

boy. In New York City, I lived in an area of all black people, and they saw me as just another one of them in the context of their lives. All along the way, there were signs that said, "You aren't who you think you are," blaring out to add, "Can you not see that you are not important? Don't you know you're barking up the wrong tree?"

All of the measures I took at that point to reverse the condition of my circumstances—the struggle to improve—I have attributed to compulsion rather than to what some may see as bravery. Apparently, it is not uncommon for people to see bravery in the acts of others but take a lesser view of their own heroism. Many have saved lives in dangerous situations without regard for their own safety, only to reveal afterward that their only thought was to simply help someone in trouble.

This tells us that there must be a very thin line between bravery and cowardice. Since bravery stands as the true opposite of cowardice, and the latter may be easier to describe, let me offer my take on its essence. Cowardice is a moment when fear paralyzes one with the imminent threat of having something come down upon them with devastating force. It might be damage to one's view of oneself, damage to one's reputation, damage to one's most treasured plans, damage to one's legacy.

The weight of cowardice as it stands before an individual is always alarming, because it is one force rather than a combination of forces. It threatens to have a combination of devastating effects, and that makes it all the more frightening.

Fear holds everybody to it. You turn a corner on an evening going home and run into fifteen guys, and they throw you up against a wall. If they want your money, or if they want to teach you a lesson, or intimidate you—any number of things—and you're forced to give up your command over choices in your life, the only one you have left is cowardice. And cowardice says: "Listen, make a deal with these guys for the least harm." Once you make that decision, you surrender yourself to whatever the abuse is going to be.

Now, the challenge of cowardice comes in many other ways. Sometimes it comes slowly across a protracted period of time. And we fight against it as best we can. When you have to face something with no option to avoid it except to surrender in the face of that fear—it may be fear for your life, fear of losing your job, whatever the fear—once you surrender to that fear, you're damaged. Surrender means, "I give up myself to your sacrifice."

Some people can make that adjustment, as long as they are not fatally harmed. Their reputation may be

damaged, but they're able to live with that. They're upset with themselves, dehumanized, but they're at least only a damaged piece of goods rather than dead meat, or left powerless or whatever it is. They'd rather accept it and try to rebuild, at least being alive to fight another day.

But cowardice is debilitating; it saps your strength, it weakens you, sometimes to the point where it is difficult to recover. But, again, you may have been facing life or death, or loss of friendships, or your reputation, or your family's circumstances, or your economic disposition. Whenever you are faced with those questions, cowardice can ameliorate the situation; cowardice can give you enough breathing room to survive long enough to correct some of it, so you look it in the face and say, "OK, I'm yours."

In adults, the economic and social circumstances of our lives are the places where cowardice usually has the advantage. If you are in a predicament, and you're dealing with a person who has the say over whether your job takes a turn for the better or for the worse, that can be a circumstance where the question of cowardice might arise.

If it is a question of your political persuasion, the question of cowardice might arise if the need in that circumstance is such that you are obliged to swallow

your own politics and let it be known, dishonestly, that you are OK with a political position or activity that you actually think is reprehensible.

There was a point in my career that I remember uncomfortably when the conditions of my employment were possibly contingent on my signing a patriotic loyalty oath specifically renouncing Paul Robeson. He was my hero and my friend, a man to whom is owed a debt of infinite gratitude by every person of color who has ever worked in any facet of the entertainment industry. When I think of the few people in whose presence I was starstruck—Robeson stands out above all. But because of his activism in civil rights and his possible association with left-leaning causes during the Cold War, he was under investigation by our government. Though in the final analysis I wasn't required to sign the oath, I agonized over what to do in the interim. I could not and would not sign it, but whether those reactions were brave or cowardly came down to my deciding which master in my own conscience I was going to serve.

Every American person—black, white, brown, or yellow—who aspires to a good, moral, and ethical life is vulnerable in the face of those who threaten them and can do them and their loved ones harm. And there you go when cowardice has you in its sights. Very few

of us, including me, are going to say, "All right, this is me, you understand, and I ain't going to take any . . ." On the other hand, there are times when all it takes to vanquish the bullying forces is that which we, including me, are capable of doing by having the courage to say, "No, this is a line that can't be crossed," or to speak out against wrongs, at our own expense, and to say, "This is unacceptable. This will not stand."

There are various scenarios in which the moment comes to choose between bravery and cowardice, young Ayele, and sometimes we must pause to summon courage if it is not instantly present. Often we succeed, yet sometimes we fail. After all, we are only human.

Close Calls

In preceding letters to you, dearest Ayele, I have written at length of what I know about facing fears and demons, about compulsions, and the narrow border separating bravery and cowardice. Those conclusions have come from actual incidents in my life that I recall again for you now—numerous close calls I have had with disaster. Some could have killed me; others could have left me damaged physically or emotionally, or could have otherwise altered the course of my life.

One of the earliest such life-and-death encounters occurred while I was still a kid on Cat Island, curious and too adventurous for my own good. You may have

heard about this escapade from other sources, but I feel it is worthwhile to repeat it here as a cautionary tale for you and your peers, lest curiosity ever get the better of you. This was the time when my impulsive exploration of the salt-pond tunnel nearly ended in my drowning. The one-hundred-foot-long, six-foot-deep, two-foot-wide tunnel, running from the sea to a pond where the water was collected to later evaporate into salt for the island's inhabitants, was just too enticing for me to ignore. But the day I crawled into that long tunnel, with only a handmade gate holding the ocean at bay, could have been my last had I been able to open the gate from inside, as in my frightened state I foolishly tried to do. Water would have rushed in at fifty miles an hour, and I would have been trapped in the flood. The energies of the universe were with me that day when my efforts to push open the gate failed and I managed to extract myself from the tunnel.

Some time after, when my family left the island, Nassau presented its own dangers, two of which I engaged in freely and of my own accord. As to the first, there was a giant warehouse more than five stories tall that held cargo arriving in the Bahamas from the United States and other places. The building was wider than it was long, and the dock in front of it ran several feet out above the sea.

A small group of young boys engaged in thrilling leaps off the top of the building into the water on days when the building was closed. The danger of it soon swept me up. The trick was to stand at the rear of the roof of the building, then race forward as fast as possible, leaping mightily out and forward just as you neared the front edge—at enough of a distance to safely clear the dock below. To fail would have resulted in serious bodily harm, at the least. Luckily, the few of us lunatic enough to try it never failed.

While those episodes had their serious physical danger, another offered a peril of its own. Having seen my first movie in Nassau, I acquired a taste for them, as had my friend Yorrick Rolle—my partner in the enterprise we developed to earn money for movie tickets by selling the peanuts we bought and roasted. When our proceeds still weren't enough to cover the tickets, we conspired to devise another way of getting into the theater.

I had noted a window that opened from the inside of the theater for ventilation purposes. It was a small window, and high enough that the theater manager could not imagine anyone climbing in. It was also a spot where passersby during the day would be hard-pressed to notice us sneaking in—unless they were up on a hill and could see us from that vantage point. So

the way we worked it was, I would get up on Yorrick's shoulders and climb inside. Once there, I could stand inside, lean the top part of my body back outside the window, and pull Yorrick up and help him get through the window.

After we were both inside, we crawled under a floor-length curtain that hung in front of an opening near the screen that led backstage. Our next move was to slither along the floor through the first few rows of seats, and if there were vacant seats about the fourth or fifth row up, we would listen carefully, then suddenly pop up and sit as if we had been there all the time. We did this often, with much success.

One day we snuck inside early, slithering into place so that we were sitting there before the movie started while people with tickets—honest people—came in and found seats. Suddenly, Yorrick and I each felt an urgent tap on the shoulder. We looked up, and standing there was a huge man, Mr. Baron Smith, the theater manager. "Get up," he ordered us, adding, "come with me."

I knew Mr. Smith, and my father knew Mr. Smith, and Yorrick and I knew we were in big trouble. Reform school was our next stop.

We meekly followed Mr. Smith into his office. He sat us down and said, "You know what you're doing."

We said, "Yes, sir."

He said, "You know what's going to happen to you." Then he said directly to me, "I know Reggie. What do you think your father is going to say about you doing such a thing?"

I couldn't defend myself, and he then turned to Yorrick, whose father he didn't know, and said, "What's your name?"

Yorrick told him, and together we tried to offer some kind of explanation, but mostly promised that we wouldn't do it anymore.

So Mr. Smith said to me, "I tell you what I'm going to do. I'm not going to tell your father. I'm going to let you go, but if you ever, ever do this again, I'm not going to tell your father; I'm going to call the police." Then he grabbed us up, led us to the front door, and shoved us out.

Outside, we must have run for about a mile. In those days, even small criminal infractions by young boys often meant long stays in reform school (as Yorrick later found out when he was arrested alone one day with a stolen bicycle).

There was another occasion that could have resulted in my spending years locked away. It occurred when I was fourteen and walking along an almost deserted Nassau street. An obviously older kid came riding by on

a bicycle, going in the opposite direction. He was wearing biker gear and thus appeared to be from a family of means. When he drew near me and veered in my direction, I thought he was about to turn a corner behind me. Instead, he lashed out and punched me full in the face. When I recovered from my astonishment, I took off after him as he headed full speed toward Bay Street and the heart of the city. Angry, I searched as hard as I could, but I found no evidence of him or his bicycle.

What was the danger here? He was white and I was black, and if I had found him, I would have tried to beat the daylights out of him, regardless of any witnesses. In colonial Nassau, with its disciplinary control over black people, my arrest and conviction would have been virtually assured. That day when I was unable to find him was a definite case of winning by losing.

Then there was my encounter with Cardod, a big guy—and an acquaintance, though not someone I considered a good friend. With a reputation for being unpredictable and having unusual behavioral patterns, he had never done anything to rouse my concern. Since we were usually out swimming or hanging with the same group, I saw no reason to be on my guard around him.

Then, one day after swimming, I was on the dock alone when Cardod showed up. We began talking, and suddenly he took a strange turn. I was amazed at the

radical shift in his expression, and even more stunned at what happened next. He was carrying a piece of board almost four feet long, and all of a sudden, without warning, he hauled off and whacked me with it on the left arm. It was a very hard blow, and I was quite close to paralyzed by it.

Knowing his reputation for unusual behavior, I was petrified and didn't know how to react. I could tell that he felt he had done what he wanted to do, and that was to intimidate me. Whatever the words were that were coming out of his mouth, they implied that he felt justified in hitting me. Meanwhile, two things were on my mind. One was that he was in some sort of unbalanced mental state, and the other was that I was in immediate danger, because if he whacked me again he could do great damage; that board was quite a weapon.

My thoughts ran the gamut: *I am offended, yes. What am I going to do about it? What can I do about it? Is my arm in such a shape that I won't be able to fight him? Should I jump him, and then what happens if he whacks me again?* This was a point where the issue of bravery and cowardice came into play, and I was caught between the two.

But I soon realized that I was injured, he was armed, and there was little I could do other than go

into a neutral state—a subject I'll return to later on. It was enough to diffuse the situation. Afterward I would see Cardod around Nassau from time to time, and he acted as if absolutely nothing had happened. Yet every time I saw him, I felt enormous apprehension because of his unpredictability. It was a fear, a fear of violence being done against me and of having an even closer call with him. That feeling served to protect me from further harm, thankfully.

Cut to: Miami, Florida. I'm fifteen years old, out by myself at night, and being accosted by a swarm of cops. I'd heard a lot about this before arriving in Florida but wasn't afraid; I had already been shaped as a person by then. Even before leaving Nassau, I knew that I had a huge resentment to being maltreated. I was always a reasonable person, but I do think I have a volatile thing inside me—an explosive potential when provoked that I try to keep out of harm's way. In America, I knew to be watchful of that, and whenever it threatened to flare, I somehow managed to get control of it.

So though I was apprehensive, I was also angry when the cops decided to have some fun intimidating me—a young black boy alone on the streets at night, caught on the wrong side of town. They forced me to walk fifty blocks back into the black

neighborhood. I knew that in Miami in the early 1940s they could have shot me, as they threatened to do, without consequence. But the fear of that did not quench the rage within me. Had I not suppressed it, I could have been just another black kid found dead of a gunshot in an alley, with little—if any—investigation afterward.

My time in Nassau was only a few years, and my time in Florida even shorter—but not as short as it might have been had the Klan found me. They came looking on the night after I had left a delivery package at the front door of a woman who refused to accept it there and ordered me around to the back. I was new to the segregationist ways of Florida then, and had questioned her stance. "But I'm standing here with the package now," I said, just before she slammed the door in my face. My perceived impudence resulted in a group of Klansmen showing up at my brother's house, where I was staying. They apparently found out who I was and where I lived from people at Burdine's Department Store, where I was briefly employed. Luckily, I was not at home, and when I did arrive later, the family spirited me away to live with other relatives in another neighborhood.

You no doubt will recall earlier letters describing the circumstances that led to my joining the army in

the hopes of escaping the chokehold of New York City in the winter and my impoverished circumstances.

It is hard to imagine a more life-altering event than what might have happened had my bizarre plot to get out of the army gone bad many months later. Instead of returning to New York and an eventual career as an actor, I could have been stuck for twenty years in a prison. In brief, I will summarize this close call by saying that after several months of working as a qualified physiotherapist in a GI rehabilitation ward at Mason General Hospital at Northpoint, Long Island, I decided to give the appearance of having gone nuts. To begin with, I tossed a heavy chair at the head of the man in charge of the hospital, missing him by inches, and sending it crashing through a bay window. Locked up and still being questioned for that infraction, I soon upped the ante by pushing over a mobile steam table laden with food while it was making its rounds through the room where I was being held with other inmates. Many weeks of psychiatric sessions and much penitence for choices I came to regret later, I got my discharge.

But as you can conclude from the descriptions already given, being out of the army upon my discharge in 1945 and back in New York did not exactly put me out of harm's way. Living very much close to the edge,

I was back to dishwashing downtown while staying in a room of someone's apartment at 127th Street between Lenox and Sixth avenues, for which I paid five dollars a week.

One night I came up out of the subway at 125th Street and Lenox Avenue and had the shock of my life: there was bedlam everywhere. There were buildings afire, people on the street going absolutely crazy, and cops shooting. A full-blown riot had broken out earlier, and because I had been working downtown and didn't have a radio, I knew nothing about it.

I would learn later that the riot had been triggered by the behavioral pattern of the police in the area. Beyond a systematic profiling and scapegoating of black residents, they had done something that was so egregious—whatever it was, whether it was beating up or killing an unarmed suspect, or whether it had to do with corruption related to payoffs—that when individuals in the community witnessed it, one thing led to another.

I didn't have any background on how the police were doing what their job required, which was to keep the community contained as a separate section of New York, almost as if it were detached. People there could go downtown to work, go shopping, or go strolling on Broadway, but few of them would look for housing in

areas other than their own. There was a fundamental awareness on the part of downtown New York, Harlem, and all the boroughs as to the relationship between races.

So the accumulated resentment exploded while I was washing dishes downtown. Emerging into the middle of the pandemonium, I saw people breaking into places and looting. I suddenly found myself inside a large grocery store. I don't even know how I got there, but I was not there to steal anything. What was I going to steal, some canned goods off the shelf, some cookies or rice? No, I was drawn to the sense of danger. There were many people in the store, and I was reaching for nothing, but just being there in the presence of the chaos all around.

Suddenly cops came rushing into the store with guns drawn. I hightailed it to the rear of the store, presupposing there had to be a back-door exit. But every door I found was locked, and there seemed to be no way out. The cops were steadily moving through the store, and I heard gunshots. There was one last door, and I ran for it and it opened. I crashed in, shut the door, and looked around, but there was no exit; it was a storeroom. There was no light in the room, so I could see the searchlights of the police as they were approaching. When the light reached the door and

it started to open, I collapsed onto some bags on the floor and played dead. My face was looking up and my eyes were closed, and I was holding my breath. I could see the light through my eyelids as the flashlight rested on me. Then, apparently being taken for dead as I had hoped, I remained frozen as the flashlight moved around the room until I finally heard the door close, and it was dark again.

At that point, I started breathing again, gasping for air—as quietly as I could. When I was breathing easily again, I cracked the door open, and there was nobody in the store. The cops had cleared everybody out. I slipped outside and walked thirty or forty steps when suddenly there were shots and I started to run in the direction of where I lived. Then I felt something at the bottom of my lower right leg, but I didn't stop. When I got to my room, I found I was bleeding from a spot near my Achilles tendon. It must have been a bullet wound, because nothing else had hit me there. In my room, I tied whatever I could find around it. When the bleeding stopped, I still stayed in my room for a couple of days, and then I went out and found some medicine to put on my leg. A couple of more days passed, and I went back to work: my job was still there.

Fade out on Harlem of the later 1940s. Fade in on the smoggy skyline of Los Angeles, circa the mid-1950s. I

was out on the town one evening with David Susskind, a sharp, creative producer with whom I had worked. We had gotten to know each other when I starred in his television show *A Man Is Ten Feet Tall,* which he later converted into the movie *Edge of the City,* in which I appeared with John Cassavetes. Good friends, David and I had gone out that evening to take a couple of young women to dinner. I was driving us back to where the girls lived when, as we came to an intersection, a speeding bus, ignoring our right-of-way as we made a left turn, smashed into us dead-on. The impact hurled our car across a center divide and into a service station. The four of us, all thrown from the wreckage and knocked unconscious, began to come around only after the police arrived. Miraculously, we were all without further injury.

When I returned the next day to the rental agency from which I had obtained the automobile, the ruined car had been towed in. No one at the agency believed it possible that anyone could have survived such a crash.

While I was lucky to escape injury in the auto accident, I may have been even luckier the year in Acapulco when I was swimming with my friend and agent, Marty Baum. A sudden, powerful undercurrent had seized us while we swam happily in the blue waters, and pulled us under, our savior being the thundering

wall of water of an incoming wave that washed us up onto the edge of the beach. But we were not carried so far that the strong receding waters did not suck us back into the ocean, where the undercurrent grabbed us again. We were dragged under four times, coughing, sputtering, and finally too utterly exhausted to fight against what seemed to be our unalterable fate. It was only then that a lifeguard, finally alerted by our screams for help, arrived to help pull us far enough onto the beach to avoid being snatched back.

Sitting there on the sand, as Marty and I regained composure, still both heaving air and relief into our lungs, I could at last appreciate the irony that, while I had begun my life on an island surrounded by unpredictable tides, swimming on my own since infancy, these many years later I had almost ended my life in what should have been familiar straits. Then again, I thought of the closest call of my existence—my premature birth, which my mother's boat trip to Miami had probably precipitated.

All of these incidents confirmed my belief that there was a force watching over me. So, too, did a couple of other events that followed. One of these took place after a call I received from my good friend Harry Belafonte, who had called to say, "I want you to go with me to Mississippi."

I said, "What's up?"

He explained: "We have to take some money down for the civil rights movement." The group in that particular area was desperately short of funds and needed the relief. I agreed to go, and he said, "I'm going to call the U. S. attorney general, Robert Kennedy, and let him know we're going. We'll take a commercial plane down, and then a private plane to deliver the money. I'll give him our itinerary, and ask him to have his guys keep an eye on us."

Several people who went South to involve themselves in the civil rights struggle had been killed, and the killers had acted with ignorance or complete disregard as to who their victims were. Harry and I did not feel that celebrity status offered us any protection.

When we arrived, it was night by the time the two of us boarded the small charter plane, and when we landed at our destination, it was pitch black. But there were our guys—leaders and organizers of the movement the likes of Stokely Carmichael and James Foreman—waiting for us with three cars. As we were getting into the cars, somebody said, "There they are!" He pointed off to the far end of the airport, and we saw the headlights of two trucks. They started moving in our direction, but Harry and I were told not to worry about it and to get into the middle car of the

three. The men in the front car had guns, as did the men in the third car.

We moved out, and as the trucks tried to catch up, the third car would move over to block an attempt to pass. If the second truck moved up behind the middle car while this was going on, our car would move up ahead of the first car. It was choreographed much like a ballet, though a nerve-racking one, as we maneuvered our way into town.

Harry and I spent a restless night under guard in the home of one of the town residents, and left the next morning.

A similar incident had happened when I was in South Africa in 1950 when Canada Lee and I were making the film *Cry, the Beloved Country*. I was there eleven weeks, and South Africa under apartheid was an awful experience. We worked in Johannesburg in a studio, and there were separate bathrooms for blacks and whites. The one for blacks was in the most horrendous condition you could imagine. I asked the whereabouts of the other bathroom, and it was pointed out to me by someone who said, "But you can't go in there."

I went nevertheless, and after I was in a stall, I discovered there was no toilet paper. A white kid had come in, and I asked if he would pass me a roll of paper from the stack that I could see outside.

He demanded, "What are you doing in here?"

I thought it was obvious since I needed paper, and I asked him again.

He said, "You get out of here," and he turned and walked out.

After I left the bathroom, I went directly to the office of the studio manager. I said, "Look, I'm not a troublemaker, and I know the conditions under which I am here: I am here as an indentured laborer because that's the only means under which we could be brought into the country to work. But I want you to know what just happened in the bathroom." I told him I didn't want him to fire the kid, but I wanted him to call the kid in and explain to him that if he saw me in the "white" bathroom again—because I was not going back to the other one—it would be best for him not to say anything to me and I would say nothing to him.

The studio manager said not to worry about it; he would take care of it.

During the next six or seven weeks I used the "white" bathroom and I had no problem. About two weeks before I finished work, I came into the studio, and sitting on a wall at the front entrance was this same kid, and he was making nice. He said, "Hello, how are you?"

I said hello, but I was a little skittish about him, because I knew what he was. He said, "You're leaving next week, I hear."

I said, "Yeah."

I later told my driver, Dickie Niaka, about my dubious conversation with the kid, and Dickie, immediately suspicious, said, "I'll take care of that. I'm going to take you to the airport."

I, along with several of the other black actors, was staying at a farmhouse twenty-six miles outside the city, in accordance with apartheid law. When Dickie came to pick me up, there were two other cars with him. Dickie put me in his car, explained he would drive between the two other cars, and handed me a gun and gave instructions on how to use it.

I asked, "What's up?"

He said, "Just in case."

So we headed out to the airport, a forty-five-minute drive. Soon after we hit the main highway, a car came out of each side of a crossroad. Dickie floored the gas pedal, and the two cars now following us sped up. Dickie, an experienced driver who knew the countryside, did everything to outmaneuver them, running through cornfields and down narrow, unpaved pathways. Suddenly, we were back on the motorway with Dickie driving ninety miles an hour and the chase cars

right behind us, but being effectively blocked off by our other two cars.

We finally arrived at the airport safely, and I offered the gun back to Dickie, but he told me to keep it.

There were British and Jewish families living in South Africa, and although it was against apartheid law for them to interact with us socially in their homes, some of them nevertheless invited Canada Lee and me for dinner. Often, they would suggest that our driver come in to join us, but Dickie politely refused, saying he would rather stay outside and rest. The truth was that he wanted nothing to do with those he saw as, no matter how liberal they appeared to be, part of South Africa's apartheid system.

What might have happened had either the South African or Mississippi chase cars caught up with us? Certainly nothing good.

I have had one more experience, Ayele, that I must deem a close call, though one of quite a different nature. Many years ago I received a call from Florida. It was my eldest brother, Cyril, calling to tell me that cancer had been found in his prostate. I told him that I knew of a wonderful doctor, and I advised Cyril to get on a plane and come to California, where I would make arrangements for the doctor to see him.

My brother came, and my doctor sent him to a highly respected prostate cancer expert, who found that Cyril did indeed have the disease, and the only thing he could recommend was to shave it; that is, cut away whatever was on the outside of the prostate that needed to be removed. In fact, the cancer was too far gone for much to be done. The specialist did the best he could. My brother went back to Miami and lived a couple of years longer, and then the prostate cancer took him away. He was eighty-one years old at that time. By then, I had come to terms with the mortality of loved ones, having lost parents and friends, some to old age, others much too early to bear. But Cyril's passing was tough. He was the firstborn of my siblings, my big brother who kept me anchored to my past and where I came from.

A few years after Cyril died, my doctor told me he noticed from my blood work that the level of my PSA—my prostate-specific antigen, a marker for possible prostate cancer—had snuck up from four to six. Not to worry, he said, but it needed to be watched. Then, a few months later, he found it up to seven or eight, at which point he said, "We have to do something about it." He sent me to another urology specialist, who ordered a biopsy, the result of which showed no cancer.

Then the PSA went up another notch, and they said, "Well, we'll do another biopsy." To make a long story short, they did four biopsies. *Four.*

Lo and behold, on the fourth one they found it, and it was embedded.

They wanted to know what I wanted to do about it, and I asked, "What are my options?" If I chose to radiate it, and if that wasn't successful, it would be too late, they told me, for surgery. My question was: "Why don't you just remove it?" The doctors agreed that would probably be the best approach. So I said, "Fine, let's remove it."

I speak of it casually now, but I was concerned then because Joanna and I have two children, and I didn't want her to bear the burden of having to bury me. I was not afraid for myself, I really was not, and I was happy to not be afraid, because I have dealt with fear, I have lived with fear, I have been seduced by fear, and I have overcome many of my fears (although certainly not all). So when I realized my concern was primarily for my wife and six children, I was comfortable with whatever the outcome was going to be. I kept telling that to my wife, and she was terrific, she really was terrific. We had to tell Anika and Sydney and their four older sisters, and they all understood after it was explained to them that the cancer

was encapsulated and exactly what that meant. Once we had talked with the children, Joanna was at ease with it as much as she could be, knowing the kids had been told the truth.

So the day came and I went to the hospital. I went under a different name, putting together the name of my grandfather and my great-grandfather, but the press found out anyway.

Once the doctors removed my prostate, it was sent out for examination, and it was confirmed that it was encapsulated and nothing had escaped, which was the best possible news: nothing had escaped. I had to go back many times to recheck, just to make sure.

But without the prostate, life was still life. Now it became a subject of concern that I was able to talk about during an interview with Maya Angelou on the Oprah radio network. Maya was under the impression, correctly so, that a very high percentage of African American males were discovering they had prostate cancer. She wanted me to call in to her show and discuss this, and I did, knowing the kind of person she is and the kind of heart she has.

We discussed the problem quite openly on her program, hoping that African American males would not be reticent, shy, or dismissive about the importance of going in and getting an examination. As a result of my

own experience, I tried to deliver to them a message: "If you can afford it, do it; if you cannot afford it, go to a hospital where they will do it for you for free, or if you can go to a hospital or a clinic where you can pay it off on an installment plan, do it. Whatever it takes, go and get an examination for prostate cancer, because it can kill you like it has killed many, many men. The truth of the matter is, if one is a father and his children are still dependent upon him, or if one has hope of fatherhood in the future, it would be sound judgment to check your prostate to be sure to stay on the road to a long and successful life."

My two oldest children—your grandmother Beverly and your great-aunt Pamela—made a documentary of my experience with prostate cancer for the American Cancer Society not long after I had my operation. And I have been known, I suppose, in many circles to be a prostate cancer survivor. Maya touched on those points and asked me questions candidly, and I answered them as honestly and correctly as I could. I wanted African American men, who die disproportionately of this disease, to take heed of my message—and obviously Maya Angelou's as well—because many deaths could be prevented. Depending on the tenacity of those who are vulnerable, numerous lives could be saved by their simply saying, "I'm going to find out

about this disease called prostate cancer. I'm going to go and get an examination." Let the doctor say there is nothing to worry about. Or, if he says there is something to worry about, accept that and do something about it.

I went in and had mine done, and I've lived a normal life, normal in every way, and I'm here—fifteen years later, I'm here. I'm fortunate, yes indeed.

There you have it, with all those and other dangers now behind me, my dear Ayele, and I sit here now at the start of my ninth decade, as safe as life and the city permit.

People of Courage

It is not a bad idea, Ayele, as you grow into adulthood, to fix your eye on people of your parents' generation, or perhaps those even older, to find those you can admire for their qualities of character and contribution. Heroes and role models are important, especially because when you think of them they have the ability to buoy your spirits and ignite your energies to move you onward.

In my own time, I found such people, and if you read of them in your history books or would like to share heroes with me that I have counted as most inspirational in my time, that would please me greatly. Some I was

fortunate enough to know personally; others I was not, but my admiration for them developed nevertheless.

But it's more than just admiration; it is also a deep appreciation for their having been instrumental and transformational in my life through their examples, their stances, and their courage. These are men and women who were fearless and yet mindful of the dangers to themselves, and to all they held close to themselves in terms of their responsibilities.

The cold, hard fact of courage is that it has to spring from within, because its opposite, fear, lives inside of us as well—as I've written about to you at length. Fear really is alive, even when it's just sitting there and we are free from its influence; still we are aware how dangerous it is, how debilitating it is, how crippling it is, and how it stops us sometimes.

The people that I count among my heroes and role models are men and women who had to make up their minds within themselves. They had to look at the cost. One that might very well be bodily harm, even death; it might very well be a stain on their character or their reputation. All those things come into play.

I am particularly grateful for having had exposure to Nelson Mandela, one of the most stalwart examples of courage that I know, and a person I was honored to play in the film *Mandela and de Klerk* in 1997. Earlier,

in 1950, I had a near-meeting with Mandela when I was in South Africa to make Cry, *the Beloved Country* and was invited by Dickie Niaka, my driver, to come to a picnic.

"What kind of picnic?" I asked.

He said, "Well, it's some people who are kind of political."

I thought, *Uh-oh, that doesn't sound too good.* But I told him, "Sure, I'd like to go," because I liked him.

It was a wonderful picnic in a park. There were members from the African National Congress and the Indian National Congress, men who were wanted by authorities for their violent opposition to the apartheid government. I didn't see Mandela, but I heard later that he was there. He was eventually arrested, and spent more than a quarter of a century in prison, a man the South African government evidently thought too dangerous to be free, but also by then too prominent to be killed. By the early 1990s he was out of prison and, in an astonishing display of brilliance and perseverance, won the Nobel Peace Prize and became the first democratically elected president of South Africa.

During all that time, I had come back to America and gotten on with my life and career. Then one day I received a call from Los Angeles mayor Tom Bradley's office saying Nelson Mandela was coming

to California, and the mayor would like for me to be there. Now, I don't know if he was asking me because of my celebrity junk, or inviting me because Mandela had given him my name. It didn't matter; I went.

At city hall, I didn't join in the crowd because I don't push myself into the forefront of things like that. Instead, as is always my habit, I was over against a wall as the grand procession passed through, with the guest of honor and the mayor amid an entourage of many lieutenants as they headed through a corridor to get to the building's balcony. Suddenly Mandela looked over in my direction and said, "Sidney!" And I am thinking: *Oh, my God! He called my name!*

He came toward me and I went toward him and he hugged me and I said, "It's a pleasure to see you, sir," and he said, "It is good to see you," and with that, we started talking and pretty soon had to be subtly encouraged to continue our conversation at a later date. I was famous in my house for two days after that.

Some time later, I went to South Africa to make the film in which I played him, and when we arrived the film company got in touch with his office in Cape Town. Mandela invited Joanna and me, my daughter Sherri, and a friend of Sherri's over, and he received us for tea.

More visits followed, one when Joanna and I saw him again in Los Angeles in conjunction with fundraising for his foundation, to which we contributed, and then a visit at his hotel—where he was staying with one of his daughters. We had a wonderful time, with long discussions that gave me grist for the philosophical mill for months to come. We visited again in his offices in Cape Town. After that, we maintained a correspondence, in the course of which he thoughtfully sent books and other written materials of interest my way.

Oprah Winfrey asked me a few years later to attend the festivities connected with the opening of her school in South Africa, and I said yes, gladly, not only out of admiration for her, but also because I would get a chance to see Nelson Mandela again. And indeed, I saw him twice, once when he came to speak at the school, and again the next day. He made himself available to all of Oprah's friends who came from far and wide, and he sat in his office in a chair. We were all brought in, but were told the briefer, the better: just a "hello" and "thank you," and a picture of each person would be taken and copies sent. I walked in, he recognized me right away, and we talked. But I was very observant of the need not to tax him. We said we would stay in touch.

He was physically weakened, but his mind was still quite good, and his memory seemed to be in excellent condition—a great man among the men who exemplify unimaginable courage.

It was a challenge to play him in the 1997 film, in that I wanted to do so in such a way that his people would see that I had made as worthy an effort as I possibly could. No one can be him but him, but I tried to re-create his physical characteristics, the way he walked, and certainly the way he spoke; I came pretty close with that. His years of forced labor in the quarries during his imprisonment caused damage to his legs, giving him a limp, and hours of punishment from the blazing sun had left their mark. Those physical details certainly gave me insights into his extraordinary essence.

Another man of my time was Thurgood Marshall. He was a man who went to the most dangerous places in the most dangerous years of social unrest in America. At great personal risk, he had to enter and leave courtrooms with caution, spend many nights secreted away in homes of local supporters, and be transported out of hostile towns in unexpected ways. It was rumored that he once was driven to safety out of a particularly dangerous town in a hearse. I heard such stories from people who were close enough to have had

firsthand knowledge. I never forgot hearing how he once said to a supporter who was courageous enough to provide him lodging that it would be best if he was given a room "away from windows."

As with Mandela, I had the great opportunity to play Thurgood Marshall in a motion picture, and it was an honor to do so. In preparing to play him, I had to know about his childhood, his life in Baltimore, when he was a young man and could hardly get into college, when he worked for the NAACP, and when he went to the Supreme Court.

Once you know about a man like that, and in your mind's eye you see what he has endured, you wonder what the forces were that enabled him to say, "I am going to do this. I might not get home alive, but I have to do this thing. I must do it." And to have the resolution in himself that says, "I am OK. If I have to do it, I have to do it. If I don't do it, I wouldn't be me, so here we go."

That is applicable to every one of the people I mention here, ones whose lives were certainly on the line but whose courage was such that they were able to face the fears and do what they needed to do in order to be at peace with themselves.

I also knew and traveled with Jackie Robinson; I was often at Dodger Field in Brooklyn in the heyday of the

era when he played. I knew that he was not wanted in that ballpark by a great number of people. I saw the way they behaved, including many of the fellow players—athletes—trying to eradicate him from the game of American baseball. But Brooklyn Dodgers owner Branch Rickey had been looking for such a man—one who had to be extremely gifted at what he did as an athlete and had to be extremely courageous to endure the challenges: to get up at bat and have people throw balls at him, the throwing of which may have looked like an accident but was no accident. Jackie Robinson was the guy.

Jackie had to make a choice: taking insults was not in his nature, but he knew that he had to do it, despite the possibility of damage to himself; his life was absolutely on the line. There were people who didn't want him there, even if they had to do away with his life to get him out of baseball. That wasn't the kind of democracy they believed in.

Jackie and I got to know each other when he was an executive at Chock Full O' Nuts. We often met at their store at the corner of Seventh Avenue and 125th Street. Later, my first wife, Juanita, and I went on vacation with Jackie and his wife, Rachel, along with Marty Baum and his wife. We went to the Bahamas and had an enjoyable time, but it was raining con-

stantly. We had ten days, but after three days of pure rain, we decided we couldn't afford to waste the whole holiday since we came for sunshine and beaches. So we decided to fly from the Bahamas to Mexico. We wound up in Acapulco, which was absolutely terrific until the day when Jackie was off somewhere else and Marty said, "Let's go swimming"—which, of course, ended up with the close call when the two of us very nearly drowned.

But there was another athlete before Jackie who stands tall in the pantheon of courage—an athlete and more: Paul Robeson. This was a truly remarkable man. He was a great athlete, an accomplished musician, and a wonderfully well-educated man who was fluent in as many as eight different languages.

He was highly respected in the African American community, but I also knew, for reasons that I touched on earlier, that some were fearful of an association with Robeson, because he was a target of political forces in the country and was often accused of being a Communist.

I don't know if he was a Communist or not; I really, truly don't know. I never saw or heard him say anything about being a Communist. He didn't label himself anything. He repeatedly said that he was working on behalf of disenfranchised fellow Americans who were being denied their full citizenship as guaranteed

by the Constitution of the United States of America. He was received as an artist of renown throughout Europe as well as Russia and was greatly admired everywhere for his concert appearances, as well as his aims and aspirations as far as his people in the United States were concerned—for whom he was asking for fair play. He wanted black people to be given the rights of democracy. I believe he was genuine in that wish, and I believe he was genuinely extending himself in that regard.

I admire him for his courage and for the person I witnessed him to be when I attended some of his concerts where he sang and spoke. I respected him and believed that he was too smart to allow himself to be used by the Soviet Union or the United States. He was interested in full citizenship in the country of his birth. He didn't have it and his fellow African Americans didn't have it, and I believe that was his mission, his principal interest.

So to me he walked the earth as a man of courage.

I spent some time with James Baldwin, too. I was in France, and he asked Joanna and me to his place in Saint-Paul de Vence, near Nice. He put on a wonderful lunch for us, and my wife was totally captivated because of what she saw in him. He was a tiny man, and very knowledgeable about life, though in his experiences he had faced enormous difficulties—some of

which had to make him the kind of remarkable, powerful writer that he was. It was a painful life—not all of the time, but certainly part of the time.

Baldwin was born in an age that was not really ready for him—a time when he had to be careful, watch his own back, when it was not a good time to be gay. But he was not in any way trying to behave to the contrary. He had most of his difficulties here in America; in Europe, it was not a problem to the same extent. He was comfortable there because he had friends who embraced him for who he was.

After spending time with him, I could see that he had no interest in denying that he was homosexual, and he was quite close with other homosexuals: great writers, filmmakers, and playwrights. He was most at ease with people who were not judgmental.

I admired him because of his courage.

Then, of course, there was Ralph Bunche, smart as a whip, bright, gifted, trying to bring peace between the Israelis and their neighbors in the Middle East. Being U.N. mediator in that part of the world was a tough job, but he had the credentials, fought his way through, maintained his responsibilities, and gained respect for himself, fellow African Americans, the United States, the United Nations, and the world, for his efforts. Fifty years later, we definitely could use his

kind of leadership. Ralph Bunche was a person who put himself on the line, courageously, with vision and tenacity.

I have seen those same qualities of vision in Oprah Winfrey, a woman I'm happy to call a friend. Oprah speaks to the heart in all of us. She has managed to tap into the hopes and dreams and lives of millions of Americans, and millions of others around the world. It seems she was designed by the power of the universe and sent forth on a mission so profound that her impact cannot be fully explained. Meanwhile, she shares with us the self that she is: from her humble beginnings, and on through the ordinary activities of her early life, creating an unbreakable bond with the spirit of millions of her fellow human beings.

Like my mother, she has a connection to the forces "Up There." Like my mother, her faith is rock solid. Because of her courage to explore unanswered questions, we have spirited discussions. And sometimes she gets the better of me!

Lesser known to the public at large, but no less transformational in her own right, is Reveta Bowers— a master teacher who for years has lent her leadership as head of school at the Center for Early Education in West Los Angeles. Educators like Reveta ought to be considered our greatest national resource. Her vision,

her methods, her understanding and that of others like her could help solve the school problems in our country. In these budget-crunching times, she has taken on the status quo and galvanized the community to support the potential of early education for diverse communities here in Los Angeles. Whenever we have worked together, as board members at meetings or in discussions, I invariably look to Reveta for her clear, courageous, articulate take on whatever the subject of concern.

There are other women also, whom I haven't had the chance to get to know well, whose lives leave me with admiration. Marian Wright Edelman is one such fearless champion who, with her aura of grace, has been able to confront the entrenched powers who would otherwise ignore her issues.

Marian's father, Arthur Wright, was a Baptist preacher in Bennettsville, South Carolina, who died when she was fourteen. The last thing he told her was: "Don't let anything get in the way of your education."

She heeded his advice. After graduating from Yale Law School, in 1963, she became the first African American woman to practice law in Mississippi. Her magnificent work since has centered on issues relating to child development and children in poverty, and in 1973 she established the Children's Defense Fund

to aid poor, minority, and handicapped children. She has been an advocate for pregnancy prevention, child-care and health-care funding, prenatal care, parental responsibility for education in values, reducing the violent images presented to children, and selective gun control in the wake of school shootings.

Another trailblazer I much admired was Barbara Jordan. I did not know her, and that, for me, is a loss. As the first black woman to serve in the House of Representatives, she altered the political landscape with power and a presence that seemed to be channeled directly from a source larger than herself. Every time she spoke, I was transfixed. One of her most eloquent and memorable speeches was delivered at the 1976 Democratic Convention—as relevant three decades later as it was then, when she spoke of the need for innovation:

> We do not reject our traditions, but we are willing to adapt to changing circumstances, when change we must. We are willing to suffer the discomfort of change in order to achieve a better future. We have a positive vision of the future founded on the belief that the gap between the promise and reality of America can one day be finally closed. We believe that.

Barbara Jordan was not only an effective political force but also a public servant and simply a good human being.

What is noteworthy, my thoughtful great-granddaughter, is the existence of earlier individuals of courage who helped pave the way for those who followed. The name of Fannie Lou Hamer, for example, is important to recall for her contributions as a civil rights activist who gained national attention with a speech at the 1964 Democratic National Convention, in which she told of voter discrimination and violence against blacks in her home state of Mississippi. Born the last of twenty children in a family of sharecroppers, she chopped and picked cotton as a child. As a woman, she worked on a plantation until she was fired for registering to vote, but, refusing to be erased, she went on to become a national symbol of the participation of poor Southern blacks in the civil rights movement. A debt of gratitude is owed to Fannie Lou Hamer to this day.

Then there is the woman who for forty years was one of the most fearless and respected women in the United States, Ida B. Wells. My friend William Garfield Greaves did an excellent documentary on this extraordinary woman. Orphaned at sixteen when her parents died in a yellow-fever epidemic in the late 1870s, she nevertheless managed to attend college, and became a

teacher in Memphis, Tennessee. She was later involved in an altercation with a white conductor while riding a train. Having purchased a first-class ticket, she was seated in the ladies' car when the conductor ordered her to go sit in the Jim Crow section, where there were no first-class accommodations. She refused, and as the story goes, when the conductor tried to remove her, she "fastened her teeth on the back of his hand." Ejected from the train, she sued, winning her case in a lower court, although the decision was reversed in an appeals court.

These were courageous acts at a time when the death of a black woman or man at the hands of someone who wasn't black was often devoid of penalty. And in spite of the awesome nature of the authorities, she stood against exploitation and threats.

Behind the broad strokes of history there are always individuals of courage who have been chosen by destiny to play their parts. Two women who exemplify behind-the-scenes heroism are Dr. Mary McCleod Bethune and Eleanor Roosevelt. The two women, one black, one white, teamed up as friends and allies on a range of issues relevant to minorities—particularly in their advocacy to create more opportunities for African Americans in all the branches of the military. Together, they campaigned publicly and personally to convince

President Franklin D. Roosevelt to activate the Tuskegee Airmen, the Ninety-Ninth Pursuit Squadron.

Many historians believe that the pilots of the Ninety-Ninth who provided escorts for the American bombers on their missions from Northern Italy to the various German targets were a key factor in the Allies' victory of World War II. Without the two women moving mountains, however quietly, the Tuskegee Airmen would never have found their wings.

Today, we are all beneficiaries of the resolve of the black students across this nation in their refusal not to back down in the early days of school desegregation. For example, in Arkansas in 1957, the boys and girls of the Little Rock Nine, as they were known, crossed the threshold of a previously all-white high school—under the guard of one thousand members of the 101st Airborne of the United States Army. A few years later, deadly riots were set off when James Meredith became the first black student to attend the University of Mississippi.

Exemplifying the kind of courage I'm talking about is Charlayne Hunter-Gault, one of the first two African Americans to attend the University of Georgia in 1961, who endured the animosity that included at one point a horde of segregationists attacking her dormitory with rocks and bottles. City police had to disperse the mob.

But she stayed firm throughout with a bravery that seemed to say, "That's my calling. That's where I want to make my stand. That's where I want to let it be known that we are not represented, and I want to represent those who feel that they are not represented." She graduated and went on to a distinguished career in journalism, winning numerous awards.

When I was in South Africa for Oprah's school opening, Charlayne Hunter-Gault was kind enough to invite me to her lovely home there. With the tireless energy that made it hard to believe she was turning sixty, Charlayne was moving about the continent constantly as an indispensable eye for others who live outside Africa and have an interest there. She had been a wonderful correspondent for PBS, was writing a book, and was doing special pieces for various networks in Europe and Africa.

Having sung the praises of individuals that others have acknowledged before me, I should point out that some people don't always receive their just recognition for acts of courage—but they do what is right because they must or because they can. Lyndon B. Johnson is someone who has rarely been given his due; I grew to have such great respect for him. He was buffeted about by circumstances, including the Vietnam War, but on the home front, and in other aspects of world politics,

he did some wonderful things. The most remarkable was that he—a Southerner—of all people met with Dr. King and the leaders of the civil rights movement and recognized that it was incumbent upon him to step up and push through the Civil Rights Act of 1964. Even though the political winds were against him, he understood that, for the sake of American democracy and the moral and ethical values on which it is based, this was his calling. Destiny had marked him for this purpose.

President Johnson went into the dungeons of the Republican and Democratic party structures and fought with those who believed that blacks were not meant to participate in the practice of democracy. They were so against what he wanted that he had to use all of his skills as a politician, all of his resonance as a Southerner, and all the chips that others owed him. He put it all together and made it happen in the United States of America.

In 1965, President Johnson appointed Thurgood Marshall as solicitor general—a tenure during which Marshall won fourteen of nineteen cases. Then, in 1967, Johnson went a step further and appointed Thurgood Marshall to the U.S. Supreme Court.

LBJ was a stone, absolute Southerner, yet he had the guts and the courage and the sense of humanity to demand equality for minorities in this country. My

feeling is that history books should reserve a place of honor for LBJ.

Another unsung person of courage to note in this context is Earl Warren, a Republican. He did for the African American community a monumental service. Many people don't know what a fight it was to get the U. S. Supreme Court school desegregation decision of 1954. When I played Thurgood Marshall in the film *Separate but Equal* in 1991, the movie script called for me to argue as Marshall before the Supreme Court. Director George Stevens put together the combination of truths lying behind that decision, including the difficulties that Warren had bringing in line the other court justices. A few of them were absolutely against it. But Warren stuck with it. He believed in it for America. It was the move of a man of character.

In Africa, there are still more men, if you're looking for courage. There, a few years back, the colonial powers were the ones who owned the government, who owned the guns—the ones who were responsible for whether you ate, had a job, whether your children got an education, or whether you lived or died. But that colonial system was challenged by, in addition to Nelson Mandela, men like Kwame Nkrumah of Ghana, Jomo Kenyatta of Kenya, Julius Nyerere of Tanzania, Nnamdi Azikiwe of Nigeria, Kenneth Kaunda of

Zambia, and men in others places. They knew that the authorities would try to eliminate them. The South African government sent warplanes to bomb Zambia, where the African National Congress of South Africa had exile headquarters. The ANC had declared war on the colonial power that had taken their country, put it in the configuration of the British Empire, and utilized their resources and exploited their people. But these men said, "That is wrong," and they stood brave in the face of all the inequities.

There are also individuals whose very names represent a distinction of courage that defines them—Dr. Martin Luther King Jr., without question, and Jimmy Carter, both the man and the president. President Bill Clinton is certainly someone I deeply admire—for his charm, his brilliance, and his humanity.

There is a group of incredibly courageous individuals that I would be remiss not to mention collectively—the artists of this world who help give humanity its soul. I'm talking about the extraordinary actors, writers, directors, painters, musicians, dancers, and others who have inspired me throughout my career and in whose company I am honored to be. Now more than ever, we must look to our artists to be our truthtellers and to challenge us toward creative solutions to the many problems mankind faces.

As I survey the changes on the horizon, I'm encouraged by the appearance of promising leaders who will surely come to epitomize bravery for your generation—Barack Obama, for one, who has in a short time altered the political landscape. I'm excited by a heightened consciousness among creative entrepreneurs and activists like Steven Spielberg, Bono, and Bill Gates—each of whom has taken on a cause larger than themselves.

When I speak of men and women of courage, dear Ayele, I also think about my own father. His acts were not a matter of life or death, but he was a man of courage nevertheless. My father had a sense of himself and his fellows. He was a member of the leadership of the community, the people who made the decisions about how they should live with their neighbors, how they should coexist in terms of sharing the land, how they should live in terms of bartering. He dealt with the farmers and with the fishermen, the people who worked the fields and those who worked the sea. He spoke with them daily.

He had little substantive education, much like his fellows, but they spoke about the stars, religion, and what they knew of history. They knew that they were there in the Bahamas because their forefathers had been captured and put on ships and transported to a different part of the world. They knew that those an-

cestors had a history and a culture, and they talked about that history and culture. Through oral history, they retained some of the fragments of who their great-great-grandfathers were, and probably even some surviving words of their language.

They didn't talk about England. They knew that the white men with the big boats came, and they rounded up people, and those that resisted were subdued or killed. They didn't know the names of the oceans, and they had no concept of the continents, but they talked about this history because they knew that the people who captured their ancestors came from somewhere else. And they knew that those people had the advantage of weaponry, and technology: they had boats. And they knew that what those people wanted was to convert them from the free people they were to slaves, transport them, sell them, and work them.

My father wasn't born until 1884, but he knew what slavery was, even though he was now removed from it. And he and his fellow men articulated their opinions and posed their positions to each other about how it came about, what happened, and how they got to be where they were and who they were, and what could have happened in Africa when their forefathers were taken into slavery four, five, eight, ten generations earlier.

Some of the men of courage I have mentioned were grandsons or great-grandsons or great-great-grandsons of some of those same people, but they had an education. Robeson, Bunche, Marshall, and Robinson had magnificent educations; Nelson Mandela was educated as a lawyer. But even though my father was not learned in a formal sense, there was nevertheless a connectedness between him and all sons and grandsons and great-great-grandsons of all the slaves who ever lived and died in the Caribbean area. There is a sense of self, of character, and of personal self-worth and kindness and hopefulness and embrace that is characteristic of such people, educated and noneducated alike.

My father was not ashamed that he did not have much of an education. He had a point of view in life, and I think that is where his character was. I see in my mind's eye a gentle, firm, meaningful, courageous person. He would discipline his children with a sense of fairness. He expected of them a certain kind of response, and when that response was not forthcoming, he whipped some bottoms and punished his kids for particular kinds of misbehavior.

Among elders of the village, he had their respect, and they had his. I can remember that. Even now I can hear him talking with his compatriots, I can see him spending an evening with his peers, sitting around

on a moonlit night, drinking and sharing thoughts on what they perceived to have been the endless complexities of life. He was quite a person; he was my frame of reference. He was the male I knew who took good care of me, spent time with me, and talked with all of his children. I remember his speaking in terms of what a person needs to do, how a woman should behave, how a man should behave, how respect should be observed—all such things that spoke to the elements of character.

Looking back, retrospectively, the man I now see my father to have been was of such texture that I would put him against any man in the outside world. What I judge him on today would be his character, his heart, his courage, sense of fairness, compassion, humanity, on his sense of himself. I think he saw himself as a good man, and he charged himself with the responsibility to remain a good man, despite the difficult life he lived. I could see him contemplating a question, looking for the right answer, searching for the proper response, examining whether it was honest or fair or reasonable or worthy of him, or of the person he was trying to help, or of the person who was seeking to help him; all of that is both in one's body language and in one's internal attitude. You can tell; that's how I learned: watching how differences were settled. And

I never witnessed a fight between two adults that involved my father—except for the time when my uncle attacked him.

More than anything, the true sense of him came to me from how he was with my mom. I never, ever heard an unkind word pass between them, not one. I would watch her listen to him, and he would listen to her. They would talk about their family, their neighbors, the seasons, when the rains were going to come, the hurricane seasons and being prepared for them. And while they didn't know about the world materially, they knew about the universe. And they knew enough about the universe to know that they were a part of it, that there were forces and energies and connectedness between human beings and the stars and the oceans.

Part III

Questions, Answers, and Mysteries

The Neutral Zone

Dearest Ayele,
 My mind reels at the passage of the days. Yesterday, or so it seems, I met you for the first time, on your second day of life. Then just a week ago you turned two years old. You are now entering your third year of history, to be written later by you, perhaps in correspondence like ours, that you write to your great-grandchildren.

As I approach my eighty-first birthday, I intend to conclude this last handful of letters by returning to those large universal questions of existence that I posed early on—together with such answers as I can provide, along with thoughts and suggestions of further mysteries to

be unraveled by you and your compatriots in the years ahead of you.

There is no rite of passage to my knowledge for the passing of that torch, but it is well established that the search for answers to the fundamental questions of life falls to every generation. It will to yours, Ayele, as it has to your parents, your grandparents, and your great-grandparents, among whom I proudly count myself. How and when that search takes form is subject to many factors, especially the subtle and unpredictable influence of time, as I know all too well in the rapid acceleration of years left to me on my watch.

Therefore, Ayele, as time continues to fly, I will try, through these last letters, to pass on final insights that have worked their way through the grapevine that includes at least the six generations of our family that, we know for sure, have walked the earth in the past two hundred years—all of whom, each in their own individual and generational manner, have already undertaken or will undertake the search.

Let me state for the record that in my compulsions to be a better person, to search for truths, to be in constant deliberation—like unraveling the knottiest balls of yarn—it has not necessarily been a pleasant experience.

Indeed, Ayele, there is so much turmoil inside me. Big questions, little questions—you name it.

There's turmoil when I am alone, there is turmoil when I am at work, there is turmoil when I am trying my best, in a supposedly relaxed circumstance, to feel at ease.

I don't know why this turmoil accumulates inside me. Where is it coming from? Is it coming into me from the outside? Is it triggered by the way I live, by my reaction to things around me? Is it long-buried guilt, struggling to surface out of my subconscious? Is it shame, trying to claw its way through a wall of denial? Is it the suppression of long-overdue apologies owed to self and to others for wrongful deeds, conveniently forgotten but still festering in some dark corner of my subconscious self?

I know that I am not alone in this dilemma. Many of us are preoccupied with countless necessities, overlaid by hopes and dreams, by obligations we do not necessarily want to service. There arc the times when we are unhappy, dissatisfied with ourselves, or when our ego is kicking us because it is not getting its perceived due.

Seeking to satisfy someone else often causes problems. We wonder, *What am I being asked to do? Am I obliged to do this thing? But then I can't say no to*

friends, so I've got to work this thing out, when really I don't want to do it. But I am tortured by a certain obligation to my friends, when I should be in a position to say, "I don't want to do it and I ain't gonna do it."

When I watch a television news program by myself, I often become aware that I am being maneuvered. The television has no interest in my well-being. The interest is in keeping me there because they have something to sell me. They don't say, "Well, you come back any time you want, and we'll be here and can talk if you like."

No, they say, "Don't go away." And in order to say, "Don't go away" in the most profound way, the ploy is often: "So-and-so shot somebody, and you'll want to know about that. Don't go away." So you sit there, waiting to see who shot who. That kind of manipulation affects you, because you can't just sit there and watch without it having some effect on you.

We also have a set of reflexes to certain activities in life. When I am at a dinner table with friends or family, there comes a time, whatever the conversation is wrapped around, when certain portions of the body respond to what I'm thinking, or the direction in which the conversation is going. So if the conversation is beginning, unintentionally, to dance around something that I am involved with, or that I find highly embarrass-

ing or painful or simply don't want to deal with, certain parts of the body get the message even in the smallest degree, and the shoulders begin to go up a little bit. If somebody asks me a question that I don't want to answer, or if I don't know the answer and I don't want to embarrass myself, the shoulders go up, and sometimes the stomach muscles tighten a little bit. It is then fight or flight.

My experiences as a public speaker have tested this reaction many times, but have also taught me to be prepared with talking points as much as possible, in order to avoid the turmoil that arrives uninvited at the least opportune time or on the most banal occasions.

But even with preparation, it's a conundrum when it does happen, which is most of the time. And much of the time, in that absence of ease, when I'm in the throes of it—like being thrashed in the undertow in Acapulco—I don't know how to eliminate it, how to detach myself from it, how to rid myself of it.

Of course, this turmoil that taunts me now has been in me since I was a kid. I have lived with it for some time, as if this was a natural state, in that I have long been drawn to circumstances in my life that create tumult—although it can be a more difficult process to handle at this age, simply because it can wear a person out!

Maybe I put up with turmoil better when I was younger—because I was stronger, more on the go, able to use it and put it to some kind of use. As an actor, for example, or in facing challenges to my survival. Besides, nothing got in my way; I had my focus, I knew where I wanted to go in life, and I was prepared to endure whatever hardships arose, including the turmoil in my intestines.

That said, as I have gotten older, I've been increasingly aware that I am more desirous of less turmoil. So I began to think, *How can I get rid of this turmoil in myself?* It manifests itself internally—first the unease, then the preoccupation with trying to figure it out, adjust, organize, as the head constantly deals with issues and their opposites—until I accept that it's my nature, I suppose. Now, if I am going to accept that as my nature, I have to have some control over it. And the control I want to have over it is to be able to keep it at a distance when I feel a need to rest myself or to find my focus when more important issues are close at hand.

How do others gain control? Some choose to relinquish it and to rely on their religion and place everything in the hands of that power. Not the priest, not the rabbi, not the preacher in the pulpit, but in the image or the concept of God or Muhammad or Buddha. And that gives them peace. For some it is simply

a matter of going to church, and they come away full of the spirit. Things are wonderful, they feel good, and life is great.

But I think many people wrestle with the stress, unclear of a solution. They are troubled; they don't manage their difficulties well. They're not easygoing people; they're uptight, short of patience, easily agitated. In the worst cases, they turn to drugs—prescription or otherwise—or they resort to violence. They have never found that area within themselves where they can be peaceful with who they are, what they are, and where they are.

In my own case, as I began to think about it—as I do about everything—the appearance was that the turmoil inside me is so all-encompassing that its presence implies that I have no counterweight, no compensating balance. And without those, there can be no controlling of the intensity, longevity, or impact of the chaos making me uneasy.

It came to me that I need to be able to create counterweight, counterbalance. How do I do that? By drinking? Should I ingest other kinds of drugs, medicines, or whatever else might calm me internally?

No. As I've stated, I know people who have tried that, with disastrous results. *Instead*, I said, *maybe I can create a counterweight inside myself*, and the

thought of that was intriguing—just the thought of it. Now, what would that be? How do I go about that?

And, son of a gun, *bingo!* I was struck by the thought of a place I gave a name to before I even began to try to structure it: a neutral zone, a place inside myself where my consciousness, my instincts, and my imagination can be at ease, shut themselves down: where they can rest.

My neutral zone would be a place where I can simply enter at will and be free of all other considerations for as long as I need to be in order to create, or have a sense of self-control and engage my capacity to think, examine, and explore. All of those things could be possible if my internal self were not constantly dealing with the turmoil as if I were unable to control the inflow of all the world's problems coming at me.

What I would like is to create a neutral zone in which I am totally aware of everything that's going on around me, yet am able to control my inner flow. I would be able to sit, figuratively, in this neutral zone and just breathe, and be aware that I am breathing, and not think of anything other than what I choose to think about; think as deeply as I wish about whatever I choose, examine it from every conceivable point of view, even examine the opposite of whatever it is. And when I so choose and I feel I have had a requisite

amount of time with myself in my neutral zone, I can come out of it, knowing I can go into it and come out of it at will.

Now, what would that do to me? I think that would be just plain wonderful: to have a neutral zone in which—when the trials of life begin to wear you down, when the concerns or obligations or just the pressure of the outside world imposes itself on you through newspapers, television, BlackBerrys, iPods, and cell phones—you would be able to control your head and your sensitive innards to a point where you could order yourself to take it easy, settle down, and just relax.

We do this somewhat naturally in life. At the end of the day, we get weary, and somehow we know, from habit, that we have to go to bed.

So, for myself, and for all of us whose consciousness is constantly in play on all kinds of levels, I propose a zone into which it is possible to just simply float into neutral, and breathe, and not think of anything; to listen to our breathing, see if we can hear, as I've tried, our own heartbeat without putting a finger on a wrist or carotid artery. If I concentrate, I can feel my heart beating; I can hear my breath being sucked down into my lungs; I can almost feel my blood moving through my veins.

The health-giving properties have been so promising that I am working now to establish a neutral zone in my insides, using my consciousness as a gateway to create a place to go into. First of all, my consciousness will help in the creation, as will my instincts and imagination. This would be a place for them to cool it as well, away from the storms of life for a little while.

If I can create this neutral zone at this stage, I think it would strengthen the other side of me. It would strengthen the usage of my mind, strengthen my mental acuity, make sharper my perception, and hone my conceptual grasp on reality. That's what I would like to do.

Will I be successful at the age of eighty-one? I don't know, but it's something I'm going to try. The awareness that you're alive, and that your mind is free, that your brain is in good shape—that in itself is reward enough; to sit and let your imagination be free to wander, if it so wishes, to sit and empty your mind if you'd like, bringing it to a resting place, with your consciousness wide open—not working, but rather at rest. You're conscious of other things—everything you see, everything you hear, everything you feel, everything you touch. But you're not making judgments about what you see, hear, feel, or touch. You are free not to make judgments, and if you are free not to make judg-

ments, I tell myself, it places me in a mode where I am automatically replenishing the strength and vigor of all parts of myself. My heart benefits, my brain benefits, my mind benefits, my consciousness benefits, my imagination benefits, my instincts benefit. And I am free to watch them, one by one, trigger themselves into action because they need to.

I tell you all this, darling Ayele, to perhaps spare you some of what I have endured for far too long. My advice to you is to start to look for your own neutral zone early, for you will in time surely need a place to withdraw to, a place in which you find a period of peace and a replenishing of your vital resources.

You are never too young to start that quest, either, as I have found myself in my neutral zone becoming once again a boy of six, seven, eight, younger or older, sitting on the edge of the rocky bank above the beach on Cat Island, looking off into the distance at the point where the ocean meets the sky—the horizon. As an adult I can say that I have been out that far, and farther, but haven't gotten there yet, so I am still traveling on, to one day reach that final destination.

Logic and Reason

logic: a science that deals with the principles and criteria of validity of inference and demonstration: the science of the formal principles of reasoning.

reason: the power of comprehending, inferring, or thinking especially in orderly rational ways: intelligence.

—Merriam-Webster's 11th
Collegiate Dictionary

Picking up where I left off in my last letter to you, dear Ayele, I hope that you will one day value, as much as I do, the problem-solving

mechanisms that helped me, for instance, to establish the concept of the neutral zone.

Those mechanisms I'm talking about are the overlapping processes of logic and reason—which form a system that is inherent in me, as it is in all people, although the level of it varies. My hunch is that in our gene pool, given what I observed in my parents and grandparents, you and I descend from excellent stock when it comes to inherent levels of logic and reason.

The best story to give you as an example takes us back to the early days of my dad's work as a tomato farmer. With his natural instinct for logic and reason, early on in his efforts to grow tomatoes in the traditional manner, Reggie Poitier made a startling discovery that in and around the caves on Cat Island, the bat dung provided top-notch fertilizer for whatever happened to be growing in the earth around where it collected. Using logic and applying reason, he tried out his theory in small test cases, and sure enough, tomatoes grown in dirt enriched by the dung of bats from the caves were more delicious, more nutritious, more robust, and more plentiful than those grown in unfertilized soil.

But to get an adequate supply of the bat dung from the cave to the tomato fields was a huge problem, since he had no drays—what we called wagons. But

in a methodical, reasonable manner, my father found a way. He saved his money, bought a donkey, and eventually bought a horse. He would take croker sacks that he picked up from some store or found on the island and fill them with the bat dung, throw them across the back of his horse or donkey, sometimes on both, and truck them into the forest where he was raising tomatoes. Undaunted by the challenges, my father is a prime illustration of someone who was able to call on whatever level of logic there was in him. And his whole life proceeded in that manner.

Both of my parents exhibited a reasonable way of dealing with life and with other people, which was inherent and developed from their experiences, since neither had much schooling. My mother didn't have an education; she could barely read and write. I know that my father, who had more of an education than my mother, himself could barely read and write. They didn't know about the world as I know about the world. They didn't learn in the schools that they attended—for a very short time, obviously—that there was a world outside the primitive island upon which they lived. They heard there was an England, because we were the subjects of a colonial possession of the English, but we knew little of England, except for that song that they, like me, were taught in school to sing:

Rule, Britannia! Britannia, rule the waves!
Britons never, never, never shall be slaves!

That was pounded into us.

Logic and reason grow out of the experience of interacting with the world, with daily life, out of the instinct for the recognition of logic and reason in oneself, and out of the feeling that logic and reason need to and should be applied in one's best interest. In the part of the world where I came from, most people without an education didn't know what the word *logic* meant. *Reason* is another such word. The majority of people on Cat Island couldn't give you a definition of either. The two words, and all that sits behind those two words, were totally unknown to so many people in my life.

Nonetheless, survival requires the use of logic and reason. Reginald Poitier proves that. My dad had a difficult life, and I suspect that it was his lot to have a tough life. But a tough life did not mean that he didn't have a requisite amount of logic in his system, in his sense of how he looked at the world and dealt with it. He was just destined to have a difficult life. Physically it was difficult; economically it was difficult, that struggle to do the difficult things that he needed to do to feed his family. But his was a remarkable life in

spite of, perhaps because of, the fact that it was a difficult life.

Difficulty surely has nothing to do with one's ability to make fairly good use of such logic as one has in one's system. Now, ultimately that sense of logic, that sense of reason, came through the bloodline. But the fact is, things that pass through the bloodline don't necessarily surface in the following generation. (This is my own reasoning, by the way.) It doesn't follow that the members of every generation are going to have this wonderful quality of logic and wonderful understanding of reason instinctively even though they don't know what the words mean and they won't learn about them until later in life, if they ever do.

As a result of these qualities not being passed from generation to generation, like eye color and other things, they travel through the blood unexpressed, remaining intact, and suddenly surface in an individual in the second or third or fourth generation, regardless of that individual's external circumstances, regardless of the society in which he or she lives, regardless of economic disposition, regardless of the educational process that is available, regardless of what the parents had no knowledge of.

Up comes this person, and logic and reason flower in them, and they are able to extrapolate in ways that

most people don't. Something tells them when something is not quite right. They'll say, "No, I don't know if that's right." What tells them that? They know that if you take this fact and that fact and marry them with something else, the result will be a reasonable outcome. Many people don't get that passed on to them, that "reasonable outcome" instinct.

I think that some of what was passed on to me by my parents actually surfaced in them. It didn't change their lives; they still had a very tough life. But what passed on to me through them will I hope find fertile ground in the onward journey of my children, their children, and my great-grandchildren—among whom you are the first.

What made me destined or fortunate to be the recipient, I don't know. What was passed on has been enhanced by the life that I've lived, although that was just the polishing of it, or the nurturing of it. But as to its origins, my theory is, applying logic and reason, that there is this force—you've heard me speak of it, Ayele, as you've read my letters to you so far—of such extraordinary disposition that it created the world, the universe, or it influences and controls it. Yet it is not something that you could describe by saying, "Oh, here is a piece of that," or "Here is what it looks like. Here is a physical manifestation of a portion of that

force." No, it's intangible. It is all unto itself; you cannot hold it, push it, or turn it or twist it or pull it: you are subject to it. The force has that influence over your life, and it might have a need for you and your life in its own existence. Its existence might very well say, "I need this kid. This kid is important for us, and this is what he will do for us." You're destined right there.

We don't know that this doesn't happen, and because we have no proof that it doesn't happen, I am inclined to say: give me a good reason why it doesn't exist.

Many people die before they are ten years old, and maybe that force was very much in that person who died before age ten. But that person was destined to die at ten. He or she wouldn't live to be sixty or seventy. But because the child will die at ten doesn't mean that the child isn't carrying a wonderful amount of that force. But the force isn't concerned about the age of the child. That force doesn't have the same concern for what we term "the sanctity of life." The "sanctity of life" for us grows out of fear, the fear that maybe we won't live a long life. Most people in the old days died in their twenties or thirties or forties. And fifty was old age. Longevity, as we know it, is an evolutionary thing.

There are a large number of people who have no concept of logic and reason, and because they don't, it

will elude them forever. You can't teach it to them be-
cause of the balancing of very delicate elements of which
we are not even aware. The proper balances are not
there, and if the balances are not there—there's a reason
for everything—the concept of logic and reason wasn't
placed there to be nurtured.

For some people who do not use the power of logic
and reason, it doesn't mean that it isn't in them, but
it's not for this trip, not for this person. It is passed
through them because they are not eligible in so many
other areas. Now, we can't be the judge as to what
those areas are, but the force can be the judge. So it
goes right through them, and two generations later—in
their grandchildren or their great-grandchildren—will
come a kid of whom we suddenly say when they reach
the age of twenty: "What happened? You know what
he was like at fifteen: he was the roughest, tough-
est kid in the whole place. He's now a congressman,
for Christ's sake." People who have logic and reason
in them have it in them, and there are huge, magical
powers in nature itself.

Logic and reason can be taught in school—as they
have been—and to very, very bright kids. But the kids
become lawyers and don't practice logic and reason;
they get to be Wall Street moguls and don't practice
them; they get to be highly educated people and don't

practice them. Yet these are people who should be able to say, logically and reasonably, that certain things are ridiculous; who should be able to say that the response to the loss of life and the obliteration of parts of the city of New Orleans by Hurricane Katrina were ridiculous; that going to war in Iraq made no sense at all, and here are the reasons and the logic for it not making sense.

Using logic and reason, some people figure it that way. And there are people on the other side who say, no, the response happened because of this and that; no, the invasion had to be done because of this and that. How you use logic and reason is determined by how you are gifted with it; ultimately, your education isn't going to affect it. I know, or know of, too many educated people who were Nazis, who killed in genocidal fashion, and those who deny children food so they will die of starvation. If they had any logic and reason, they would not have done such despicable things. Logic and reason would have said that any way you slice it, it's going to come out as wrong.

For example: slavery. There was a time in these United States when slavery existed, even while we were very adept at calling ourselves a "democracy." There were rules and regulations laid out by the founding fathers as to what democracy meant. These

rules and regulations would cover every American, and being American meant being someone who was born here and lived here under this Constitution. If you say that to someone who is really logical and reasonable, that person is going to ask: "What about the Indians? What about the blacks? What about the Mexican Americans?"

What, then, would come from those people who were using the Constitution as a cover for what democracy should be? They would have to say, as they did for far too long, "Well, you see, they are not full human beings." As a chief justice of the United States once said, blacks were three-fifths of a human, and only a full human being should have rights, the implication being that three-fifths of a human being was something fit to function only as a beast of burden.

Well, that is a distortion exposing the enemies of logic and reason, and among them are mass hysteria, hate, prejudice, and ignorance.

With courage, by standing our ground and not forgetting who we are and where we come from, we can and must, Ayele, take on those enemies.

Science and Society: Friends or Enemies?

Ayele, my dear, now that you have heard many stories from the world that first raised me, a place in time that was void of all technology, you can probably appreciate my sense of the wonders that have sprung from technological advances in the course of my life—which have been at the least eye-catching, at the most mind-boggling. You may not think so when you are twenty-one, but nonetheless, the explosion of creativity out of scientific advancement across my eighty-one years was impressive enough to raise, over time, questions of comparison between what my eight decades have produced and what your first forty years will witness.

For instance, will the continual bombardment of television's invasive sounds and images further degrade the hearing mechanism of human beings and overwork their visual apparatus, causing prolonged stress on both senses, which in turn will induce the brain to engage in excessive processing of what is fundamentally useless information?

Perhaps the essential question to be raised here is one of the relationship between science and society: friends or enemies? And why does one progress at a more accelerated rate than the other? The whole of science, as I'm referring to it, encompasses the study, knowledge, and development of the technology and tools used for the advancement of civilization. The breadth of society, as I'm referring to it, takes in all of humanity, not just in a given time but across the millennia.

Let me start this exploration by telling you of my earliest introduction to instruments of science, ancient inventions so mundane now that your schoolbooks may have made little mention of them.

Science was a word I didn't know. I didn't know what it meant, and I doubt if I ever heard it on Cat Island. The first scientific development to which I was exposed was electricity. That was when we arrived in Nassau and I went into a store where there was a light-

bulb. Imagine how that altered my worldview. To my knowledge, there was no place on Cat Island that had electricity. Instead, to light our home at night we used kerosene lamps indoors and kerosene lanterns so that we could see outside—especially on those pitch-black moonless nights.

As for the lack of indoor plumbing, for bathing purposes we brought in brackish water in buckets from a community well, and poured it into a tin tub at home. All other toilet functions were accommodated in the "Great Outdoors," at an appropriately hygienic distance from our house—a particular spot next to which grew a tall plant with leaves as velvety soft as toilet paper, and similarly as useful. As for laundry, my mother often took me with her when making her regular treks into the forest to wash our clothing in the freshwater ponds and streams, where she beat the dirt out of the clothing with a force more powerful than that of any detergent or modern washing machine. But of all these practices, not many of them were in the realm of the workings of science or technology.

Not surprisingly, when we moved away from Cat Island, I had no frame of reference at first to process the reality of science. For example, even though I had heard about cars before, when we arrived in Nassau and I saw my first car on a hill up from the water as we approached

the harbor, it looked like a huge beetle making its way down to the dock. My mother couldn't explain to me that a car was the scientific result of finding ways to create wheels out of rubber and metal—stuff taken out of the ground and converted into tin and steel.

As we entered the harbor, there was this whole incredible panorama: huge ships, motorized boats, and then, lining up past the dock, more cars and trucks, all of which compounded my amazement as I tried to understand how they moved and turned, with people inside of them doing the turning.

As you can see, in this awakening I had total future shock as instantly I was hit by science; it was there in my face, and I had to figure it out. An electric light: what makes it glow? A car: what makes it move? Who's talking to the car and telling it what to do? I was being whammed by science everywhere I looked.

Suffice it to say, my coming to any knowledge of any aspect of science occurred at a much later age than it did for most kids in the world outside my early Bahamian upbringing.

And then there came the day soon after the move to Nassau when a couple of the guys in my new group of friends suggested that they take me to a matinee.

"Oh, sure, I'll go," I agreed. I didn't know what a matinee was, but I didn't want to show my ignorance.

They led the way and we went to the theater and sat in the seats—waiting for what, I had no idea. Then, when the lights went down, I watched this big screen light up, and the first thing I saw on it was writing and I thought, *My God, those are big letters.* Then the movie started, and I saw people on the screen, and I thought, *What's going on here?* And then I saw horses and cows and people dressed with feathers in their hair and animal skins strapped to their bodies— Indians, and I had never even heard of Indians. It was a truly shocking, but exhilarating, experience.

After we got outside the theater and the guys started walking away, I told them to go on, saying, "I want to stop off for a bit. See you later." As soon as they were out of eyeshot, I dashed around behind the building to see if the cows and horses and people I had seen inside were going to come out of the back of it. I sat there and waited and waited, but of course, nothing came out.

So I was by now acquainted with three scientific inventions: the car, electricity in its several uses, and what I would later know as celluloid, from which movies were projected onto a screen. (Again, I had no idea that was where my future lay.)

Another discovery for me in Nassau was radio. Most people still didn't have it, so my real exposure

to it came a little later, in Miami. Contrast that box of sound with nights spent on Cat Island, listening to the conversations of my parents, the lapping of the waves just outside the house, the wind, and all of the music created by nature and her inhabitants.

Indeed, at the end of the first ten years of my life, I had acquired very little knowledge beyond the joys and limits of Cat Island. But as my travels continued, I began to become accustomed to electricity, to glass windows, to motion pictures on the screen, and every day I would feast on new and unbelievable sights. And the day would come when I would actually learn to control that wondrous invention that first caught my eye: the car. But that control would be slow in evolving.

It started in Miami when I went to look for a job, having promised my brother that I would try to earn some money to contribute to my keep. My first job was as a pharmacy delivery boy, with the disaster of my leaving an order on a front step in Miami Beach when a woman refused to accept it from me at the front door. But after that, I passed a parking lot where men were parking cars. I lingered around, inching closer and closer to see what the guys did when they slid behind the wheel of a newly arrived car—how they turned a key to start the ignition if it wasn't left

running, how they shifted the gears and guided the car around. I also began to watch the drivers on the buses.

Eventually, I said to myself, *I can do it,* never having actually been behind the wheel of a car in my life. So I went to a lot and said I was looking for a job. It was wartime, and people were always looking for employees. The man asked a few questions about where I lived and so forth, and he wanted to know if I had a driver's license. I said, "Oh, sure, I have a driver's license." Then he told me to go to a car that was sitting nearby, and take it to a certain spot.

Getting behind the wheel for the first time in my life, I was able to get it started without a hitch, but then I was confused about the order in which to shift the gears, and when I got to the parking spot, I almost hit another car. That was the immediate end of me there.

Undaunted, I watched other parking-lot attendants at other places until I thought I understood the driving process better, and then made a second attempt at getting such a job, without much better results. Through trial and error, however, I eventually learned to drive a car, but I was still not that good at it, so I couldn't hold a job as a parking-lot attendant.

At sixteen years of age, I had my first experience with a telephone. I went into a phone booth with my

nickel, and I stood there wondering how to go about using it, and who I would call. I looked in the telephone book and saw that behind the names were a number of digits. So I picked a number at random and dialed it. When a person answered, I hung up real quick. I did that a couple of times until I had guts enough to say, "Hello." And the person said, "Who is this?" and I hung up again. That's how I learned to use the telephone.

By the time I was in New York for a while, the true magic of electricity in all its uses burst into my awareness and kept showing itself to me in countless ways. Eventually, I became somewhat conversant on such scientific objects as electricity, combustion engines, phones, motion pictures, and other things. The early forties were wartime, with films and pictures of airplanes, tanks, and cannons that appeared in newsreels and in the newspapers—which was my main tool for trying to learn to read.

The more I tried reading, the more I came upon the word *science*, and how it was associated with objects and inventions. Slowly I came to know what it meant, and it had an enormous circumference. What it encompassed was extraordinary, even for me then. The more I read, slow going though it was, the greater my thirst for understanding and learning, fueled by curiosity and imag-

ination, and they collectively brought me across a great divide—to a point where I could learn to seek information; to a place where I became almost entranced with trying to figure out things, like trying to understand the car. It took me years to comprehend that there was combustion, a contained explosion, going on inside the motor. That discovery was mind-blowing.

Meanwhile, scientific inventions and discoveries continued to arrive upon the scene. Television, which now even in my day blares incessantly yet largely unnoticed in several rooms of a house, was so wondrous an instrument in its infancy that entire families would gather around to spend the evening in fascination at the moving pictures brought into their homes. In many cases, neighbors who for whatever reason had not yet acquired a TV set would join them.

Being there on the scene when television came into its own was an education unto itself, one that coincided with my interest in learning even more about what came before—including the earliest discoveries upon which civilization propelled its advancement.

Ever since the years when I became a proficient and then an avid reader, I have never been able to get my fill of scientific explanations from as many sources as possible. But as you probably have noticed by now, my zealous quest for explanations started when I was very

young. The precise moment of being bitten by that bug may well have occurred when I was six and a half years old or so, and my father came home one day and said he had something to show me. Both of his hands were behind his back as he said, "Do you want to see what I have here?"

I nodded yes, but before I could answer, my dad said, "Now, I'm just going to show it to you once, all right?"

"Yes, yes, what is it?" I asked impatiently.

"I'm not going to explain it to you," he warned. "I'm only going to show it to you this once."

Again, I nodded yes, my curiosity rising.

From behind his back, he produced a dish that couldn't have been plastic, I'm sure of it, but which was full of water with little fish of different colors swimming in it this way and that.

I looked at the bowl and the fish, charmed by how they swam to and fro in the water. But before I could gaze at them much longer, my father took the dish away and put it behind his back again.

A moment later, he showed me the dish once more—only this time, the water and the fish had completely vanished!

Then, as he had promised from the start, he removed the dish from sight, never to be looked at by

me again. And true to his word, he never explained how the little fish and water had gotten into the dish the first time and disappeared the next time.

It remained a mystery that made me seek out answers scientific and otherwise for a lifetime to come. Somehow, I coupled that experience with a suggestion for making dreams come true that I later overheard my father telling someone about. Apparently, if you filled a tub with water and put it on top of the house with a two-shilling piece in the center of the tub, and then placed it directly over where you slept at night, under a full moon, and you went to sleep thinking fervently of your heartfelt quests, your most desired dreams would be realized.

Well, I never found out if that worked, either. But from then on I remained fascinated by the intricate workings of human inventions.

Fire, for example, which provided early man with warmth, protection, and new ways to prepare food, was undoubtedly borrowed from its natural occurrence in nature, and later reproduced by artificial means so long ago that its birth is unrecorded in human history. The wheel, invented somewhere in Mesopotamia thirty-two hundred years before the birth of Christ, lifted heavy burdens from man and animals, and remains a constant companion in our universe. The

building of the Great Pyramid in Egypt around 2500
B.C. gave civilization a marvel of architecture that has
stood for centuries as one of the seven great wonders
of the world.

Now, with all the places I've lived and all the ex-
periences I've had in my eighty-one years, I have
seen marvels from electricity to planes to television,
to computers, to iPhones and all kinds of wonders
in between. Science, therefore, has moved at such a
pace that it outstripped me a long way back. Though
I do my best to stay current and work on my laptop,
search around the Internet, download photos and
music, I'm still a novice. I don't really know how to
type; I have only a general knowledge of science, of
anthropology, of paleontology, and of a few other
useful branches of research.

There is so little time, and so much to know! Sci-
ence has even given us an idea of what life was like in
the universe a billion years ago. Scientists now tell us
that the universe came into being 13.7 billion years
ago, and they tell us how it probably started and how
it developed and became what it is.

Here we are in 2008, and a tremendous amount of
science has been accumulated and tested, proven and
stamped and sealed as "This is how things happen."
Are there variations? Yes, in some instances very small

variations, in some instances profound variations. Science is able to determine what causes the minuscule ones and the gigantic ones. All kinds of wonderful information and answers to difficult and very delicate questions are everywhere as representations of science.

Where we are today is that we have science coming out of our ears. And if we weren't structured the way we are, we could sit here and be satisfied for the next five thousand years.

But that's not how we are structured. We say: "Oh, my goodness, look what we did! Ah, but listen, don't you see, we could do even better than this." And we did set out to do better, and we kept doing better and better until now in 2008 we can put an airplane that weighs thousands of pounds with five hundred people in it into the air and send it to Europe and bring it back, or to any other place on earth. It can go around the earth.

Now, if you went back to the people of early times and made a suggestion that such a thing could happen, they would try to find a way to lock you up or burn you at the stake.

With science and society, there often seem to be conflicts between the two. A love-hate relationship, you might say. Society depends largely for its continuance on science, as a major part of our sustenance. There was

a time, going back to very early social structures, when we had a horse and a buggy, or a mule and a dray. The power used was that of an animal, and animals were absolutely essential and prized possessions because they helped in the work of society: in the lifting of heavy loads humans ordinarily couldn't lift, on the farms, even in warfare, and in various other ways. They were appropriate then because we didn't have gas-powered engines or coal-burning furnaces, or all the subsequent energy sources developed to illuminate and heat our dwellings.

But the pivotal moment of change came when somebody in the world came up with harnessing the power of electricity through lightning. For centuries nobody knew how to harness lightning—some tried and failed, but someone ultimately discovered a way to convert lightning into energy. Then other imaginative men, like Thomas Edison and Alexander Graham Bell, came up with lights and telephones and other interesting things that enhanced life and added to the growth of the social structure. And through education, other gifted people, whose tenacity was strong and whose imaginations were better than average, came up with all kinds of things—one leading to another and eventually to where we are today.

Now we have, clearly, reams and reams of text-books that can tell you all about lightning, but there was someone, somewhere in the evolution of human creatures who took notice of it, and it intrigued them. They kept thinking, and maybe made a note or two about it if they were able to read and write, and then they died. But gifts like that are not just placed in one individual; they are placed in other individuals as well.

The most rare of gifts are not just walking around in one person; nature doesn't do that. It spreads its gifts, and it was the collective curiosity of gifted individuals that brought about science.

But science, as we know it, is not formed in nature. It is no more represented, for example, by birds than it is by a tree. After all, the tree is fine just standing there, sucking up the water and growing. And birds fly around and land in the tree, but they aren't carrying little notebooks under their wings and thinking they have to note what the temperature is and stuff like that so that they can know about science. We humans are the ones primarily concerned about science, because nature probably explains it to the birds in ways we would never understand.

And nature probably speaks to all of its other creatures. We don't know that a butterfly just may be more intricately in tune with not just nature but physics and

gravity and communications. How is it that a butter-
fly can travel from Canada to Mexico? By the time
it reaches Mexico it can never go back to Canada be-
cause that's not how it goes: on the trip back, it will
probably die. But its offspring will make the trip back.
How does the offspring know where to go? The off-
spring knows where to go because it's built in. And
also built into that butterfly are skills, protections, and
understandings that we will never know. If you put in-
telligence on a scale, the butterfly may be a hell of a lot
smarter than we are.

When we are talking about science, we're talk-
ing about what has come about with us. We still don't
know why the shark is such a quintessential preda-
tor, but it's been there from its first appearance in the
oceans of the world.

Society is the incubator: we have built the build-
ings, we have made the automobiles, we have built
the houses, we have made the airplanes, and we tend
to extrapolate about God and good and evil; we can
do all of that; that's how it is with us. Science there-
fore is within us; it is our trying to reach beyond our-
selves—our essential human quest. We all do that,
even the most uneducated of us. Just out of the love for
our children we will reach for a job because we know

we have to feed them, and we will endure much more than we ordinarily think we might endure.

Society is made by whatever imagery comes about from human activity. Science is a part of the development, the creation of society, education, understanding, the compulsion of mankind to want to understand things. So science is a natural outflow of man's reaching to understand, and there is no limit to his reaching.

As a society we have proven an ability to adapt to the new benefits of science. Computers? Yes, we can do that. Cell phones, iPods? Yes. Science now brings us such rapid innovations and capabilities with what it produces that we can say, "My goodness, just a year ago we didn't have this."

But now, Ayele, here's where the friction comes. Scientific developments aside, if you look at society a year ago, ten years ago, we haven't come too far; not in the area of communications—we can communicate almost instantly with another person practically no matter where they are in the world—but in other ways. We hold on to the ideal of democracy, for example, much as it was conceived by the signers of the Declaration of Independence; yet though we have evolved and continue to do so, after centuries we continue to have unresolved

matters of faith, racism, sexuality, and regional and international conflicts. In such areas, society has not advanced at the same pace as science.

But it is impossible for society to move at the same pace. Society has to move at the rate at which mankind develops. Do you know that it takes humans twenty-one years to educate a child to be able to conceive what there is in the world? You cannot as yet crowd a child's head, or put something in the brain to accelerate it to where it is ten, twenty times smarter. We still have to spend twenty-one years, and we have to stay on the development of the child almost every day of those years, particularly once the child is three or four years old. We have no shortcuts that will let us give that child what it will ultimately have at the age of twenty-one in terms of the world as it stands, or the information that science has collected and proven. We can't give the child an injection of all that knowledge or put a chip in its head, pull a switch, and suddenly have it at the child's disposal. It takes twenty-one years before the kid can even be considered for going on to medical school, and then the child has to spend additional years in internship before going to work. It took eighteen years to get the child even to the doorstep of the college.

Now the child is at the age of twenty-eight or thirty. By that time a whole new generation has come

into being. That time frame is somewhat comparable for someone going to work as a teacher or lawyer or in the business world.

This tells us that it takes thirty years for a generation to start replacing the one that came before it. Society is slow because we are limited as creatures. We can't move faster, in societal terms, than we can move in scientific terms because of the wider gap in our development. As human beings, to get where we are and to have devised a society as imaginative as ours is took a long, long time. Not three generations, but thousands of generations.

Science can't take us with it. It develops and grows in dimension faster than we do. So by virtue of our individual structures and capacities, society cannot possibly move as fast as science. And because of that, there is going to be an eruption between the two. The capabilities of science are such that in a matter of ten years it has provided us with the most amazing machines—stuff that was unimaginable just a hundred years ago.

A hundred years from now, I expect we're still going to be in control of our societal disposition, and science within it is going to be a hundred times more imaginative than it is today, and what it is today is mind-boggling.

In your time, Ayele, science may have found a way not to pollute what is absolutely essential to our survival. It may have found a way to colonize one or two of our nearby planets, a way to increase our life span. It may have found a way to create what we need in profound ways we have not even thought of.

But despite the possibility of an increased life span, we may get to a point where science will have to decide whether we can live only a certain number of years, because if you live too long, overpopulation becomes a problem. The state may well have to say that there will be only one child for every so many couples. If, Ayele, you were extrapolating from how many we are now—over 300 million in America—then the next doubling is 600 million and the next doubling is 1.2 billion. Where are you going to put them? What is science going to give them for food? What is science going to give them for transportation?

However, by that time there may be satellites built here and put out on other planets or on space platforms, and those who can afford it will live out there and grow food, make medicine, and do all the stuff necessary for their survival.

Still, in our effort to improve the whole world, we in my time may in some peculiar, unintentional way

be bringing it closer to its end. New technology itself brings on new environmental problems, since we also send into the air chemical elements that have the potential to change climates. Within this new cauldron, habitats and some species are becoming extinct.

In profound new ways we have grasped the ability to have power over life. And we continue to manufacture weapons of increasingly destructive power. Eventually, nature may choose to recede, leaving all the living creatures on earth doomed. Our only defense against such an outcome might be how we treat nature, not only in terms of the forests and rain and sun and every natural resource, but in terms of how we deal with the entire environment.

So, society has its responsibilities now; science has its responsibilities now. And there is no governing force that says that the two have to work together. Yet if science gets too far ahead, if society does not or cannot control science, its destructive capabilities will lead us all to extinction. And if society becomes too influential in how science functions, in what its purposes are, that will be terrible.

But as we continue to struggle for the balance to survive, as we always have, a question arises about the evolution of human beings. Is modern man as good as

it gets? If we look at ourselves today, we don't see much difference from what we were in the old days. We wear clothes today, but our shapes are pretty much the same. Aside from updating our appearance with hip sneakers and such, our looks are only slightly altered from what they were thousands of years ago; there hasn't been much change. We are civilized—as much as one can apply the word—but we are the animals who brought about science.

This raises a fascinating question: is there more evolution of the human species to take place? The expanding capabilities of athletes may hint at it. That leads us to ask whether, in the evolutionary development of mankind, we are possibly just the end of the beginning, or the beginning of the end.

However that question can be answered, science tells us that if a time comes when we all are no longer here, this earth will continue to move around the sun; the rains will continue to come and bring new possibilities. Even if, ultimately, the rest of the universe has no interest in what happens to us. There's too much space, too much stuff. Who cares about one little planet with some living things on it who don't know how to behave themselves?

If humans one day do become extinct, will nature say a billion years from now: "I'm going to start it all

up again"? Or will nature say: "I've got ideas for making a planet better than that one anyway," and just opt to create something else?

I hope these questions will be here for you to ponder in your adult years, Ayele, for that will mean you are alive and well, and you just may be helping to provide some answers—with the echo from your elders in these written lines to you, urging you on.

The Warrior Within Us

My dearest Ayele,

Long after I'm gone, when you and your generation come into your own—eighteen, twenty-five, thirty years from now—your world will quite likely not be free of the devastation of war. That will not be your generation's fault, but it will be up to you and fellow generations of that era to face the challenge of war.

As I write this letter to you, I see you in my mind's eye on the occasion of "The Morning of Ayele's Outdooring," recalling both the peace and protection created within the community circle, the village, that

welcomed you out into a world in which you could grow and thrive.

Meanwhile, at the beginning of the century in which you were born, our nation had plunged itself into a disastrous war. At this writing it grinds on, with repercussions that will last well into your lifetime, and at a human toll that in time could defy count.

The contrast was striking, summoning memories of the relative peace and protection of the island of my youth during decades when world wars simmered and raged elsewhere. Why? Could it be that though humanity speaks incessantly of peace between all of the tribes of the earth, actually achieving this goal may be beyond human grasp?

Then again, the failure is not truly our fault. Peace, it seems, grows out of war, and war, in turn, grows out of peace. On the face of it all, it appears that at the very heart of nature itself lies one of the mightiest of all life forces: the instinct to survive. Peace is often seen as being in service to that function. Sometimes war is viewed as a necessary ally to that force.

Let me explain what I mean, first from the context of history and evolution, and then in more personal terms.

For me, war comes down to a philosophical question, one that has to do with who we are. For many

years, most of what I could observe came from knowing about World Wars I and II, the wars in Asia that involved us, and, of course, the Civil War. That was pretty much it. But after that, in a deeper look into human history, I found that those wars do not even begin to represent how many wars we have weathered, going back past the 2,008 years since Jesus's birth and beyond. War was always there somewhere, among the Romans, the English, the French, the Italians, the Germans, the Scandinavians, the Spaniards, the Russians, and no less on the continent of Asia, not to mention all the kingdoms and empires, east and west, that were constantly at each other's throats long before the discovery of America—which itself led to war against the indigenous people of this continent, erroneously named Indians. And the Indian tribes themselves made war against each other long before America was "discovered" by Europeans. That is man's pattern; that's who he is. Times of war and periods of peace alternate, as directed by the hand of nature, and for reasons known only to nature itself.

As much as we may not like the fact, Ayele, we must understand that mankind came to be that way out of a staggering evolutionary experience that started way back when there was not a living cell on the planet.

In fact, the planet itself was a boiling cauldron of chemicals out of which arose the first life-form: the one-celled amoeba—which in turn triggered the process responsible for all that followed across that entire evolutionary span. Was the survival instinct an inheritance handed down to all living creatures, including us, from that single-celled amoeba? Possibly!

As the process of billions of years of evolution rolled on, those creatures whose adaptability allowed them to survive on land would gradually develop into other creatures who would move around through the treetops in the jungles and forests that blanketed portions of the land area of planet Earth. Adaptability meant survival, and survival required adaptability.

Throughout that whole process we, *Homo sapiens,* were still nowhere in sight. There were many, many stages before evolution brought about humanlike creatures. Among our closest ancestral relatives were apes and chimpanzees. Ultimately came the evolutionary progression in which we arrived, but we were late in the game. Yes, we have been here many, many thousands of years, but in terms of the history of the planet, we've just barely arrived—or so modern science implies.

The survival instinct was a drive of such intensity that cannibalism was a frequent indulgence among

some species in their desperate struggle for survival, because our survival needs included food enough to keep the species nurtured. We modern *Homo sapiens* are, therefore, carrying within us the entire drive of our ancestors' need to survive. It is so integral to our makeup that at points in our history we have spent most of our waking hours in pursuit of that survival.

Though certainly the needs of survival change from time to time and from species to species, we carry the same power, the same drive that the other, earlier creatures carried. However difficult it is to wrap our minds around who we once were, it lays bare the fact that there is a central force in us all, and that central force is survival. The survival force is a monumental energy. We are designed with it, irreplaceably, in ourselves.

So here we are with this highly honed instinct, so finely honed that if we go back from our generation just six hundred years to early man in European countries, everybody was fighting. Colonialism was born out of that warlike behavior. In those days, the important thing was power: power was domination; power was subjugation. France was into it, as were Germany and the Scandinavian countries. In Asia, the Japanese and Chinese were into it. Tribal chiefs in intertribal wars throughout Africa were into it.

In the later progression of wars of mankind, power has been the driving force more than survival—although mankind's need for power, I think, grew out of the survival instinct. Opponents proclaimed: "We are not going to let them have what we have. It is our birthright; this is who we are." And so they made conquest the most important thing.

Conquest eliminates the enemy, and the enemy's spoils become the conqueror's. This emboldened early nations with large armies like England to eye the Middle East and to say, "Let us build a fleet of ships, and have a navy *and* an army, and just the vision of us will be fearsome. We can sail along the Mediterranean coast and into the cradle of civilization, with its ancient treasures, and forge alliances with the region in trade and commerce that will bring other nations closer to the empire of the queen. Resources will be developed in the interest of the modern world."

The game of war has not changed. Instead, it has intensified. Because we have technology, television, and newspapers, and because our subjects can read now—which is wonderful—we manage our wars differently.

We are at a point now where our need to survive and our gratification of it take different forms. We have Wall Street, we have farms, we have gleaming

workplace towers, and we've got all kinds of things that cause us to get up in the morning and go to a job.

In America, we, too, have battle relationships on many levels: political, economic, class, communal, religious, and philosophical—to name but a few. These are wars that we believe we can live with, if you are going to use the yardstick of logic and reason and the need to survive, plus all of the moral and ethical things that we superimpose on ourselves.

Still, nations do go to war—sometimes to defend themselves, sometimes to ensure the security of their borders, and sometimes for all the wrong reasons.

The power question still bothers me. Power was always in the mix, either exercising itself on its own behalf or to weaken the power of its adversaries and prevent unwanted challenges to itself. What changes is that power takes on different forms as we are a world no longer of, say, 1 or 2 million people, but rather of 6 billion, and we are all still playing that game. In much of my lifetime there were only two countries playing the game of power: the United States and the Soviet Union. And we played it for many years, to the disadvantage of a lot of smaller countries and at the threat of eliminating everybody on earth.

Now we have refined the game. In all too many countries in the world, leaders who wish to maintain or

increase their hold on power have found it necessary, in order to go to war, to manufacture an argument to convince their people that it is necessary for their survival.

Not only was that how we were sold the war that was supposedly waged to take down an impotent tyrant named Saddam Hussein, but that was the means used to convince us, in spite of our inherent faculties of logic and reason, that such a thing as "preemptive war" could ever be in our own interests.

Now, I don't think we are killing people because we're any worse than anybody else or any better. I think that what we are doing is showing the darker side of what human beings have always been: we have a capacity for love, a capacity for kindness, a capacity for passion, and we have an equal capacity for their opposites. Love is infinitely more effective in the world than hate, but love and hate have their opposites, and we have now a huge dilemma: we have the world's number-one spot, we are the strongest military in the world, and we have more people hating us than ever before.

I think it is not altogether wise to presuppose that their hatred of us has to do with their envy of us; it isn't that all the time. Some of the time it has to do with who we perceive ourselves to be, and who they perceive themselves to be.

Now, we know that, in this latest exemplar of the warrior within us, we should have taken another tack. Where we are now, we look at each other in terms of what we are to each other: enemies. And where we are now is a dangerous, dangerous place.

Thus we, Ayele, the generation before you, and many generations before that have been derelict in opposing the warrior within us long enough or hard enough to provide you with a less violent, more agreeable world.

We had our chances. While the early wars were often fought between tribes or nations who knew nothing of each other and feared each other's strange looks, customs, and unknown powers, much of that changed over time. In the wars of my time, while people spoke different languages, nations were no longer fighting total strangers. We knew, at least, the overwhelming similarities of the various members of the human family. Beyond our mutual need for food, water, and air, we knew that even among our enemies there were similarities of love, kindness, religious worship, and reverence for children as inheritors of our space on earth.

But war remained the ultimate way to settle our differences, even when we described the most recent one to be the last. The First World War, sometimes called

the war to end all wars, involved twenty-four nations and claimed an estimated 11 million dead. Still, some twenty years later came the Second World War and its staggering human toll of more than 59 million.

That should have been enough for man to say, "Stop! Enough!" But the fate of the young men and women who pay the ultimate price for our national disagreements was totally in the hands of older men, the politicians charged with the care of the world, the elder statesmen. In this important responsibility, they failed their generation, Ayele. And during the time of that failure, the Hitlers and the Stalins ravaged the world.

But even though we speak of the warrior nature within mankind in its most cruel manifestation, it is not one-dimensional; that same warrior instinct, that same battling for survival, has produced not just the bad wars, but also the good wars.

The good wars are the ones we fight in the name of children, in the name of the poor, in the name of those oppressed by overwhelming odds or forces beyond their control. We fight good wars in medical laboratories, endlessly seeking to cure the scourges of cancer, heart disease, diabetes, and mental illness. We fight good wars when we devote time, energy, and money to relieve the suffering of hungry people around the world. We fight good wars when we come to the aid of those

struck by the overwhelming forces of capricious nature: fire, flood, drought, hurricanes, and earthquakes. We fight good wars when we refuse to allow injustice to be done to others. We fight good wars when we oppose hate, bigotry, and ignorance.

These are the battles, Ayele, in which you and the best of your generation will need to engage. While the energies of my generation have grown fragile with age and worn with effort, your generation can bring fresh insight, boundless vigor, and rigorous intelligence as you merge into the ranks of those a mere generation ahead of you. You must fight to make the words *freedom, democracy,* and *equality* more than just the buzzwords of men and women seeking higher office. In the current time of my life, the words *terrorists* and *terrorism* have become almost daily chants to be absorbed into the public psyche.

I do not know how the atmosphere will be for you, Ayele. But understand that terrorism is not just the landscape of the terrorists; it is also inhabited by those who cry out the word to spread fear for their own political gain. Do not easily accept the premise that another war will change things, or that it is necessary. Demand more accountability.

While collectively you can change things, you can do that only if you firmly believe that you, as an individual, can make a difference. Too many good causes have

met bad ends because too many otherwise good people felt there was nothing that they, individually, could do to make a difference.

Let me rush to explain, Ayele, that I am not suggesting that you devote your life to being a missionary. You are entitled to your share of love and joy and leisure and pure happiness. But within the warm periphery of your life, there should be room for passionate involvement. As the Italian poet Antonio Porchia put it: "In a full heart there is room for everything, and in an empty heart there is room for nothing."

Racial, religious, and sexual bigotry must be your enemies. Go for the jugular when you encounter the principal adversary: ignorance.

Why did we not do it, my generation? We tried, despite our overall failing grade. And we succeeded in modest bits. We fought the scourge of AIDS and its early bigots. We raised our voices and our hands against genocide, and we began our efforts, although belatedly, to better protect the planet. My generation and the one that followed have not been totally negligent in trying to make the world a better place.

Ah, but yours, Ayele, will be better educated, more worldly-wise at a younger age, and early adapters of the technological magic that the people of my time can hardly understand or utilize. Our society

tends to cling to old ways, safe customs, and cautious acceptance of new and sometimes seemingly strange ideas. We lag behind despite the speed afforded on the communications autobahn. We often watch but do not always listen. We have come to prefer entertainment to information. We blame some of these traits on the young, but we, the old, have been the ones at the steering wheel.

We hope you will accept our apologies.

The Environment

As I'm certain you've concluded from my last few letters, Ayele, the purpose of the questions, answers, and mysteries that concern all of us, regardless of our station or background, is not only to provide grist for the philosophical mill. We can hope they do more by occupying us, awakening us to matters we have been ignoring or denying, and, for most of us, that they call us to action. In our time, dear great-granddaughter, the issue of our environment is of the utmost urgency.

Think of it. The air we breathe, the water we drink, the food we eat—they all bring us life, miraculously, year in and year out.

The snows and the rains come, and the water accumulates in mountain regions and flows toward the sea to form rivers and lakes, and it happens every twelve months. Almost like clockwork, it comes, it comes, it comes. For thousands of years we have lived as if these forms of abundance were in inexhaustible supply. But here in the twenty-first century we have come to the slow realization that they are not.

Now we're at a place where the coming of the rains and the snows is seemingly being altered ever so slightly, but more progressively than we might think. We are now hearing phrases like *global warming* and *climate crisis.* We are talking about shortages of water. We are concerned about those essential environmental aspects of our lives without which we are all doomed.

These concerns take me back to my original classroom in nature where I learned about the environment when I was a kid. Cat Island was the home, the environment, of some nine hundred to one thousand people, in a land area two times as large as New York City, of a shape similar to that of the isle of Manhattan. The environment itself was the force in control. The air over Cat Island was bathed with purity, clean and fresh, and it enveloped us. We'd breathe and not wonder if the air was pure. We drank water that came from the ground and never wondered whether it was contaminated.

Food on the island was abundant; we turned to the earth, and we turned to the sea. The sea constantly replenished us. The land nurtured us and replenished itself, year in and year out. In that environment where I spent my early years, I flourished. I learned how seeds placed in the ground burst into a sprig and then become a tree, and how trees bear fruit. I understood and accepted this as a part of my life, a tree's life, and a part of nature itself.

But we're now at a place where we have begun to tabulate our obligations to the environment rather than the environment's obligations to us. The environment's obligations to us have been met for billions of years. The environment was in service to us, altering itself, changing itself, maturing itself, widening itself, dimensionalizing itself for our arrival. When we first came, the environment was ready to receive us, and it nurtured us. It was so massive, so pure, and so thunderously healthy that we had no need to worry for generations upon generations whether it would be able to sustain itself on our behalf. In its infinite beauty, it has done that, but now things are beginning to change.

We are 6.4 or 6.5 billion human beings on the planet. The water supply is shortening. The amount of topsoil to produce food is dwindling. The remaining clean, fresh, unpolluted air for breathing and for nurturing all

living things is being poisoned by substances incompatible to its health.

Pollutants foul our air and water, damaging the food supply in the oceans and on land. They threaten the very ozone that protects that earth's atmosphere. In our joy for life and our voracious consumption of resources, we have carelessly reached a critical point in our own survival. Even yet, Ayele, as I sit here, many people are reluctant to accept the responsibility that rests with us all to pursue answers to the problems and, as we find them, to engage in them.

As a society we have grown to prefer the easy over the difficult, the quick over the slow, the cheap over the costly—and those choices are not often to the benefit of nature.

Lord knows we've been warned; books and essays by the hundreds have been tumbling off printing presses since the 1970s; some even much earlier. Still we respond higgledy-piggledy, if at all, against multiple threats: nuclear meltdowns, acid rain, leaking oil, hazardous waste, and contaminated watersheds. All these present a menace not just to us in the industrialized nations, but to indigenous peoples threatened by expanding globalization.

Acid rain, that mixture of nitric and sulfuric chemicals arising from the burning of fossil fuels, affects

large parts of the United States and Canada, damaging lakes, streams, and forests along with the plants and animals that live there. Using pesticides arbitrarily and haphazardly threatens to wipe out whole species of animal life, and threatens our food chain.

These are not theories, Ayele; they are facts. It has taken some time for too many of us to realize that the building pressure of world population, along with the mixed blessing of vast new technological capabilities, now threatens the survival of life on beautiful planet Earth. We are faced, as Nobel Peace Prize winner and former vice president Al Gore, a longtime champion of the environment, observes, with the moral responsibility to respond.

The arguments that contest a belief in limitless natural resources, or that confront those who insist air and water quality are not worsening, can no longer be dismissed.

Some of these problems may be less dire in your lifetime than they are today. Nevertheless, they are certain to be present well into your young life. And so, Ayele, there may be a need for you to look around yourself and take, as we are now taking, the small steps as well as the larger ones to make the earth a continuingly livable place. One example is energy; we use it to drive, to light and heat our homes, grow food,

raise livestock, and dispose of mountains of garbage. All of this sets loose greenhouse-gas emissions, a noxious substance we can all curb easily by simply changing lightbulbs and properly inflating auto tires. We all desire clean water, but keeping it uncontaminated is not enough; it is a vital resource that must be consumed more judiciously than it has been in the past.

We are just now realizing that an army of one can be effective. We can turn off lights, computers, and other appliances when they are not in use, and use electric appliances only when we need them. Energy-efficient appliances should be in abundance for your generation as some are now, Ayele—among them, refrigerators, air conditioners, washing machines, lighting equipment, and others.

We can avoid other extravagances of comfort: keep thermostats at sixty-eight degrees in winter and seventy-two degrees in summer, and turn them even lower in winter and higher in summer when we're away from home.

In California, where I live, the automobile has replaced the old cowboy's horse. Big-time! We each ride our own. But slowly, we are beginning to carpool, use public transportation, and a few even walk or bicycle whenever possible. Still, despite the enormous benefits, for the most part we continue to be resistant.

Why do I mention such mundane things to you, Ayele, such small potatoes, such middling advice? Because they are ignored by too many who sit greedily consuming resources with no concern for tomorrow. I do not want—and I certainly do not expect—you to join the ranks of the dim-witted or obtuse. So if you are with me so far, here's a word or two more.

Besides the small steps in the salvation of our planet, there are larger ones to be taken. This may mean avoiding companies and their products if they continue to dump chemicals into water that poison sea life and us as well. If they send toxic fumes into the air, demand their change or closure. Some may argue that in too many cases the economy will suffer. But what good is a thriving economy to a dying public?

The planet and everything on it must be considered as an integrated whole of creation, and rallying to its cause must be more than a passing fad in the panorama of mankind's life.

So, Ayele, talking to you about the environment is important for me, because I would like you to have a sense of its importance as well as the knowledge that your existence is intertwined with it. This makes you—you and the fellow human beings of your generation, of the generations behind you, and of the generation ahead of you—partially responsible for what

used to be automatic. And what used to be automatic was clean air everywhere on the planet. What used to be automatic was an abundance of drinkable, usable water—for food, for nurturing the fields of the world, for accommodating the scientific needs that depend on clean, pure water.

Things are changing, so we must change. The face of the earth is being altered in certain ways that are alarming. We must do what we can to make the cut for our survival. To that end, I would hope that you'll forever be cognizant of the importance—the absolute, absolute importance—of water, of air, and of food. There is no life for living things without those elements.

I've not been one to preach to you, and will do my best to keep it so as long as our relationship lives on. But I am now asking you to be mindful of the needs of the planet, mindful of the environment that must sustain the family of man—not for a century, not for a thousand years ahead, but on into perpetuity. And if we consciously work not to throw the intricate, extraordinary balance out of sync, if we are in harmony with the universe, the snows and rains will continue to come, and we will honor and preserve the earthly home given to us by our maker.

That entity we know as God is the subject of my next letter.

Faith

Many letters ago, you will recall, I wrote to you, Ayele, about the evidence of things not seen—the faith in God—that sustained my mother in her anguish when faced with the prospect of losing her child, when confronted with not knowing how I was faring during those many years when, without a sign to the contrary, all she could do was believe that I would return.

I return to the subject of faith to add a few more thoughts that seem fitting in connection with the larger questions of our individual and collective purposes. And one of those questions we're hard-pressed to ask at times when we look back at our lives in sum

is whether our faith was well placed. Mine was not my mother's religious certainty; rather, it was a spiritual recognition that I had a purpose, even when I didn't know what it was. Does that mean that God made all the decisions in which I was an instrument in His, or Her, design? Or was it the day-to-day choices that, in the aggregate of the day's accumulation of choices, I had to learn to trust?

To answer those questions for myself I have to ask, again, whether I feel that what I have done in my life was by my own determination. No! I really do have a wonderful curiosity, an instinct for the possibility that God is as big as I think and as immeasurable as I perceive; and the faith that I have invested in that belief has delivered me into a life that is beyond anything I could have asked for or sought.

It is one article of faith to accept that I am here as part of a larger picture, in which my choices played an important but lesser role. It is a further article of faith to be mindful of what this power has done for me. I think it protects me. I think it will use me ultimately in a manner it so chooses, and my entity is a part of an energy of which there are many parts. So, for His design to be effective, my life has had to take a certain turn, as it will continue to do. If God needs me as an entity to sidestep the buzz saw, I will. And if I assume that my

having sidestepped the buzz saw was all my doing—that's crazy, that's ego.

But conversely, I don't believe that God wants me to sit absolutely contented that He is going to make all the decisions for me. I think, as I perceive God, that it is my responsibility to make the choices in my life that I feel are necessary for me to be the kind of person that I am. One or another of those choices will kill me, probably, but that's how it goes. Before me there were hundreds and hundreds of millions of people who died, generation after generation. All of us live and we die, and it is to the honor of this great intelligence that I perceive as God that we live life as we feel we have to live it if we feel decency, honor, respect, compassion, truth, love, sympathy, and empathy. All of those are the forces, energies, dispositions out of which we make our choices, for they are very real for us, and within our abilities to offer to others, because somewhere within our individual existence is a need for love, for compassion, for a safe harbor in the arms of somebody.

My choice is to have faith in that infinite intelligence and to trust that we are where we are, when we are, how we are, for a reason—that each of us has a perfect life, lived as it was meant to be.

Of all the human beings alive at this moment all over the planet, some are moving slowly toward the

closing of their lives, some are just beginning to come alive and are being spanked on the behind as they begin crying, some are enduring in the middle, some struggling for wisdom, some for clarity, some for understanding. That's the whole process; it is constantly in motion. We reach for small, incremental improvements. We would like a better job; we would like health for our family; we would like a long life; we would like an absence of war; we would like an ability, collectively, to put a lock around the impulses we have that are destructive for others, and around the impulses others have that are destructive for us.

My faith is enough to stand on, no matter how early or late the hour of the day, to look at where everyone is in the course of all their struggles and triumphs, myself included, and to say—*My God, life is so arresting!* To take it all in with great thanksgiving, even knowing that we could all be dust in one fell swoop. I don't mean in ten years or fifty thousand years or eight billion years.

We could all be dust for reasons we don't understand. The dinosaur probably had no idea that one day it would be extinct. And we could go as well, because we don't rule; we are not the driving force behind the planet. But knowing that we were here and believing that we mattered—that's faith.

The ability to look back at your life and see all the things you might have done differently, but still recognize that everything happened organically and for a reason—that, too, is faith. I have put that faith in the only God that I can see in my mind's eye, a God who is an invisible, intangible force that is the ultimate in forces that cannot be described, that does have a direct relationship with everything about us—how we come into being, how we breathe, of what use we ultimately are to the larger frame of existence.

What is our purpose? You have to either go into structured faith or, as I do, try to figure out—and I don't have much time left—all of these possibilities. I just am reluctant to embrace a format for faith that says that the embracing of it is all you have to do, and then you'll understand, and then you'll leave it all to God. It is the nature of mystery, as I see it, and of God, not to settle for finite explanations.

How can we know whether we have measured up to our given purpose? Again, faith will tell us that we have, that we have done the best with what we've been given. After all, I doubt that God, if He exists in those terms, leaves all that much to us, and is sitting there clucking his tongue, waiting to give us a bad report card, or is watching us and saying, "Oh, Lord, there

they go again. How can they not see that they're going over a cliff?"

I readily admit to being bedeviled by thoughts about how imperfect we human beings are. I could argue that if there is a God, then He made us the way we are. No, I'm not placing blame, and let me hasten to add that I don't question the actual existence of God. I believe that it's either one way or the other. It can't be that there is a God and there is no God. So I give the presence of God equal time with the opposing thought that there is no such presence. I can't say *positively* that there is a God, because I don't know. I cannot say there is *not* a God; again, I don't know. So I leave it, but in the leaving of it I have now granted myself permission to think further and deeper. And as I go deeper, I find other mysteries.

I assume that there is a power and that it has a relationship to us, and its dimensions and its image are beyond me. So I give it its due. Its due is, we're here.

And not only are we here; the planet is here. And not only is the planet here; the galaxy is here. And not only is the galaxy here; billions of galaxies are here. And they all form a universe.

We don't know much about this universe. Science tells us some little bits about it. We don't know if there is an adjacent universe. We don't know if there are bil-

lions and billions of universes. And with the limited capacities of our minds, that's enough for us to figure out. It's enough to drive us for billions of years to come if we're smart.

Contrary to some thinking, science and faith to me are not mutually exclusive. I believe that only the God who has been a force in my life from the time I entered the world, ahead of schedule, could have been the spark that ignited it all.

Since these matters are highly likely still to be unresolved in your time, Ayele, you will need to do your own deep thinking and arrive at your own conclusions. And, if you are the educated, well-rounded, ethical, decent, moral person that I am sure you will be in your adult years, you will be able to make your own choices.

Death

Dearest Ayele,

As your life blossoms, both your great-grandmother Juanita and I will be attending to our final accounts. And let me state for the record that regardless of my differences with her that came many years earlier, she will have enriched you in countless ways. No doubt you will wear the imprint of her affection proudly in all that you will be; and likewise she will take nothing but pleasure in watching you grow up.

You've been so fortunate to be raised with the love of three generations of women, starting with your confident and caring mother (my granddaughter Aisha);

Beverly, your life-embracing grandmother (my daughter); and your great-grandmother Juanita, who has been blessed with a very long life.

Many of us live to a fairly ripe old age, as I, too, have been fortunate to do. Nevertheless, the possibility of loss of any of your loved ones is a subject that can't be ignored.

It is easier for me to make comments on death than it will be for you to hear comments on death. At your tender years, you are probably quite unmindful of the fact that death is a part of every life, for every life eventually ends. It falls not to you but to your elders to convey that fact as gently as possible.

Indeed, you may run into a loss as early as among your classmates in elementary school. Death is not off-limits to that area, nor is it off-limits to children in high school and college, and the further you go into adulthood, the greater the chances that you'll encounter it. Life is certainly not a guarantee.

Many times, the length of our survival on earth depends on circumstances over which we have no control. Quite important is our inherited infrastructure—who we are in terms of our vital organs, how able our cells are to replenish and replace themselves, and whether nature smiles on us with all of the fine work it does in keeping us together in one single unit of life.

I suspect that, with the discoveries of modern medicine and your being mindful of your own life and those things you must do in order to enhance it, protect it, and nurture it, you, Ayele, will live quite a long time beyond my years. As a matter of fact, I'd be disappointed if you didn't. I don't want you to be even thinking of having one gray hair until you're eighty. And for you to have all of your hair go gray, I'd want you to have to live to be at least 125. So, you see, I'm charging you with a responsibility even at these young years of yours.

But death does come, my dear Ayele, and when it does it brings a sadness, a solemn moment. It brings a time when separation and departure are experienced. It brings contemplation and reflection. It brings back days, wonderfully well spent, that are etched in your memory of all that transpired between you and a loved one or a friend. It does that even when the loss is not yours but is experienced by a close acquaintance. Love and concern and compassion travel across genders, across generations, across ethnicities, across races, across religions—all touched in one way or another by that loss. Death comes not only to the person who has to receive it, but also to those who will experience the absence of that person.

Death is a frequent visitor. The larger the family, the more frequent the visits; sometimes it appears

without notice of any kind. Sometimes a simple message is sent to say that it will soon be dropping by. It comes and leaves, always in the company of at least one family member. When a visit is merciful and unbearable pain and suffering are brought to an end, the visitor leaves us to mourn our loss and to heal, until it comes again, as surely it will.

In my lifetime, the number of visits death has made to family members on both my father's and mother's sides is sobering: grandparents, parents, aunts, uncles, cousins—first, second, and third—and then my dear granddaughter Kamaria, who died at a very early age.

My memory chain of death as a frequent visitor among my family began with my grandparents on my mother's side. Most of those on my father's side were gone before I was born. My mother's mother and father, Mama Gina and Pa Tim, have been locked in my memory since I was five years old.

To this day, I can still draw up images of Mama Gina stooped over a cooking fire just outside the kitchen that her husband, Pa Tim, built for her out of palm leaves that he fastened to a sturdy structure made from the limbs of hardwood trees. The kitchen was for use on days of wind or rain; otherwise, she preferred to do her cooking outside. I can still see her

there, with her hair covered as usual by a white cloth tied behind her head in a knot at the base of her neck.

When I was around the age of six, I watched Pa Tim noticeably change. Where before he had been tall and sinewy, weathered though sturdy from a lifetime of working out in the elements, he declined suddenly before my eyes, growing frail and feeble; his life and times had worn his body down. It could no longer fend for itself. Day after day, whenever I went to see my grandparents, I wondered why he sat quietly, looking for long periods of time at the ocean. I had no idea a process was in motion: his life was drawing to a close. Day by day, dementia was slowly enveloping him. He simply was waiting for release. When it came, with him went portions of the Poitier family history, never to be reclaimed. The frequent visitor death had called on Mama Gina's husband, and soon thereafter it returned for her.

My father had moved the family to Nassau by the time my mother received the news of her mother's passing. She wailed for hours, uncontrollably: "Oh, God! My Ma, gone! My Ma gone! My Ma gone!" She completely lost it, and ended up in a deep gloom that took her weeks to climb out of.

My mother was destined to eventually mourn a son, a daughter, a sister, a grandchild, and finally her

husband—the last a loss that ran so deep she was unable to recover, and she joined him soon thereafter.

In my own case, as I'm sure you will read in my letters to you, I have been so close to death that my salvation was of a nature that I could not possibly understand. I'm alive for reasons I cannot explain. The many close calls I've had were of such nature that under normal circumstances they would have taken me away many times over. So that is why I, at this point, choose to talk to you about death.

And let me look at my own demise. It will come, as death comes to all living things; as it arrived for my parents, as it arrived for my brothers, as it arrived for my sisters, cousins, friends, acquaintances, fellow workers. The loss was always registered by me in terms of its totality. It is, and it will be forever, a total loss.

Religion says that we will, we hope, meet up with some of those who left us through having been called by death. My mother believed that very deeply. I have my own thoughts on that, as I'm sure you know by now. And although my thoughts, my expectations, head down a different path, I am respectful of my mother's deep faith in her beliefs. I'm sure she grants me the prerogative to embrace whatever opinion I have in terms of life and death.

But I raise the question to you now because it's an exchange that we must have. By all indications, I will precede you in death, and probably by many, many decades. If that is the case, I would like you to know that I am comfortable with whatever lies ahead, and that I am comfortable in my feelings that you will have a long, productive, happy, useful life. It will not be automatically presented to you, however. You will have to carve it for yourself out of all that is around you.

A tiny bit of myself is lost when my friends are gone. A tiny bit of myself was lost when my brothers, all but one, passed away. I experience a loss when friends, relatives, and acquaintances with whom I had a human connection go.

But there are other aspects of death, some of which science and society are just beginning to explore. Do our parents actually live on in us, or does just their memory? If so, is it more than memory? Is inside us the actual resting place of that elusive quality deemed their "soul," and thus is it passed on from generation to generation?

Somewhat to the contrary, science now indicates that the sum total of our existence resides in our consciousness, and with our passing comes the passing of everything, and so the "soul" as an actual entity does not exist. Since the world's major religions hold

that consciousness is indeed located in the soul, and therefore does not die with the body but goes on to an afterlife of reward or punishment, this presents a ponderous question for those who hang their hopes on a spirit world.

But when does a person actually die? Is it with the last breath that passes from the body; the last beat of the heart; the last fading signal from the brain?

Some people believe that you do not truly die until the last person who knew you dies. In that case, your life could go on for half a century or more beyond the legal declaration of death.

While most of us fear death, there are those who seem to reach a state of calmness when it appears near, and those in great pain welcome it. Some, by virtue of religion or temperament, are stoic in the face of the prospect of death; they see it as merely the next step in the existence of one's life—a further adventure rather than a sad ending.

Still, until and if we reach that calm state, most of us wish mightily to avoid death. As the phrase often goes in religious circles: "Everybody wants to go to heaven, but nobody wants to die."

Woody Allen put it another way. "I don't want to achieve immortality through my work," he said. "I want to achieve it by not dying."

But since death is unavoidable, perhaps what we can best seek is a long life that comes peacefully toward its end, and then have that end come swiftly. A lingering death is the most undesirable of all.

Part of the fear of death is the feeling of stepping into the great unknown—a vast, dark void of which no research has been recorded, no news reports sent back. Ah, but what of people who claim to have been there and back? Those who say that, in a time of critical illness, they saw "a white light" unlike any they had ever seen before, and maybe even for a time moved toward it. They believe that they were in that moment at the abyss of death, and somehow, miraculously, stepped back from it. Was this an actual occurrence in the subconscious, or a medical, drug-induced aberration?

Again, science seeks to provide an answer. Those "near death" or out-of-body experiences are symptoms of eye and brain oxygen deprivation, we are now told.

So most of us are left to deal with the known aspects of death, and among our fears is the pain associated with demise. For that reason there are legal and moral issues surrounding death. Do we wait for the inevitable, no matter how intense the suffering, in the belief that the date and time of the cessation of life can be set only by a supreme power? Or should such moments rest in our own hands? What of families, seeing agony or

probable irreversible coma endured by a loved one, who seek to bring an end to it, often as a result of conversations held with the soon-to-be-departed long before such time arrives? "I do not wish to be kept alive if that time ever comes" is not an uncommon expression.

The legal and religious ramifications of these questions will likely be fought in American courts for years to come.

I shan't stay on this question any longer. I just wanted to make a point of discussing it with you, and having you know what my thoughts and feelings are about death. As you are likely to experience my own, I want you to know that, however much sadness it might visit upon you, the sadness will be temporary. But I will be peaceful. If my mother is right, I fully expect to visit with her and my dad. And if that is not the case, I'll find myself closer to what my thoughts have been all these years in that regard.

In either event, here I will always be, on these pages, living on through you, lifting you up through these memories to show you to the heavens, lowering you for your feet to rest on mine, and then setting you down onto the earth and watching you go.

I love you, and I wish for you all the best that I can imagine.

The World I Leave You

Your time, Ayele, might not necessarily cross with my time. I see you now at almost two and a half years old, and by the time you are fifteen or twenty, the likelihood is that my time will have ended. And in that regard, I want to talk to you about the world I am leaving you, the world my compatriots are leaving you.

Unfortunately, we are leaving you a world with much of it fractionalized far beyond the point to which it was when I was a boy. Much of it is infinitely more threatening to the overall survival of the human family than ever before. The devastation found in the weaponry of today is such that one weapon—one single

weapon—can destroy a city. Two such weapons could irreparably damage a country.

The world that we are leaving you as I write this is a world of wars, genocide, terrorists' attacks, unrelenting street violence, financial uncertainties, unbridled greed, and the lingering stain of racism. Calamity seems to lurk at every shadowed doorway.

But if you will recall, my dear, from our earlier discussion of the beginnings of our civilization, the odds against human survival were similarly slim: no language, no scientific knowledge of the world around us, fearful ignorance of the calamitous forces of nature, and our lot as innocent prey for the beasts with whom we shared the earth.

Yet we survived, enduring an evolutionary process that brought us to a civilized state in which we evolved bartering and currency systems, amazing geographical discoveries, stunning science, and a system of social intercourse between individuals and nations.

In truth, Ayele, while much about my present time seems dismal, there has never been a perfect period for human existence. When I was born, in 1927, while life was meager for my family and me, much of the world outside our known boundaries was suffering.

Before I came into the world, there were challenges, danger, and hunger. I don't know if there was as much

hope then, Ayele, as there might appear to be now. By the same token, I can't say that hope now is much more substantive than it was then. I do know that the world as it is today is much more dangerous than it ever was in past years.

The population eighty years ago was 2 billion. The question of life and death itself was vastly different. A child today has the opportunity, due to modern medicine and modern protection of our food supply, to live a long and productive life.

In contrast, in my day death was a frequent visitor. It came to most men in their early years: forties and fifties, some few in their sixties. When I was a child on Cat Island, we had absolutely no such thing as modern medicine. We had no aspirin; we had nothing that was manufactured in an industrialized country and made available to those citizens for a very small amount of money. Populations in those countries could relieve a headache with aspirin, or heal broken skin with a salve or other medicine. We, on the other hand, had no painkillers—nothing. What happened was that someone, usually a mother, would go into the forest and gather leaves, certain plants, and the bark of certain trees. Then they would bake or boil them; the residue was usually a dark, thick substance. That residue was then used for colds, for anyone who had

stomach difficulties, or as a diuretic or for other ailments. It's possible that some of those seeds or plants were brought with the slaves from Africa.

In the year I was born, a black man, with luck, could expect to live only forty years, yet here I sit at eighty-one. Discoveries in medical techniques and chemistry, and healthier lifestyles, can claim a large amount of credit. But luck and geography played parts as well.

Two years after my birth, the United States fell victim to the Great Depression, a decade of high unemployment and brutal poverty, which touched most places around the globe. Pneumonia, influenza, tuberculosis, and diarrhea took lives by the thousands, and countless children died of malnutrition.

As you have read in previous letters, my good fortune at surviving those often-catastrophic illnesses of childhood was also with me when I was brought face-to-face with more dangers of life itself. It was not, and has never been, a world without opportunities or appointments with destiny waiting for us all.

Then again, you'll recall by now that when I was sixteen years old, if I had had the presence of mind to foresee opportunities, I would have seen absolutely nothing. If I had not been at the intersection of 145th Street and Seventh Avenue, had I not looked at a

local newspaper, the *Amsterdam News,* picked it up, thumbed through it to the want-ad pages, looking for a job as a dishwasher, which was my profession, and stumbled onto an ad headed "Actors Wanted," my chances of finding my ultimate path would have been pretty slim.

Had I looked in any direction, whatever I would have seen would have been off-limits to me, not just because of race, but because I didn't know anything. It wasn't just that I was in culture shock in a totally new, huge environment—a big, bustling, world-famous American city; it was that I had no education, guidance, or tools that I could use to improve my chances of survival.

All those things that I gradually learned from listening to other people were things that should have been learned in kindergarten. That is the environment that I came out of, and that's what I took with me to that corner where I bought the newspaper. I came to that corner with the aggregate of my experiences. As to resources to chart my way into the future day by day, I had none.

How did I manage? Serendipity was a friend; the universe was a friend. Was it planned? I certainly didn't have a plan for myself. It is more likely that the universe had a plan for me. It is more likely that I was

surrounded by all kinds of energy forces that were having an effect on me. We've talked about God in those terms, of course, but now we get down to the nuts and bolts, the practical, moment-to-moment planning of the force of the universe. I was not smart enough, and I don't think anybody is smart enough, to know how those forces conspire to create opportunities in our lives, because they are a part of the universe, a part of nature. And nature doesn't tell you, "I'm going to have one of my guys tap you on the shoulder, and everything is going to be all right for the rest of the day."

You have seen all along that curiosity was also my friend. My survival, I understood, was totally up to me, however many friends I might have had looking out for me in the universe. I had no knowledge, no proof, no instinct of their existence, so naturally my survival rested with me.

And maybe figuring it out wasn't so different from my father deciding how to get the bat dung from the caves in order to enrich the soil for growing tomatoes that would ensure his survival and that of his family.

Through trial and error, I found that if I earned fifteen dollars a week and ate my meals at the restaurant where I worked, with five dollars paid for weekly rent on a room with bathroom privileges, I couldn't afford to buy clothes or go anywhere—except occasionally to

the movies, which cost twenty-five cents during the day and thirty-five cents at night.

So there I was, and what do you do? I was driven by a life that forced me to think for myself in the world that I had inherited.

But you will have your life in the world I leave you, and while I have spoken of its many problems, you will have many advantages undreamed of in my time. I see you, Ayele, at fifteen in a far more advantageous place than I at the same age.

At fifteen, I see you with not only fifteen years of life experience, but at least twelve years of, I believe, strong, consistent, dimensional, encompassing education, a part of which will be an understanding of the world. If you live in the city, in a very short time, perhaps at four or five years of age, you will be conversant with the city, sufficiently so that you will not be overwhelmed and can tell anyone where you live, who your parents are, what the phone number is at your house, and why you might be by yourself if you have wandered away in a shopping mall.

You will have all the tools necessary to think for yourself. At fifteen, you will know about mathematics, history, the geography of the American continent and other continents, and the countries that are on those continents. You will know about modern medicine,

and such medicine as you have been exposed to will have been explained to you by family members.

So I would expect you, Ayele, at fifteen to be very close to being an independent, resourceful young woman, conversant with communications, possessing the skills for maneuvering through all of the vast, seemingly endless fields of information and knowledge.

In time, you will understand the world and all its contradictory parts, and what power is and how it is applied, and who the men and women are who have the reins of power and to what use they put it. All those things you will have a good fix on. Not the ultimate fix, but a very good fix.

And I might hope that you become, or aspire to become, one of the people at the table where the big questions of the world are dealt with. I am sure there will be questions that will concern you personally and culturally, racially, ethnically, universally. The world is going to need all the young people who have a knowledge of it, who understand how it works, what its frailties are, where its faults lie and where its strengths lie, how its strengths are representative of a power that is very well used to the benefit of the human family. And in instances where they are not very well used, it will be a part of your and your compatriots' job to question. And not only to question, but to force the world

to take the ethical and moral stand needed to assure the continuance of the entire family of mankind.

That's where I would like to see you. Now, this is a great-grandfather speaking. You may be even better applied in another arena. There are many in modern life: medicine, mathematics, science of all kinds; there are professional people well versed in one or two disciplines who can spread their understanding, experience, and knowledge in such ways that they are useful contributors to the organizing and the functioning of a healthy cultural society.

As I draw this last letter of several in this series to a close, I will echo some thoughts with which I began, many letters ago, by saying that in the world that I leave you there will remain that part of myself for you and fellow readers to have and with which to know me better—not only from what happened to me but as an imprint left behind so that you can know who I was, what my values were, what I believed. What I understood, what I misunderstood; the times I was wrong, and why; the times I was right, and why. The many times I aimed and missed the intended mark. The few times I didn't. All that I was and was not, I hope to leave glimmering here just below the surface of these letters written to you and to the world that will succeed me. I hope to leave you some of the music that

has played for me whenever I've put my ear to the mysteries of the universe that have never ceased to catch my attention. You have heard me mention many of them: how did the fish get into the sea, the birds into the air? Where do thunder and lightning come from? Why was I so petrified by the bogeyman when I had never even seen one? How do we stand our ground in the face of legitimate fear?

After all, how can an old grandfather make himself available to his great-grandchildren and others after he's gone other than to leave something of himself that he hopes will be useful?

To that end, in addition to the larger questions that I've already explored—who, what, where, why we are and how we got here—there is one more I'd like to raise, one that will bring us full circle. It is the question of our human drive to reach beyond the limits of our potential, and how, even in the face of unanswered questions and unfinished lives, our search manages to go on.

There is the scientific answer that says we do it because it is in our wiring to do so, and has been since the beginning of creation, the aftermath of the violent detonation of an object far smaller than a grain of sand that resulted in an explosion so massive that it marked the birth of time and the universe. Or so modern science would tell us 13.7 billion years later.

The search goes on because we go on. Within this world I leave you, there are still enormous and nagging questions, most of whose answers lie in secrets tucked away at a frustrating distance beyond the reach of the multitudes still struggling in the dark, waiting for answers to point them toward the light. And that, my dearest Ayele, is exciting!

Yes, life is tough. It offers no guarantee that one road will lead to another, no promise that we won't get lost. And when we do, as surely we will from time to time, be advised that we'll stand alone. Whenever trouble strikes and we find ourselves abandoned where disaster of some unimaginable kind is feared to be roaming the darkness, listening for the aimless wandering of unsure footsteps, no protection is extended.

When we have no place to run, no place to hide, and our hearts scream in anguish for rescue, relief, salvation, we are left with only instinct for guidance and trial and error for judgment.

But the tools for meeting life head-on, as I see it, are acquired knowledge, belief, and hope. No one knows all that there is to know. (This despite Mark Twain's observation that between him and Albert Einstein, they encompassed all human knowledge. As he put it, "Einstein knows all that there is to know, and I know the rest.") The task is to learn as much as you

can about as much as you can; the great disease of mankind is ignorance.

With knowledge you can grasp tight a belief: that you can be better, that the world can be better. With that, you can claim hope.

Hope is the eternal tool in the survival kit for mankind. We hope for a little luck, we hope for a better tomorrow, we hope—although it is an impossible hope—to somehow get out of this world alive.

And if we can't and don't, then it is enough to rejoice in our short time here and to remember how much we loved the view.

Acknowledgments

Dear Reader, I have no tally as to the number of stories, moments, occurrences, life experiences, and serendipitous happenings that, all taken together, have added up to the eighty-one years through which I have managed to, somehow, survive and finally share it all with my great-granddaughter, with you, and with the world at large. How many stories, dear Reader, have been woven into the fabric of my eighty-one years of life? Even the wildest guess might fall far from the mark. All I know for sure is that "stories" are the bedrock on which each human life is built.

With that thought in mind, let me begin by thanking you, my readers, who have become part of my extended family over the years and who have encouraged me through this book to visit old and new turf.

Now it is my turn to encourage all of you, particularly those of you who are among my peers, age-wise, to consider setting down some of your stories and recollections for the younger members of your family trees. We are swiftly losing our histories, and many us are the last witnesses to the oral and familial accounts of how we got here. I can assure you that the rewards will be well worth your efforts. As for readers of younger generations, I hope that you might be inspired to take the time out of your busy lives to ask a few more questions of your folks and your elders. You'll no doubt find an inheritance to expand your vision of who you are and where you came from—and one that you can pass on to your kids later on. No matter how old or young you are, a journey of discovery is there just for the asking.

Writing this book has certainly been that for me. It would not have been possible or nearly so enjoyable without the support, enthusiasm, talent, and vision of a handful of individuals who are owed my lasting gratitude. This book has been enriched by the formidable skills of two truly gifted editors. Lou Robinson has worked by my side from day one to the completion of the first draft, at which point we were joined by the publisher's in-house editor, Mim Eichler Rivas. This book of mine could not have rested in more cre-

ative, more imaginative hands. Lou Robinson and Mim Rivas's contributions to this book, I can say with confidence, have been immeasurable.

My enduring thanks go to Jane Friedman, CEO of HarperCollins Publishers, for championing this work from the start, and to Michael Morrison, president of HarperCollins, for being in my corner as well. To the team at HarperOne, the imprint I am pleased to call my publishing home—you have gone beyond the call of duty and I'm forever indebted. Special thanks go to Eric Brandt, senior editor, for your scrupulous devotion to the creative process and for sensitively honoring the spirit of *Life Beyond Measure.* Further thanks belong to HarperOne's leading lights: Mark Tauber, publisher; Claudia Boutote, associate publisher; Mickey Maudlin, editorial director; Terri Leonard, executive managing editor; and Suzanne Wickham, director of media relations.

As for the team that has assisted me on my end, I must start with a profound, overdue thank-you to the great Mort Janklow, longtime literary agent and friend. You are a person of courage who always has my back. Everything that I've written has been the beneficiary of your encouragement.

Thank you, thank you, thank you to the team in the office—to Darwyn Carson and Susan Garrison,

two brilliant women I'm fortunate to know and to have assisting me on a daily basis.

Finally—to my wife, the love of my life, my best friend, thank you for cheering this book on. And to my daughters, my grandchildren, and my great-grand-daughters, thank you for your unconditional love. I love you all and I'm so proud to be your old man.

Photo Credits

Diligent efforts have been made to locate the copyright owners of all the reprinted photos that appear in this book but some have not been located. In the event that a photo has been printed without permission, the copyright owner should contact the author c/o Harper-One, 353 Sacramento Street, Ste 500, San Francisco, CA 94111, Attn: Editorial.

All photos are from the author's personal collection except for the following:

Sidney Poitier at 1963 Academy Awards, © Getty Images

Sidney Poitier after the 2002 Academy Awards, © Berliner Studio/BEImages

Sidney Poitier with Oprah Winfrey, © Harpo, Inc./ All Rights Reserved/Photographer: Kwaku Alston

Photos of Sidney Poitier and his family at his eightieth birthday, © Alberto Vega, Photographer